Paperback ISBN: 978-1-64873-386-4
EBOOK ISBN: 978-1-64873-387-1

Printed in the United States of America
Published by:
Writer's Publishing House
Prescott, Az 86301

Cover Design: Creative Artistic Excellence

Smile of Depression…

'Learning to savor the strawberries and flush the shit!'

Gail F. Woods

Dedication

Smile of Depression.... is dedicated to Earth Angels everywhere, whose souls are kind, caring, and essentially, spread light throughout other people's lives. Sometimes you recognize them, sometimes you don't.

To those Earth Angels who have intersected my path, bless you.

And to Costa Rica, the kindest country in the world.

Contents

Prologue

"It's never too late to let go and find new meaning. It's never too late to take a step in a new direction. Take a chance and trust yourself today."

It has taken 20+ years since my diagnosis to process, reflect, and educate myself enough to feel empowered to tell you my story. Spending the last 6 years retired in Costa Rica has helped; providing the time, the heavenly surroundings, and the healing needed to compose.

When I began to write my story, there were only four generations of Deatcher/Frankel family members diagnosed with various types of emotional/mental illnesses. Sadly, there are now five.

Who knows how many more are as yet undetected?

I invite you to accompany me as I share this authentic pilgrimage into the questions of Who, What, When, Where, and How contributed to both my descent into, and ascent out of, the depths of depression. *I left out Why because many of those questions cannot be definitively answered.* We'll consider the:

- Interdependence between nature and nurture

- A simple mantra of "Communication Matters," by all definitions of the words
- Truthful Mindfulness and acceptance of who you are
- Understanding of our stories to help lower the stigma attached to mental/emotional illness.

To the very best of my cognitive ability, my smile-mask has been exposed and ripped off 100% throughout these pages, and 99% in my life.

Taking into account any minor flaws in my memory, this is absolutely my story, reflections from my past, my present, and my remembrances.

It has an eclectic cast of characters, from family to friends, preachers to God-led counselors, and blessedly, the Holy Spirit.

It is shared for both my continued healing and more importantly, yours.

You owe it to yourself to take this journey. You are worth it.

Chapter 1
1996

"Behind every mask there is a face, and behind that a story."

Anonymous

Keep my eye on the ball.

Keep my left arm straight.

Swing.

Drop the club and slowly slink to the ground, clutching my heart.

"Babe, I feel like I am having a heart attack. The pain in my heart that I felt all weekend is way worse."

Dan and I had rendezvoused at the Red Oak Valley Golf Course after surviving hectic last-month-of-school days at our respective campuses. It's May, 1996. The previous weekend had been a difficult and emotional weekend at a family wedding in New Jersey and the plan was to relax with a round of golf before dark. Flying back home to Texas, I had felt a dull, aching pain in my chest, but self-diagnosed it as stress from having to play my

family's favorite game for three days straight: "We are fine. Just fine."

Ha! Many of the family members in attendance were so far from fine. Behind those smiling masks, were masks of sad tears and distrustful thoughts....

Dan wastes no time gathering me up off the ground, securing me in the golf cart, and driving the most direct path back to the parking lot. There is no mask on my face now. We are both genuinely scared. I am only 42 years old, but I have been struggling with multiple health issues all school year, seen numerous gastroenterology specialists, yet no one has managed to diagnose the definitive problem. No one has considered my heart to be the issue, either. Now the doctors at the Waxahachie Medical Center emergency room will get their chance to solve the mystery.

Dan is driving fast, somehow keeping one eye on the road, and one loving eye on me. I am pretty much in *pushing-on-my-chest-and-moaning-mode* until we get there. Running into the ER, Dan immediately gets attention, yelling, "She thinks she is having a heart attack." Those will be the last words I hear from Dan for hours. The last words I remember hearing in the ER are, "I can't get a good vein," from the nurse, which I have heard for my entire life. "100, 99, 98, …"

I wake up in a hospital room, hearing the sounds on the monitor, and Dan is sitting by my bedside in the dark, carefully holding my bruised hand. We are both relieved to be looking into each other's eyes again. Trying to answer all the questions I have on my face, he first reassures me that I did not have a heart attack. "Thank, God." I vaguely recall Dan sharing that the medical team ran other tests, not really focusing until he sadly says, "They do not know what is wrong." That's the one millionth time we have heard that this year. *Gross hyperbole!*

Turn on the water works. The heavy feelings dragging down everything. Let me go back to sleep.

Please.

The next time I open my eyes, it is still dark, and there is another tall dark-haired man sitting by the side of my hospital bed. After introducing himself as Dr. Walker, my primary doctor from the ER, he reassures me that Dan went home to get some sleep.

Then, in the first light of the day when dawn is just approaching, he quietly utters just five profound words that will light the way down my next path.

"Tell me about your life, Gail." He pauses with a look of compassion, and then says, "Truthfully. We ran multiple tests, yet there is no evidence of any physical reason for your pain."

The mask begins to just barely dissolve. And so begins my path toward healing.

I invite you to come along on the journey…

1957

It is Wednesday night dinner at Pop-Pop's house.

We have to dress in clean clothes and use our best manners. My brothers have been chattering the whole drive about having real food for dinner. I am not too sure why what Mom cooks is not 'real,' but she is the last-minute Casserole Queen! All the food on the plate mushes together. Anyway, as soon as Mom parks the station wagon, we all climb out of the car and run for the front door. Screeching to a stop, we line up before we go inside. Since I get to be first, as I am the littlest, I try to reach the shiny doorknob and turn it. My next-up-in-line sister reaches over my head and the door opens. Hmmm, maybe you have to make a mean face to get the door to open, because Barbara is always frowning.

My Pop-Pop's gigantic red brick house is four stories high. That means there are at least four staircases, all with twists and turns. Two are just wood floors, with no railing; one has dark, red-colored carpet with a beautiful wood-carved banister. The fourth one is the "do not ever play on these" outside cement stairs that lead to the dark and scary basement.

Charging into the "castle," we instantly calm down, put on our best manners and slowly advance to the huge foyer. The fancy staircase dominates the room, just waiting for us to play.

Big, long stairs; some skinnier and shorter ones on the turns. They climb to the white balcony upstairs where the bedrooms are, with closets big enough to get lost in, and all kinds of places to hide. I like being <u>carried</u> up those stairs the best.

As soon as we see Pop-Pop, my daddy's Daddy, we all smother him with hugs and kisses. He is a little man, with a mustache that tickles. Next, we kiss our daddy, who beat us here somehow, and then skip into the kitchen for big hugs and "sugar-kisses" from Sarah. Now we can go play until dinnertime. Lots of times, I just want to stay in the kitchen with Sarah, the long-time live-in housekeeper from Ohio. I love her. Sarah lets me fall asleep on her lap. When she visits the neighbors, she also takes me with her. I love it when we walk "all the way" to the Giant grocery store. I can always convince her to put some special snacks in the basket. The very best thing about Sarah is that she feels like a big, soft, cuddly stuffed bear. But tonight, when I hang on to her leg, she tells me to, "Scoot, Dorothy Gail. I got some more cooking to do..."

My actual memories of being at Pop-Pop's house begin around 3 years of age. At this time, I have two older brothers, John (10) and Scott (8), plus my older sister Barbara (4). I am The Baby, a label I really like, but my siblings do not. As I just described, my parents have this weird practice of lining us up by

size quite often, with the littlest one in front. We do it every night when Daddy comes home from work, gathering at the front door when someone hears his car pull into the garage. Think "The Sound of Music" without the Navy whistle. However, once the line-up is finished, it is free-for-all. Which leaves little me constantly trying to catch up, as they all scatter, especially in Pop-Pop's house. In a house filled with staircases, my brothers and sister have a great advantage for ditching The Baby.

Pouting because Sarah is too busy to play, I set out to find someone else to play with me. Standing in the big doorway into the grown-up room, I can see Pop-Pop, Daddy, and Mom sitting in the living room, in the same chairs they always choose. Pop-Pop on one end of the couch, and Daddy in the big chair at the other end of the room, leaving Mom closest to the doorway. That way, if Mom sees or hears us, she can quiet us down without Daddy knowing! All three are talking and laughing while having their grown-up drinks and snacks, not to be disturbed until the dinner bell. Sometimes, like now, I forget that I am not supposed to go in there and try to sneak past Mommy to get to Pop-Pop. But tonight, Mom sees me and quietly whispers for me to "find my sister and brothers." Does she really think I can find them?

They have already started playing their favorite game "Hide and Go Seek," but to me it feels like it is a "Leave the Baby

Behind" game. My brothers love to use the two old, skinny, wooden staircases. One leads to Sarah's attic bedroom, and one goes down to the really scary underground basement. My sister likes the fancy carpeted stairs with a curvy wooden railing. Me...I just want someone to play with me.

Therein lies the conflict. This sweet little girl faced with navigating stairs is a disaster waiting to happen, over and over again.

Tonight, I can hear John's voice coming from the basement. Exactly who I want to find. Trotting over to the door to the basement, I find it already open. Standing at the top for a minute, I remember it is so dark down there, even if the big light is on. And cold, too. But John is down there. Ready, get set, go down the steps, one at a time, being extra careful with the big curve in the middle. The week before it might have been the attic steps, with their right turn. And the carpeted grand staircase leaves many boo-boos and bruises, too. With no rail at the turn, I inevitably tumble down, head over heels, roly-poly multiple times.

And just lay there.

I do not cry, at least not on the outside where my crying would be heard. No way!

I have already begun to master a skill that I will put to use for 30+ years.

Stifling my emotions.

Masking my true feelings. "Don't cry, Dorothy Gail."

The method I have already learned as a toddler is to hold my breath until I pass out. Thank goodness my brothers, or sister, already know to look for me after a few minutes, I guess. Because it happens a lot at Pop-Pop's house. One of them would go get Sarah, and she would pick me up. I remember the times where "My-Sarah" would splash water on my face, "make me all better" and plop me in my chair at the dinner table, with my napkin on my lap.

Oh, if only Sarah could have made me all better.

For most of my growing up years, Pop-Pop's house is my favorite place to be, especially when my brothers and sisters are in school. Sarah spoils me all day, every day, except when her "stories'" are on. Then we go upstairs to Pop-Pop's room, sit down together in the big rocking chair, and watch *As the World Turns* and *The Guiding Light*. I think I am supposed to be napping, but Sarah is always talking to the television! "Don't you believe that sleazy snake! He is cheatin' on you!"

Pop-Pop and Sarah's house is my go-to place for hugs and kisses for many years. It's where I make my first best friend, Ann,

who lives right across the street. We are both five years old. She has a bunch of older brothers and sisters.

Pop-Pop and Sarah's house is the one home that will remain constant. Even though it will be years before I will be all better.

Dear Sarah,

Family is not just about blood. It's about who is willing to hold your hand when you need it the most. The one who is always there for you, unconditionally.

You were already a part of our family, long before I came along, hired by Pop-Pop when he married my daddy's mother Dorothy, when my dad Gordon was a teenager. Widowed during WWI, Dorothy suffered most of her life with Diabetes, and her diet and health restrictions required supervision. You and your husband both moved in to be full-time caregivers of the house around 1940 and take care of Nana, Pop-Pop, and teenage Gordon. I remember the story they told about your husband, who also worked as a conductor on a cross-country train. One day he left to go to work, and never came back. You stayed on and lived, worked, and provided loving care to all who came to Kirkside Drive for another 50+ years. Thank goodness.

You were our Nanny, in all connotations of the word. While you never had children of your own, you not only shared your abundance of love with Pop-Pop's grandchildren, but your numerous nieces and nephews, and many of the neighborhood children. Oh, you had your serious techniques for keeping all of us under control;

"I'm going to send you out back to get your own switch out of the tree, and then I'm going to spank you with it." Even now, I smile while typing it, because you never once followed through. You didn't have to.

It was your nurturing spirit that drew me to you, even as a little girl. You seemed to know just what was in my heart, the love and care that I craved, before I could express it. When you dressed me and Barbara up in our fluffy dresses, and took us to your big African Methodist Church in Washington DC, you mirrored color-blindness for me. A lesson I never forgot, Sarah. Our connection only strengthened as I grew and became aware of the blessing of Sarah as a special Earth Angel in my life. You pretty much could "heal whatever ailed me" with one of your teddy-bear-hugs, and some chocolate chip cookies.

As an adult, I understand so much more about the dynamics of your role in our family. I acknowledge that it was status quo in the 1950s and '60s for you to eat in the kitchen while we ate on the other side of the closed door, but I never accepted it. Even as a little girl, my heart felt how wrong it was. I asked every time, "Can [May] I eat in the kitchen with Sarah?" I treasured those times when Miss Anne, my mommy, said yes.

In addition, one of my most vivid "coming of age" markers happened in my teen years. While visiting from New Jersey with a couple of girlfriends, face-to-face I asked Pop-Pop, "May Sarah eat with us in the dining room?" Check the **yes** box!

Thank you, Sarah, for always being there, not only for me, but for all the family.

All my love,

Dorothy Gail, **The Baby**

Chapter 2
1959 - 1963

"Stress, anxiety, and depression are caused when we are living to please others." Paulo Coelho

Oh, how I have learned to be a perfect little people pleaser.

Just do everything you are asked to do to the best of your ability and smile a lot. It puzzles me when Scott or Barbara gets scolded for something they say or chores they leave undone. What is wrong with them? Can't they just be good so that Mommy and Daddy will love them? John, the oldest, seems to have it figured out. Not that he is perfect. He is just the best at playing the Frankel game. Or maybe he was just born good. He looks just like Daddy, and mostly acts like a grown-up. Plus, he willingly does everything our parents ask him to do; or so it seems to me.

Being the oldest, John is conveniently assigned the task of official babysitter. Good for me! That means I have an in-house

protector. (Remember, I am still The Baby.) During this stage, it feels like Scott is always using my little head for a drum, beating on it with his drumsticks. He is sneaky, and especially strikes if no one is around. I try to look around corners, checking if the coast is clear, but I am not very good at it. At least Barbara doesn't try to physically hurt me, but she sure is bossy all the time, especially about my hogging the bathroom "every day." *Could I have stood up to them? Oh, how I wish I had.*

It's moving time for our family.

We are leaving my first house, and moving from Bethesda, Maryland, a suburb of Washington DC, out to the small village of Potomac, Maryland. "Everybody out of the house, and everybody into the station wagon," Mom yells one last time. This is my first time moving, and everyone sure has been upset about it. "Clean out your toys. Weed out your clothes. Pick out some toys to give away," Mom says over and over. Barbara, firing orders of her own, sounds just like her. Finally, we are pulling away from our old house to our new one.

The ride out to the country does not seem to take very long. There are lots of trees and flowers outside my car window, and not many houses. I am trying to pretend I am out there in the trees, all by myself.

It is so quiet. Just the sound of the birds.

I can tell we are there because the inside of the car gets silent, just for a brief minute. "On your mark, get set, go!" We climb over each other, the seats, and scramble out of all the car doors.

"Oh, my goodness!" "Holy cow!" "It's so big!" "Wow!"

The yard is gigantic with lots of grass and some trees, too. The red-brick house is really long, with a big, screened porch on one end. From the street, it looks like it only has one story, but we soon discover that "underground" is another whole layer, and this awesome-to-sled-down curvy driveway goes into the garage. Up on top, there are 2 bedrooms (still have to share with Barb), a kitchen, dining room, family room, living room and porch. Right in the middle of the house, there is a door with stairs going to the "down-under" part. There is almost another whole house down there: a family room with a built-in bar, another bedroom for John and Scott, a laundry room, 1½ bathrooms, the garage, and big glass doors out to another huge lawn and more scary-cool looking woods. We are 5, 7, 11, & 13 years old and moving into our own castle.

"Olly, Olly, Oxen free," Scott yells after catching Barbara trying to get to home base. All four of us are actually playing

together on the top floor only. We have not been living here for very long, and I am not handling the new staircase very well. Surprise! Pretty soon I will be tall enough to hold onto the railing, but not yet. Plus, I don't ever have to be 'It'. John's rules! Sometimes being The Baby is a good thing. Soon, though, John and Scott are going downstairs, so I guess gametime is over. It's fun now having brothers and a sister to play with, sometimes. We even go out and run around in the front yard, playing tag or just being silly.

Tomorrow, we are taking a road trip to New Jersey to see Granny and Grandad, Mom's parents. They are going to meet us at the rest stop, halfway between our house and theirs. Then all four of us will change cars to go to their beach house in Brigantine for a week. Everyone is excited, especially Mom and Daddy. Hopefully, I will get to play on the beach, eat soft ice cream from the Dairy Bar, go on the rides on the Atlantic City Boardwalk, and, my favorite, cuddle with Granny. She has the softest "pillows" to snuggle with. She sings these pretty little Scottish songs, like "Cheerio Chin, Chin," with the funniest accent. And I will also turn five years old when I am there. Granny makes really good birthday cakes, like my favorite, yellow with chocolate icing.

We are getting close. All the car windows are open, and I can smell it. It smells like fish, sand, and salt water. The air feels warmer, and wet. First, we have to drive over the bridge because Brigantine is an island. How cool is it that the bridge is open when we get there, so a big boat can go by? The road just breaks in the middle, and one part is lifting up. "What if you are driving across when it is opening?" I ask, and all the boys in the car start laughing, John, Scott and Grandad! John tries to tell me how it works, while we are driving over it, but I think I am too little to understand. I do see the big red gates that block the cars from driving on the bridge, so I'm not scared any more. I am just excited to get to Granny and Grandad's house. This is going to be the best trip ever!

We are having so much fun that the days just fly by. Their house is white and green, with a little road in the back where I am allowed to bounce a big red ball by myself. It must be so cool to be able to live at the beach. Even Scott seems to like it! He makes funny faces when the sand gets all over him, but it does feel itchy to me, too. So then I just run into the Atlantic Ocean and get clean.

After getting to do all the fun things on my list, the visit is already over, and we all piled into their car, suntanned and happy. Plus, Granny and Grandad are driving us all the way home

to Maryland to see our new house and stay with us for a few days. We have to be quiet in the car when Grandad is driving, so we all take naps; even John and Scott, I think.

It is as quiet as my closet. So nice.

We are all awake and happy to be home when Grandad pulls the car in the driveway. Mom, Daddy and Pop-Pop come hurrying out the front door to greet us, which means something special is going on if Pop-Pop is here. Maybe my birthday is what's going on! For a few fun moments there are lots of hugs and kisses, that's for sure. "Time to show Granny and Grandad our new house," Mom says, and herds us through the front door. Barbara grabs Granny's hand so she can be the one to show her our room. What? It is spotless, like no little girls lived there. Wow. I can't help but look at Barbara and we giggle together. Somebody cleaned up our room. Cool!

After a little while, Daddy says he wants to show Granny and Grandad the down-under part of the house, so we all head for the stairs. John and I go down last, as I still need help to keep from falling. By the time we creep down step-by-step, everyone else is already out back waiting on us. "Happy birthday, Dorothy Gail," they all yell when I go outside, but I don't see any cake with candles. I see a big, gigantic swimming pool, down in the

ground, filling up the whole backyard with pretty blue water. "Surprise! This is your birthday present."

Now, I know now that it is almost impossible to build an inground pool in one week, but I have never admitted that, ever. Furthermore, no one told me anything different, ever. So, even today I refer to that pool as MY pool.

It doesn't take long for the four of us to find our bathing suits and get in. There are steps on the shallow end, and I can stand up there. There is even a board down on the other end that John and Scott bounce on and jump into the pool. This is going to be so much fun.

My swimming pool is more fun than we could ever have imagined. Everybody likes it. Every weekend there are pool parties, with grown-ups and kids. Pop-Pop comes over a lot, driving his fancy car, but never goes in the pool. He just sits in the shade and "has fun watching us having fun." In one hand he has a drink, and in the other, the latest 8mm camera.

What a blessing his home movies have been. We are able to witness, over and over again, how we grew up. Made it easy to watch our bodies change from year to year, not to mention swimsuit styles. Our swimming skills improved rapidly, as evidenced from the difficulty of jumps and dives off the diving

board. There is a classic home movie of Granny, who could not swim, holding on to the side of the pool, with a tire inner tube around her waist. She accidentally floated away from the side and started panicking until Scott pushed her back to safety. She made the funniest faces, even though she never left the shallow end!

Mom always walks around in her one-piece bathing suit, being the best hostess. I even have one that matches. Every once in a while, she puts on her bathing cap and gets wet, but not often. Even when she swims, she only swims "sidestroke, like a lady!" Dad loves to be in the pool. *Looking back, I guess it made his painful arthritic joints feel a little better.* He has his "Dads Only" inner tube, with a holder for his beer can and usually smokes a cigar while floating, too. Silly John and Scott like to try to dump him over, but they rarely, if ever, are successful. Daddy just smiles. Soon after, Daddy and the boys gang up to try to dump Barbara and me off our raft. My protector John always pulls me up out of the water and plops me back on my raft, and then goes back to dunk them.

This is an important memory. There were not many times the Frankel family played together.

I learn how to swim pretty quickly, in order to save myself.

The years at the pool house were the happiest years for all of us. Living proof that we could experience some sense of normalcy as a family, sometimes.

In the colder months, when the pool is covered, there are snowball forts and fights in the front yard, riding our Flexible Flyer sleds down the driveway, and building snowmen. If John is willing to take us, we are allowed to walk a little way up the main road, to the huge hill behind the Monastery. When we get too cold, the nice monks let us come into their basement and warm up by the big heater. *In a recent drive by, the "huge hill" has gotten much smaller.*

When the trees outside have pink flowers on them, John comes and gets me. "Hey, little one, will you go outside with me?"

"Let's go now," is my instant reply. Out on the sidewalk I see Barbara's blue two-wheel bike. What? "Am I going to learn the coolest new thing: how to ride a real bike?" I am so happy that I really don't even care that Barb got a new pink bike. I practice every day on the front walk, and then move to the neighbor's driveway. I am going to practice until I am really good. John will be so happy.

Eventually, I am able to ride all over our small neighborhood, visiting friends from elementary school, and making new friends with the neighbors. Seems like my natural smile got me a lot of cookies from those neighbors. All our lives seemed good then; not perfect, but normal.

After all, even though we were having fun, we were still the same four siblings, fulfilling our roles...

The worst is when Scott and Barbara team up; like tonight, for example. Someone is knocking on our front door when Mommy and Daddy are out to dinner. Sitting in the living room, reading books with John, the noise interrupts our quiet time. There is a loud knock on the front door. Scott and Barbara are nowhere around right now, but soon they come running into the living room, with shouts of, "Do you hear that knock? Someone's trying to get us!" John knows that we are not allowed to open the door when our parents aren't home, but Barbara and Scott keep yelling at him. Staying true to my label, I am really scared, clinging to John and trying with all my 6-year-old determination not to cry. Then my protector decides to open the door. Surprise! No one is there. John says, "It's okay Gail. No one has ever been there, except for Scott and Barbara who were playing a joke." Boy, we all scatter then.

I run straight to my bedroom closet and quietly cry. I can hear Scott and Barbara getting a big-brother scolding by John, which makes me feel a little better.

By the time Mommy and Daddy come home, all of us are "sleeping." We can hear the car as it makes the long drive down that curvy driveway.

John never told them anything, or at least that's what I believe. He knew how to play the game. He definitely earned points in the big-brother category from Scott, Barbara, and me. I don't think they ever heard about the nighttime swims in our pool, Barb and I trying to stab Scott with my hand-mirror's pointy handle, etc. John could be everyone's hero.

Upon reflection, the time we lived in the swimming pool house bubble was priceless. The core years, when all 6 of us were living under the same roof. What if it could have lasted forever?

Turns out God had a whopper of a surprise planned for our family that would change everything and everyone. And it was coming up too quickly. The only constant in life is change, right?

Dear John,

I never knew for sure whether you were just that good, or if you had mastered the masking techniques too. There were just too many years between us to have many opportunities to share with each other, and we just didn't have enough time. I do know that you surrounded me with kindness. I do realize that you seemed to know that I struggled to "play the game," and you covered for me many, many times. And I do know that I have never forgotten what you did as my big brother.

You were my safe person for my first ten years, and then it seemed like overnight you left for college. Why wasn't it more of a big deal that you were moving out? Oh, I came to understand it was a natural, coming-of-age step for you, but it seems like something that left that big of a hole should have been recognized as a special event. No more John around the house. Surely, someone should have noticed I was sad and confused.

Bottom line is you were focused on your future: getting a college degree and falling head-over-heels in love. Little sisters lose their place as big brothers grow up. It happens all the time, a natural progression. But it still hurts a little; a lot. With God's Grace, once we have

all reached adulthood, we'll find our way back into each other's lives. One big happy family.

I love you, oldest brother.

Hugs and kisses,

Dorothy Gail

Chapter 3
1964 - 1965

"The only thing more exhausting than being depressed is pretending that you're not." Anonymous

Well, as God's plan for our family moves forward, a Shakespearean tragedy is playing out.

The next handful of years are overflowing with big changes. Some happy, some not. Not to mention, I officially became a woman. With that many emotions churning inside, along with lots of unshed tears, you have the ingredients for thick Depression Soup, 1960s style.

About this time, after only four amazing years, our parents make the decision to move again, from our "big, swimming pool house" to a new townhouse where the maintenance and lawn care will be handled by someone else - not Daddy. We definitely do not have a Frankel family meeting to talk about the possibility of moving. We just get the already-been-decided news at the dinner table. I feel the tears pooling, but if I let them drip, I will be sent

to my room. This time I want to hear everything Mom says. It comes as a surprise to me to hear that "Daddy is not able to do those things anymore." No one has actually said anything to me about him being sick. He works hard during the day and relaxes in his chair at night. I'm still small enough to sit in his chair with him. It feels pretty scary for me to realize the truth. Why don't we take better care of him? Keep Daddy company more? Talk about what is wrong with him?

Thoughts and questions like these are getting more into my heart as I grow, and they just fester. I would later discover that Rheumatoid Arthritis, Diabetes, and some other medical problems had aged him, at the young age of forty-three.

John has gone off to college this year. He tries to explain it to me before he leaves, but I don't understand how far away he is going. Scott is set to leave in another two years, and our parents decide we are moving. That's that. So, we move in the spring of 1964 to Woodley Gardens in Rockville, MD.

It sure feels like we move far away, but Daddy shows us on the map that it is just one town away. Barbara and I even ride a school bus to our old school until the end of the current school year. Mr. Tom, the bus driver, lives in Rockville, so he lets us ride with him to Potomac.

I'll admit it ends up being a pretty cool place to live. The three-floor townhouse has three bedrooms upstairs. (Maybe Barbara and I will get our own rooms when Scott goes to college.) Our new house seems like it is in a nice neighborhood, with lots of places to ride my bike. When summer comes, there is a clubhouse and swimming pool right across from the park.

Even so, this new house can never replace the swimming pool house, and for a while I just continue to feel lost that John is not there. I still miss my go-to brother who would be there when I am sad or confused.

Mom is getting a little chubby, so we tease her about needing a girdle to hide her "midriff bulge." *It was a popular advertising slogan at the time!* "She is middle aged, isn't she?" mutters Barbara. Well, not old enough evidently.

Not one of the four of us saw this one coming. At the age of 44, with Daddy in poor health, our parents are having a new baby. It seems kind of gross.

In about five months he will be born, and named William Douglas; AKA Billy, Beezer, Bubba, or Willy-lump-lump. And at the ages of 11, 13, 17, and 19, the four of us are adding a fifth sibling to our clan... *There goes my hope for my own bedroom!*

At first, Barb and I are grossed-out, and actually want to keep this secret. Mom and Daddy, our grandparents, and their

friends are acting like they think it is incredible news. Over-our-head stories are shared within our hearing range. The family obstetrician asks my mom who the father is, since Dad is taking multiple medications that should have rendered him sterile!? At the announcement party, Barbara and I are even allowed to be downstairs at the party for a little while when they make the big announcement. Their best friends bring them a framed picture that jokes, "You and your 'once more for old times' sake!'" It depicts an old lady sitting in her rocking chair with a big belly. Everyone is really laughing at that one.

Pretty soon after, everyone can tell our mom is having a baby just by looking at her. Boy, do people look at her, too. It is so embarrassing going to the store with her and her growing belly. Why do women come up and rub it? *Having a baby in your 40s was not a common event back then.*

Finally, on a cold day in early February, our new little brother is born. All "doubts" about his DNA are put to rest when Mom declares the (new)baby looks exactly like Daddy; just like John did 19 years earlier. Maybe he will grow up to act just like John, too.

When they both come home a few days later, we all have to learn how to take care of Baby Billy; to make a bottle, warm it up, feed him, change diapers, give him a bath, etc. I wonder why

we didn't practice ahead of time. Mom may have had five babies, but Scott, Barbara and I hadn't. It is a lot of work. I can hear Barbara quietly mumbling, "You had this baby, not me," every time she changes a diaper.

To be honest, I tried to really like Billy, not just pretend. Oh, sure, I fell in love with him instantly. He was cute, sometimes it was fun to feed him his bottle, and his birth meant Mom stayed home more. Nevertheless, I couldn't help pouting at the loss of my ranking. John was still the oldest, Scott and Barbara the middles, and now Billy was The Baby. I felt like a nobody and struggled to hide my jealousy for a while. I didn't really like my new label either: **The Baby Watcher...** But, I had no choice but to step up. That's what you do when you love someone. Mom took lots of recovery time, and Billy needed baby care.

Reflecting on these memories, even though I was eleven years old, or maybe because of it, I was resentful of the new baby in the house. Two conflicts of the heart: loving my new brother yet silently begrudging his intrusion. Those next couple of months were just as mixed up: lots of smiles and giggles enjoyed with Billy, followed by bouts of confusion and sadness. Definitely significant ingredients of depression to add to the simmering cauldron.

Then the best lifter-upper in the world happens: John is coming home from college for an Easter visit to meet Billy. Everything will be so good again. I miss him so much.

Epic fail; not so fast and not so easy...

John is here but he is not the same. This John is a grown-up! All of a sudden, the eight-year difference seems huge. He is in college, and I am just finishing 5th grade. He is drinking coffee, not a soda. So far, he has been spending HOURS talking to Mom, making faces at Billy, and teasing Scott about having to share a room with their little brother. Scott leaves for college this summer, and then Billy will have his own room. Aside from one hug and some pats on my head, I am staying curled up next to him, just waiting for my turn.

Trying to be very patient, while silently longing for more of John's attention, I am just about to lose it when Mom saves the day. "Why don't you take Billy for a walk in his stroller, Dorothy Gail? Maybe John would like to go with you."

"Yes! Thank you." Please, please, please; everyone else say no so John and I can re-connect. I am praying silently the entire time it takes to get ready.

Finally, we set off; just John, me, and Billy in his stroller. We walk and we talk and we laugh. I talk and John listens. My heart remembers that John is, and always will be, my brother. It

is turning into a great day. He talks, and as I listen to him, he shares his grown-up plans for after he graduates. He is going to be a banker, just like Daddy! No surprise there. He has always been a talking, smiling, cuddlier version of Dad. He is going to marry Lois, and he is so excited. They are going to be living in Pittsburgh.

What? Why is he going to live there?

I am suddenly so sad, but don't want to ruin John's joy. All I know about Pittsburgh is that it is really far away from our house in Maryland. That's why we do not see John very much...

"Why can't he be a banker at Daddy's bank? What's so great about adulthood? Don't let John see my watering eyes. He is happy," chatters my monkey brain. It seems like it is going to be a long time before I get to see John again, the day after tomorrow.

The remaining twenty-four hours of John's visit is the first time I actually remember wanting to cry but smiling instead. It felt like days.

Put another portion in the simmering brew, with a full cup of dried-up tears.

Dear Little Bro,

It took me many years, and many events, to grasp what a necessary addition you were to our family. Of course, everyone could immediately notice the pep in the step of both Mom and Daddy, and the smiles on their faces. Baby Billy was the center of attention, inside the house and everywhere we went. You were adorable, with those cheeks people loved to pinch.

I took care of you a lot. When Mom and Daddy had friends over for drinks and dinner, a routine was quickly established. Barbara and I brought you into our room upstairs until we got "the signal" from Mom. Then we would carry you downstairs, and Mom would show you off to their friends. Barb and I would smile while clearing the table and rinsing the dishes, then grab you back from Mom, and head back upstairs. Whew! Performance is over for tonight.

Your birth really did bring lots of joy to our family. As you grew a little bigger, my friends always wanted to play with you when they came over. Soon Scott left for college, Barbara began 7th grade and I settled into a smooth 5th grade year. Mom's friends came to expect you to come along when they made lunch plans together. It was quite exciting for a middle-aged

woman to have a healthy baby, and they would pass you around the table.

In short, we all adjusted to the new star of the show.

There will be many seasons for us to experience together, Bill. Some will be really bumpy, some compassionate, some joyful, some heartbreaking. You and I actually spent your first ten years living under the same roof, more time than any other sibling spent living with you. You continued to be the main focus of Mom's attention, and the primary source of her laughter and tears. Mine, too! Even though you looked like John, (nature) you did not act like him. In your defense, you didn't get the gift of growing up with John (nurture). You grew up in a very different family dynamic, almost as if you were an only child. You thrived on all the attention, yet, as you began to grow into adolescence, you started to master the subtle art of manipulation. "Let's make a deal," was your motto. You would only leave me and my friends alone if I paid you.

We will continue to ride that roller-coaster relationship over the years, even now. We both have a lot of life left to live.

Love from your big sister,
Gail

Chapter 4
1965 - 1966

"I am just fine. I'm a daughter hiding my depression. I'm your sister making a good impression. I'm a friend acting like I'm fine. I'm a teenager pushing her tears aside. I'm the girl sitting next to you. I'm the one asking you to care. I'm your best friend hoping you'll be there." Anonymous

Wait! What's that noise? Someone is pounding on the front door and keeps pounding.

Carefully peeking out of my upstairs window, I see two boys from my new class standing on our little front porch. I don't know their names yet, but I did notice them in class. They look like they are too old to be in 6th grade. *Even today, as I am writing this, I can clearly see them in my mind's eye.* Tall, long, stringy hair, and baggy bell-bottom dungarees. And now, here they are, banging on the door and taunting me, yelling, "What happened at school today? How are you doing? Come on out and talk with us."

Mom and Dad believe I am old enough to be home alone, but at this moment I feel about as helpless as a five-year-old. No

John or even Scott to help me. Barbara is not home yet. I have no clue what Mom's new work number is, so I grab our little princess phone and dial the only number I know by heart, my mom's best friend. She is my friend too; a safe person who has wiped my tears before. When she hears my shaky voice, she says she will be right over.

After waiting a little while, my scared and scrambled brain remembers: Mrs. Ashworth lives close to our other house. Oh, my goodness! Mom might even get home before Mrs. Ashworth gets here, and she will not be happy with me when Mrs. Ashworth shows up. This only serves to add to my no-good-horrible-day mess.

Finally, the jerky boys stop having their sick fun, and take off on their bikes just before Mrs. Ashworth arrives. She is the coolest friend my mom has, and even sits down on the front porch with me, holding my hand until I finish crying. She isn't even a little bit upset with me. Wow! I wonder what it would be like to have a mom like her. Someone to wipe my tears and make it all better. Her kids are really lucky. As she is leaving to go back to her house, she leans out her car window to remind me, "Be sure and tell your mom what happened so she can help you feel better..."

Welcome to September 1965, at our house on the first day of the new school year.

Summer is over and our lives have been juggled again. Mom has gone back to work at a new job, dropping Billy at a sitter. Scott moved out a few months ago, to begin college in Philadelphia. Barbara is riding a bus to middle school. And today is my first day of the 6th grade, at a brand-new neighborhood school. The second new school for me in two years. A few friends from 5th grade will be there, but not my very best friend. Hopefully I will find a new best friend quickly, because riding my bike to a friend's house is an easy way to escape. Sounds hopeful, right? As you just read, life does not always go as we plan...

This time disaster strikes around 2:00 pm when my "friend" of a female kind (my first menstrual period) starts today, in a new school, and I have to go to the nurse.

I am not even sure where the nurse's office is. To make things even worse, my new teacher is a man, Mr. Cousins. All my teachers so far have been women. I sure hope he understands that I need to leave the classroom right now. I am pretty sure that this is what Barbara has been teasing me about; my growing boobs and warning me about getting a "period" but she doesn't ever explain what the heck she is talking about. Thank goodness the

nurse knows exactly what to do, but my eyes overflow with tears for a second anyway. And, when I come back to the classroom, I just know that behind all those staring eyes everyone knows my latest secret.

As soon as the bell finally rings to end the school day, I hop on my bicycle, and zip down the road as quickly as I can. Thank goodness it's mostly downhill in this direction. Dropping my bike, I tear into my house, run upstairs to my bedroom, lock my door and change my clothes. Great start to a new school year. Could it get any worse?

(Someone is pounding on my front door…)

If only Mrs. Ashworth really understood how hard it is for me to talk with my mom. But I know I have to do it, because they talk to each other on the phone, a lot! Plus, what about having to tell Mom about the other life-changing event that happened to me today? Maybe I should go up to my room and fall asleep before Mom gets home.

I only make it as far as the bottom of the staircase before I hear her car door slam. Too late! What if she and Mrs. A. passed each other coming and going?

Hoping to delay the inevitable, I run outside to get Baby Billy out of the car. As soon as Mom sees my swollen eyes, she will know something happened, so I run right by her and snatch

Billy out of his car seat. My stall tactics buy me a few fly-by minutes, but at first eye contact I am caught. "What's the matter with you, Dorothy Gail? Have you been crying?" Mom asks. Trying not to cry again, which only lasts about 5 words into my "nasty boys" story, I truthfully blubber out an answer to her question. I only make it through the events of the second half of my really bad day before Mom is through listening. After a quick hug, I am to spend the rest of tonight in my room for 'bothering' Mrs. Ashworth. I do not even try to tell her about my visit to the school nurse. Why bother?

Luckily my older sister Barbara, with whom I still share a room, takes pity on me and quietly explains to me how to "be a woman." It feels nice to have a sister who cares for me tonight, no matter the reason. Maybe there will be more times when we will help each other as we grow up. When Mom eventually finds out, she just as quietly leaves a pamphlet to read on my nightstand… *Another ingredient in the stew.*

While those ingredients simmer in the cauldron, the months slowly drag by. There are a couple of John and Scott sightings, but the visits are short and both brothers are focused on college and love, probably not always in that order. Scott even brings his new girlfriend Beth home to meet all of us. She has really long brown hair, dresses all in black, and plays the guitar,

like Joan Baez. My first encounter with a real live hippy. She makes quite an impression on all of us. Lazy Scott even walks through a snowstorm to get Beth some cigarettes at the local store, which became a legendary family story. Is this what happens when you fall in love?

In the summer months, I join the swim team at the community pool. I love it, especially because we have special team swimsuits, and because I am the only one in my family on the team. No Barbara. However, I do have to hear lots of Barbara's snarky comments about my even being on the team. Could be because she also has to help more with Billy when I have practice. I am so embarrassed when she talks about my swimsuit being too small for my growing boobs, and other topics. It's just how she is. And just how I am not. Plus, I am the only available receiver of her cutting sisterly comments, now that John and Scott have escaped, and Billy is too young…

One of her cruelest comments comes blasting out of her mouth the next month, when Barb, Mom, and I are taking a walk around the neighborhood. Mom and I are holding and swinging our hands, and Barbara is walking behind us, pushing Billy in the stroller. "You two are homos," she blurts, and follows along chanting, "Homos, homos!" Mom stops and asks her what that

even means, and Barb says, "When two boys or two girls kiss each other."

I really don't recall what happened to her for saying that, but I do know I stopped holding my mom's hand for a long time. On the other hand, her words also awakened my empathic tendencies, as I distinctly remember pondering the concept of homosexuality for the first time. What must it feel like to have people make fun of you, just because you are "different?" It must hurt a lot. God made "those people" too, right?

Throw another ingredient in the stew and call it compassion.

We are only halfway there creating my infamous Depression Stew. The next 14 months would add enough items to the recipe to cause the caldron to boil over. Let's press pause in waiting for the pot to boil over and take a visit to my bedroom. The sanctuary provided there is soon to be my saving Grace. (And still is.)

Dear Barbara,

We were sisters, but we were not much alike. We had our good moments, but those were rare. That's the way genetics crumble, I guess. You took after Daddy in temperament, and sadly inherited the Type-I Diabetic illness from him when you were only nine. That diagnosis seemed to bring you two closer, and rightly so. While I didn't really understand the seriousness of the diagnosis when I was seven, I know now that it was a life-changing, scary time for you; one that would affect your life forever.

You were the older sister, which inherently you seemed to translate into your advantage. Your fallback personality was definitely bossy, and not an ounce of timidity. The rules you created about sharing a bedroom read like a contract. But that bedroom was my only sanctuary, so I spent lots of time under my covers, or in the closet. I did like that you were at least willing to be the go-to one whenever we needed to "ask your father." In our early years, I was afraid of you most of the time, usually agreeing with whatever you said. But later I came to understand why you couldn't always have a smile on your face. You began each day having to stick

yourself with a needle, and it hurt. Tough to pull a smile out after that.

I am thankful for the times we found sympathetic sisterhood, and regret there were not more of those. But you led with your head, and I led with my heart. This in turn affected the way we responded during the growing up years, and on into our adult lives. I am thankful, however, that you were the one who lit my empathy light. (Oftentimes I have wished God could have given me a dimmer switch, though.)

The next few years will be bumpy. And we will need each other.

Your sister,

Gail

Chapter 5
1966

"A memoir (/ˈmɛmwɑːr/; from French: mémoire: memoria, meaning memory or reminiscence) is any nonfiction narrative writing based in the author's personal memories. The assertions made in the work are thus understood to be factual." Wikipedia

"If you are going to cry, Dorothy Gail, then go to your room."

A command, spoken to me by either my mom or dad, between the ages of 5-19.

According to my personal recollection and perspective, I spent hours upon hours in my room during my formative years. Countless dinners at the dining table were by far the most frequent family scene where either Mom or Daddy would say their line. Their tone was never angry, or sad, or concerned, just a matter of fact. After a few years of hearing this, I would begin folding my napkin, and leave the table when I heard, "If you are going to cry…" and head to my room. *Pavlovian response!*

Maybe I got caught trying to hide my vegetables under my mashed potatoes. Maybe it was my turn to share aloud something from my day. Oftentimes the tears would come because someone else at the table was getting in trouble or sharing something sad. It could be happening just because "my tear-ducts were too close to my eye lids," another frequently stated excuse. *Who knew that was really a thing?*

Whatever the cause, the effect is a trip to my bedroom for the rest of the evening, where no one ever checks on me. "What are you thinking all these times I am in 'solitary confinement'? Does it at least momentarily pop into your heart, Mom, to come check on me, only to be overruled by your brain? Or do you feel a sense of relief; one child down for the night, only two more to go? How about all the goodnight kisses I miss from you both?"

For the first 12 years, I share a room with Barbara, so I can always count on her being perturbed with me because she had to do the dishes all by herself again. Or "Why don't you just grow up?" Thank goodness we have twin beds, arranged conveniently so we do not have to look at each other all the time. During this stage of self-isolation, I develop the skill of making tents out of my covers. A tiny flashlight, my little girl's locked pink diary, and my current selection of books are all that is necessary for comfort. Those items are always close-by on my headboard!

The hitch in the scenario: hunger, since I never seem to stay at the table long enough to eat. Snap, Crackle and Pop, the Rice Krispies elves, became my cavalry... *They still are.*

Peeking out from my tent, I make sure that Barbara is asleep. Quietly creeping out of my bed, I slowly open the door. "Yes! Mom and Dad's bedroom door is shut. Time to sneak to the kitchen." Silently dashing from cabinet (cereal box) to cabinet (bowl) to drawer (spoon) to refrigerator (milk), I am back under my covers in less than five minutes. I have to remember to say, "Thank you, God, for Rice Krispies," in my prayers tonight.

This scheme works well for a long time, even with one serious flaw. I "temporarily" hide the used cereal bowls in the hutch of my dresser, but then I forget to take them into the kitchen the next day. Busted by the weekly cleaning lady every time. Thankfully, most of the time the box of Rice Krispies remains right where it belongs, right next to Daddy's Wheaties in the kitchen cabinet, unless it is being used as a means of passive discipline by Mom...

My emotions about being sent to my room run the gamut - angry, confused, and sad to quiet contentment and restoration. Each year I appreciate the benefits more, since each year my susceptibility to depression is growing, increasing my need to cocoon. A delicate balance to maintain.

Dear Snap, Crackle, and Pop,

You have been my comfort food for most of my life. But, during my growing up years, you often served as my main source of nutrition. Thank you, little guys, for being there for me whenever I needed you.

I have discovered that you three have an established birth order, and individual personalities, just like my brothers and sister and I. Snap is the oldest, first appearing in 1933. He wears the chef's hat and is known as a problem solver. Crackle is the unsure "middle child," known as a jokester, and wears a stocking cap. Which leaves the mischievous youngest, Pop, who wears a drum-major's outfit and is the center of attention. The three of you have been spotted on adventures all over the world, bringing joy and comfort to many.

Thank you for being a constant in my ever-changing life, except for a brief few months in November, 2017 when you disappeared from the grocery shelves in Costa Rica. There were many rumors floating around about you guys being kidnapped, lost at sea, etc. but luckily friends searched high and low and managed to sneak you past customs at the airport.

May your elfin magic keep you in my life forever, my sweet friends.

All my love,
Gail

Chapter 6
1966 - 1967

"It's not always the tears that measure the pain. Sometimes it's the smile we fake." Unknown

As the end of my 6th grade year is coming to a close, I am looking forward to rejoining the swim team. In the school year, Barb and I became designated babysitters by default, but at least Baby Billy is now walking, and learning to talk, and more fun to play with. Moreover, he keeps on going to the real babysitter during the weekdays. Cool! It is going to be a great summer at Woodley Gardens, Maryland.

Hold everything. Not so fast... *Are you beginning to see a pattern?*

After dinner tonight, instead of the usual, "You may be excused," Mom says, "Stay-seated-we-need-to-talk-to-you." Call me paranoid, but so far, family meetings have not been joyous affairs, and definitely not an open forum for discussion.

True to form, Daddy quickly, quietly and simply states, "We are all going to Brigantine this summer." A flash of happy excitement lasts just a microsecond as he finishes his sentence, "Not just to vacation with Granny and Grandad, but to live there. I have accepted a job offer at a bank in Atlantic City." His voice drones on in the background, yet my ears are ringing, and I cannot hear him. When Barbara and I make stunned eye contact across the table, she looks like she is about to explode. Now!

Barbara pretty much instantly begins crying about how another move is going to ruin her life at the age of 14. *Little did we know how prophetic that was.* True to form, I sit in silence, but inside, my scrambled thoughts are screaming, "I'll be changing schools for the third time in three years. Well, moving does mean the Atlantic Ocean and the beach will be within walking distance. But there are no swim teams in the ocean, are there? Do John and Scott already know? Will we be closer or farther away from them? What about Pop-Pop and Sarah? They will be more than four hours away if we move. What will they do without us? What will I do without them? Holy cow, Mom and Dad. What are you thinking?"

At the mature age of 12, I am well aware that nothing I say is going to make any difference. Plus, I will cry, so I will get sent to my room. It's a done deal and we are moving. So, I

carefully lower my smile-on-my-face mask and dutifully begin to pack up my part of our bedroom. During these quiet weeks, I start to recognize both the strength and the spirit of sympathy in my heart. Poor Barbara keeps trying to find a way to stay behind, like begging to live at Pop-Pop's. Her godmother Nancy, a single woman and a powerful lawyer in the U.S. Department of Justice, offers to care for Barbara, and pay for her schooling in Washington DC, but that doesn't work either.

I actually feel sorry for Barbara, yet in awe at her strength to try to stand up for herself.

Nevertheless, we all move together that summer. Again!

It really isn't nearly as horrible as it seems, at least for me. Maybe I am getting used to starting over every year.

Our parents buy a nice one-story turquoise house on 21st Street in Brigantine, with lots of rooms, lots of yard to play in, and lots of gardens that need a lot of weeding. The absolute best thing is that finally we will all have our own bedrooms, with doors that lock.

The ocean beach is just a block away, and the bay is two blocks the other way. Granny and Grandad's house is on 28th Street, just a seven-block walk. When we first arrive on the island,

it is pretty busy, but more than half of the people leave their summer houses behind when school begins.

Just a few weeks later, I begin 7th grade at Brigantine North School. The kinda-small school is just a short "Island Bus" ride away, and the kids in my class seem friendly enough. Bobbie (Barbara's self-created new nickname) rides a bus across the island bridge to Atlantic City High School, a huge 4-story building with 3000+ students. It might take her a while to settle in, if she ever actually wants too.

Daddy seems to be liking his new job at Boardwalk National Bank, even though he hasn't really said much. He is dressing in some nice jackets and ties lately. Pretty colors.

Mom is already working as the secretary at Brigantine Community Church and getting to know the cast of characters she inherits along with the job. She is actually giggling as she relays the story. "My favorite helper so far is little old Mr. Kinsey, who has been helping fold the Sunday bulletins on Friday afternoons for 'many, many years, Honey.' He just walks right into the office, plops down his bottle of Scotch, and fetches two glasses from the church kitchen. Then, we proceed to fold bulletins, talking and sipping our drinks at the same time. Best church secretary job so far."

Pretty soon, Granny and Grandad retire from their jobs in Philadelphia and permanently move to their house on 28th Street. Billy runs around everywhere without a care in the world and gets dropped off at a babysitter's house on the island. I am very thankful for her. John and Scott are still at college, and it turns out we now live a little bit closer to them. Both are now planning weddings; John and Lois for December, 1967, and Scott and Beth in June, 1968. Whew, that's everyone accounted for!

On the surface, to our new friends and neighbors, we look like a family where all is well within. Barbara has finally stopped crying to go back to Maryland. I make some new friends at North School and see many of them at the Community Presbyterian Church on Sundays.

We are all settling into our new lives, and we have successfully survived another move. Maybe things will be quiet for a while.

No one would have ever guessed it would be John who would cause such a fuss.

John and Lois are getting married during Christmas break, following their college graduations. John has accepted a job offer at Mellon Bank in Pittsburg, which Dad seems to be very proud about. Lois will begin teaching elementary school after the

wedding. Pittsburgh is Lois' hometown and will now be John's home too. So, a family Christmas trip is in the planning stage but sadly, not all the family will be going.

Granny and Grandad, lifelong Presbyterians from Scotland, are not going to 'bless the marriage.' In fact, in their hearts they feel they must 'disown' John because not only is he marrying a Catholic, he is converting to Catholicism. I know just enough history to understand the longtime violence between Catholics and Protestants, but cannot grasp at all why my grandparents are feeling this way about their grandson.

Now I understand, but still don't accept their actions 50+ years later.

This horrible reality is kept very much under the self-preserving radar until the day that Dad decides to go over to try to talk some sense into his in-laws. Taking us with him, me and Billy wait outside, playing in their front yard while Daddy is inside. Daddy promised us a trip to Dairy Mart for ice cream. It doesn't seem like much time has gone by, when Dad storms out the front door, with Grandad following behind him. I freeze in place as I see Dad throw a cocktail glass at Grandad, who is standing on the porch. Grabbing Billy before he makes it up the porch steps, I run over to our car to be safe. Luckily (or not,

depending on whose perspective), our minister, and Mom's boss, lives right across the street and sees this horrible mess. At least he gets Grandad to go back into the house and Daddy to go home, for now. Driving along those seven blocks, from 28th Street to 21st Street, takes forever when I am holding my breath. There is no trip for ice cream.

Whoops - no more "everything is just fine" for this family. The front door has been blown open. Reality has shown its face in Brigantine. No more being with Granny and Grandad for who knows how long. When we travel to Pittsburgh for the beautiful Christmastide wedding, they stay behind in Brigantine.

Becoming more self-aware as I grow up, I am beginning to recognize the effect these situations have on both my emotional and physical health. Lots of sadness weighing down my heart. Headaches a lot, paired with multiple quick trips to the bathroom. Lots of time spent wallowing in the precious solitude of my own room.

Rev. McNaughton slowly tries to create a reconciliation in the next few months, but no one but God knows there is so little time…

Dear Granny and Grandad,

I never doubted your love for me. Granny, you always complimented me on my "beautiful smile, Lassie," when I was little, continuing even when I was nine months pregnant. Grandad, you always hugged and kissed me, after taking your pipe out of your mouth, and then quickly checked my fingernails. I bit my nails as a little girl, and sometimes still do now. Even though your Scottish brogue sounded very serious about "not biting my nails anymore," I always knew you loved me.

Unusual for this family, I learned about your choice to erase John from your lives in real time, yet in no way did I fully understand why. To be honest, even with all I have learned in the past 50+ years, I still cannot fathom how you could do that to your grandson. Yes, he was making different choices than you did but he was making them in 1967, for his future life, not back in the early 1900s in Great Britain. Why did he need to suffer for the sins of the father?

The thought of how much you all must have suffered hurts even now. However, I stand proud to say that I have never been able to comprehend your decision. I am blessed that my empathy allows me a deeper understanding of people, even though my heart

aches often. I have learned how to lead with my heart, but in consultation with my brain. In a strange way, you taught me to love my husband, our children, and our grandchildren unconditionally.

I missed being with you both during the winter of 1967-68. We had just moved to Brigantine a few months earlier, and I had been looking forward to your hugs and kisses, sweet songs, and your amazing toast with real butter.

Cheerio, chin, chin,
Dorothy Gail

Chapter 7
1968

Depression is no joke. When you encounter depression at a young age, you'll end up questioning who you really are.

One of the best things about our house in Brigantine is that my sister Bobbie (Barbara), little Billy, and I all have our own rooms. It is the best feeling ever to be in my room alone. My own sanctuary of real peace and quiet, without pulling the covers over my head. I can read as much as I want, with the light on. I am taking guitar lessons now, so practice immediately becomes healing. I continue to enjoy the company of Snap, Crackle, & Pop, but other snacks are available now too, and easier to hide. Most importantly, I value the "go to your room" process now and begin to call it cocooning.

Unless Billy is crying from his room next door! Mom and Daddy are way down the other end of the house.

It is the middle of the night, April 21, 1968, when I wake up to see Barbara standing in the dark, next to my bed. We have lived here almost two years, and she has never done this before.

Being the oldest, she has her <u>own</u> princess phone in her <u>own</u> bedroom. So, when it rings, in the dark, on April 21, 1968, she answers it, and runs down the hall to get Dad on the phone. Returning to her room, she listens for a second to make sure Dad is on the extension before she hangs up. We all do that, so we don't break the connection. The words she hears on the phone, and shares with me, will forever be imprinted on our hearts and our minds.

"John died instantly, and Lois is still in surgery," utters Mr. Lacy, Lois' father, to our father.

For the next 3-4 hours, we silently share my bed, waiting, and waiting, for Mom and Daddy to come tell us about John. We are not cuddling, not holding hands, just lying there. "Maybe it's not true. Why isn't someone coming to talk to us?" are questions swirling in my head. But truthfully, I can't speak out loud.

Only when the alarm clock starts beeping at 6:00 a.m. does Mom finally walk into my room, with Billy on her hip. It seems like hours have passed. Instantly, both Barbara and I sit up, anxious to know the truth. With red and puffy eyes, but no fresh tears, Mom says, "There was a car accident last night in Pittsburgh. Lois was badly hurt, and John was killed instantly."

Don't cry, I tell myself.

Do not cry.

How can Mom not be crying? John, the best of all of us, is dead?

What about Daddy? Where is he?

What's going to happen if Barbara or I cry?

Could everyone please get out of my room so I can breathe?

Turns out that is going to be a problem. Mom's next words are, "Get dressed for school so you don't miss your buses. We'll talk more when you come home."

"Is that normal?" I remember thinking for the first time. *It will become a mantra over the years.*

Later that afternoon, after a surreal day at school where no one seems to know John is dead, our friend Terry walks over to visit Barbara and me. Terry is Barbara's age and her brother Andy is my age. Their mom had heard through the small island grapevine about John's death.

Eventually, Terry and Andy would both become my best friends, and we are friends-like-family to this day.

Just recently, I asked Terry to share her memories of this day, April 21, 1968. Terry reflected how unnatural it felt at our house that day…

"Walking up to the back door, I see your parents sitting out on the back porch, having a cocktail. There is no evidence on their faces that everything is not "normal." No red eyes, no boxes of tissue, nothing. We all smile, say hello, and before I can say anything else, your mom says, "Go on into the house, Terry. I think the girls are in their bedrooms." That's it! As I open the door, she suggests, "Why don't you hit some balls at the tennis court?" A question, but not really a question. So, that's what we do to get out of the house.

The three of us spend a little bit talking about your brother, who I had not met yet and now will never meet, but none of us seem to know the right way to act. You tell me that your parents are not letting you go to the funeral. They 'want you to remember John as he was at his wedding.' After a little while, you both are ready to go home, and so I head home, too.

Walking home, I feel so sad for you all and confused about what I just saw and heard. Nothing about this day seems normal.

That was pretty much it. We didn't talk about it for years…"

The next morning, Barbara and I go off to our schools, and Mom and Daddy head to the airport. My mask feels like it is cutting off my air supply. No one seems to know yet at my school, and it sure isn't going to be me who blurts it out.

We will be staying in Brigantine at Granny and Grandad's house. How bizarre is that? The same Granny and Grandad who

are now dealing with the death of a grandson they disowned seven months ago. After school, Grandad will pick me up, we'll pick up Billy at the babysitter's, and go over to their house. My heart is about to burst open from all this heartache. *Should I be proud or sickened that it would take another five hours before the flood of tears broke through my dam?* During lunch, I have to pretend to eat something because the lunch ladies are all watching me. After lunch, my really cool English teacher, Mr. Rose, who has now been told about John's death, asks me how I am. Uh oh, oh no. Starting to feel a little shaky now. Don't cry. I sink down to the floor, then pass out!

The next thing I remember is waking up in my bed at Granny and Grandad's, and Granny is holding my hand, and I grab her hand too, which comforts us both. Tears are sliding down her face, and soon my tears join with hers. Now this feels normal. When I realize they are not upset with me for having to leave school, my tears and my breathing slow down. The next few days I am curled up to either Granny or Grandad, and cuddling little Billy, waiting for Mom and Daddy to come home. My mind is racing with questions, but I do not ask them...

True to form, I am the focus of very disappointed looks from Mom and Daddy when they came back from Pittsburgh, and a short talk to verify that I understand that I had let them down by

being a burden to Granny and Grandad. For a while, the atmosphere in the house is sadder and quieter, but outside the front door, you never would have noticed.

In the time after John's death, I spend more time over at Granny and Grandad's. I overhear conversations about Lois' condition while there, and it sounds horrible and painful and so sad. Twelve hours of surgery! *They had only been married four months. Why did God take John so early in his new-found happiness?* I had overheard my Uncle Bill, my mom's younger brother, telling Granny and Grandad that Scott had gone to John's funeral, using his own money to fly there in defiance of our parents. *Thank you, Scott, for finding a way to be there. This is all way too much to process by myself. Too many questions, too few answers.*

Truth is, I do not ask any of those questions. *Ever!* I snoop in Daddy's desk drawer months later and find the newspaper article about the accident, with pictures. *Snooping is bad. You can't unknow what you found.* Coming home from a nighttime Pittsburgh Pirates game, John drove into the back of a flatbed trailer that had no lights on it. Wearing his seatbelt, he was crushed instantly. Lois had taken her seatbelt off for some reason, and she had fallen asleep. When the crash occurred, she limply

slid to the floor on the passenger side, sustaining multiple injuries.

I mourn in the sanctuary of my bedroom. New dreams visit often; the one where John was just away at school and he would be back. Or the one where he was sitting in the trees above our house, watching over me.

Add the most powerful ingredients to the pot, which causes spontaneous combustion in the long-simmering cauldron of my Depression Stew.

In 1968 at the tender age of 13 ½ I experience my first full-blown episode of clinical depression. No one takes it seriously coming from me. I am just "the emotional one."

It will be a journey of many years, down a bumpy, roller-coaster of a road, before I smash into the proverbial brick wall. Through God's Grace, there will be an Earth Angel waiting at the wall.

Dear Mom and Daddy,

When you had baby #4, God created a "perfect storm" baby. Oh sure, I was cute and content. I seemed healthy. And let's not forget those "big, beautiful, deep blue eyes." However, I was also born with genetic tendencies for clinical depression, sensitivity to and for others, and empathic capabilities. I realize now that God had plans for me, particular paths I would travel. But I struggled to navigate through the long journey, before finally seeing clearly.

In my formative years, you could not have been expected to put the pieces together. Depression was just in the early stage of awareness. Even in 2023, there are still too many who do not understand this medically debilitating condition.

Now I recognize that you both were carrying the effects of your parents, and their parents before them, through your behaviors. Behaviors that reflect the norms at the time. Generations of ancestors' history inherent in future family members. Depressive tendencies go way back in our roots, mostly in the females but not exclusively. History suggests that most of those certainly suffered silently, or worse. After all,

it wasn't until the early 1900s that Freud began to take a closer look.

I cannot blame you for "not knowing what you didn't know."

Nevertheless, the facts remain that in 1954, I was born into the family as it existed. Daddy was quiet, and sometimes let me sit in his chair with him. It seemed like Mom was busy most of the time, but for me it felt normal. And I still had Sarah and John.

Until I didn't.

By 1966, we had moved away from Pop-Pop and Sarah.

By April 1968, John was dead.

By May 1968, I was suffering from what I now identify as my first full-on depressive episode. Life was not anywhere close to normal anymore.

It was the perfect set-up for the classic nature vs nurture duel. While there may not have been a recognition of "clinical depression," surely the individual warning signs warranted attention. All I felt at fourteen was an overwhelming sadness, confusion, worthlessness, and a need to be loved.

In the summer of 1968, I wanted you to notice me and needed you to nurture me. Today, through years of counseling, prayer, and reflection, I understand that

both nature (heredity) and nurture (environment) are perpetually molding our lives. As a grieving teenage girl, I needed you to provide more than you could comprehend. We all did.

Upon deep reflection, I realized you were both grieving, too. What if we had grieved together as a family, instead of hiding in our rooms? Oh, how I wished for you to open my closed door, snuggle under those beautiful, bright rainbow-color bed covers and talk. We now recognize that communication matters so much to our emotional health.

Rest assured; I have no doubt that you loved me. What I wonder is whether you ever really knew the "me" who lived behind the mask? I eventually perfected the power of a smile. An ideal way to mask my true emotions, and to tell believable lies for too many years.

Even now, as I write this letter to you both, I am struggling with expressing my true feelings. I eventually learned the necessity, and the joy, of removing my mask, but after years of conditioning the instinct remains lurking in the background, and still sneaks up occasionally. Plus, my lack of filter requires an awareness of the right time and place before I blatantly blast my truth.

It is still a struggle to get my thoughts from my heart to my fingers without going through my brain. But I am determined to share my story.

Your youngest daughter,

Gail

Chapter 8
1968-69

"I'm not faking being sick. I am actually faking being well." Happyplace.com

To me, it feels as if an entire lifetime of events happened in this one year. I wish someone would notice my silent suffering, and whisk me off to get some help, but even I am not able to connect the dots on the various signals coming from my body.

Not in 1968. Not in my family. Even medical science was still years away from recognizing the devastating effects clinical depression could cause on physical health, not just emotional health.

When I start having sharp pains in the middle of my chest, fainting spells down the bus steps, real crying spells "for no reason," etc., the individual episodes are conveniently being explained away one by one. The Emotional One, The Sensitive One, and a new addition: Adolescence.

I add journal writing to pass the time in my room. If I can't talk to anyone else, I can talk to myself. Maybe it will help. Come on, Mom. The sharp pains are right in the middle of my chest.

Near my heart, for goodness sake. And they are happening a lot. Oh, if only pain made noise. Maybe then she would notice. What if I just stood up at the dinner table and yelled? I am experiencing these fantasy moments more and more. The ones where I speak up, loud enough to be heard. And Dad and Mom stop in their tracks and really see me. What if...?

It's hard to sleep with all those thoughts running through my head, which only makes me feel worse.

Finally, a doctor's appointment is scheduled to "check me out" and we are on our way. "Why are we going into Barbara's diabetes doctor's office? Please don't let me have diabetes," I nervously wondered.

I do not remember why Mom finally made a doctor's appointment, but I distinctly remember walking into Barbara's diabetes doctor's office and thinking that this is weird.

I have never been his patient before. I went to his office, but just because Barbara was getting checked. This time the nice nurse is taking me back to the exam room, without Mom. Maybe I'll be able to find my voice and ask her some questions. No such luck, as the nurse is the one asking <u>me</u> all the questions. Dr. Baird rushes in, really! He is out of breath and seems like he is in a hurry. He glances at my chart, "Deep breath in, let it out slowly." A few taps on my chest area, a couple of questions, and

pronounces a quick and simple diagnosis: "Muscle strain from twirling your baton." His prescription is, "Take it easy practicing your twirling, and take some Aspirin if it hurts!" When the nurse walks me out to the waiting room, she shares the great news with Mom, who looks very relieved...

"What? Never mind that I have been a twirler already for five years. What about the fainting or all the tears that overflow my mask lately? How about you ask me what I think about this."

30 years later, hindsight will reveal how vital that identical chest pain will be in finally getting a correct diagnosis. Too bad Barbara's diabetes doctor didn't ask me about my life in 1968. Too bad I was incapable of telling the truth for myself.

As the summer of 1968 ends, I am leaving the protective comfort of life on the island of Brigantine and literally crossing over the Brigantine bridge to Atlantic City High School. Brigantine North School, grades 5-8, has a couple hundred students. ACHS has close to three thousand! In the beginning, I just keep my head down and concentrate on my classes. A new friend convinces me to try out for the twirling squad with her; a social niche for my fourteen-year-old self. Diabetes doctor be damned. Friday night football games are the place to be, and I get to sit with the Viking Band and my new twirler friends.

Life is going to be alright.

Freshman year remains uneventful until the end of the school year; June 1969. That's when I meet my future husband. Really!

Gary and his buddy show up at the local Catholic high school's Friday night dance, and I am at the dance with his friend's girlfriend. So, with shy smiles we realize we are stuck with each other, two shy teenagers who at least could dance. He seems nice, but quiet. I too am quiet, but not quite as shy. He has red hair and lots of freckles on his face, and a really nice smile. We both like to dance, so we have no trouble enjoying ourselves.

Is it really time to go home? So soon?

In the "small world" category, it turns out Gary and my sister eat lunch together every day in the school cafeteria. Her boyfriend Michael and Gary are friends. Barbara gives her unasked-for-approval to Gary at lunch, but not to me! After that, it doesn't take long before he is walking me to my classes, and we slowly begin to drift towards girlfriend-boyfriend status. Our first real date is to the movies: "Oliver" on Friday, June 13, 1969!

My first and only boyfriend!

Dear John, Scott, and Barbara,

We are all Anne and Gordon's children. Loved, of that I am sure, but not always as removed from the real world as they would have preferred. We all made mistakes. It's part of real life. I have realized that the biggest mistake I made during our lives together was not having the courage to walk up to each of you, look you right in your eyes, and ask, "How are you? Really?" For that, I am truly sorry. What if...?

It took me until the age of 13 before I began to wonder about our parents' choices, and I can only guess how the three of you actually felt when you were growing up. I cannot remember us ever sharing meaningful conversations when we were growing up. Even in the midst of writing this memoir, there is still so much bewilderment surrounding major life events that affected all of us.

Powerful but simple: Conversations matter.

I recognize that the times were different than they are now, which tempered Mom and Dad's choices. I know now that Mom's arrival to Ellis Island in the late 1920s from Scotland means she lived a working class, rural European life for the early critical years of her development. Knowing she was the oldest (five years old)

of three children, who shared the burdens of responsibility when her father left for America ahead of the rest of them, contributes some empathy for her adult decisions, but not an outright pass.

Most importantly, I clearly recognize that the individual burdens we were carrying could have been eased if we, as siblings, had formed a familial bond rather than retreated to our bedrooms. There were four* of us. I was conscious of John being the favorite one, so I assume you all were, too. I put him up on the top of my list also. Yet, I never even considered how hard that must have been for the rest of you.

Just recently, I learned that after John and Lois' wedding in December 1967, John wrote a letter to Scott, apologizing for not standing up for Scott when Mom and Dad treated him differently. Scott, not knowing that John's time was short, had not yet been able to craft his reply.

Then John died.

Somehow, Scott, you found the fortitude and the means to not only get yourself to the funeral, but to provide support and strength for our grieving Dad and Mom. Thank you, Scott. As we got older, there would be many years in my young married life when you and I were close and saw each other frequently. Jeff learned to

walk at your apartment, pushing off from your bean bag chair. Visiting with all our children are bright lights in my memories. However, regretfully we never found the strength to have any heartfelt conversations. **

Barbara, burdened with childhood diabetes from nine years old, you sure would get upset at all of us at various times, but seemed to quickly recover. Barb, you are the most like Daddy, in many ways. It seemed like you were able to maintain a balance with your health and your emotions, though. Not many highs, not many lows, just matter of fact. Thank you for all those times you were the "Ask Daddy" first responder. You did have the most guts.

John, may you be resting in peace. I miss you every day, still.

Scott, may you find the peace you have been searching for.

Barbara, we were sisters from birth, each with our own natures. Fluctuating between warm and cool, understanding and confusion. May you also be resting in peace.

Love and hugs,
Gail

* There were five Frankel children, but during our formative years, Billy was no more than a toddler. He will get his turn in the spotlight eventually!

** On Mother's Day, 2022, in Marmora, New Jersey, I was thrilled to reunite with my brother Scott. We had not been in communication for 20 years, since our mom's memorial service in Brigantine. For unknown reasons, Scott left all his family behind at that time. On this day, in Scott's assisted living room, mask-free, I looked him in his eyes and asked the question: "When did you first realize that you suffered from depression?"

Loud and clear, his reply was, "April 21, 1968."

Loud and just as clear, I answered, "April 21, 1968, a millisecond behind." The day that John died. A jaw dropping, dam bursting moment.

Scott's story is his to tell. So far, since this reunion moment, Scott and I have not managed to have another conversation. He is just not able to handle it.

Chapter 9
1969-1972

"You cannot travel back in time to fix your mistakes, but you can learn from them and forgive yourself for not knowing better." Livelifehappy.com

Before we leave those roller coaster high school years, let's flashback for just a second to 1966. Our parents decided to move us from Maryland to New Jersey. Remember, Barbara was really upset about moving from Maryland to New Jersey, declaring that her life would be ruined...

The 1969-1970 school year has started with all the usual stress and commotion. Gary and I are supposed to meet Barbara and her boyfriend Michael for some ice cream after school. Goofing around like typical high school sophomores, we slide into the booth laughing and flirting. One glance at Barbara's face quickly erases my smile. She and Michael seem serious for two people just beginning their senior year. "What's going on with you two?" I ask.

"Barbara's pregnant," Michael blurts out.

Gary's face has an "Oh, shit" expression.

I stare at them in total disbelief across the booth. Mindlessly eating our slowly melting ice cream, the details start spilling out. Barbara is already five months pregnant and is due around Christmas. Both sets of parents were told recently, and their reactions are polar opposite. Michael's parents, a large family of Irish Italians, want them to get married and live with them. My parents told Barbara she **will** go stay at the *Florence Crittenton Home for Unwed Mothers* in Pennsylvania right away, give up the baby for adoption, and then come home - and of course, no one will be told. Absolutely no one. Showing my naïveté, my first comment is, "That's why all your new back-to-school clothes are so baggy!" (Such moral support!) After a few more moments of quiet shock, Barbara tells us that they have already decided to get married and stay with Michael's family. They will both drop out of school, and Michael will go to work. They wanted us to know today, because tomorrow, Barbara plans to tell our parents their decision to get married.

We all know that is not going to go well.

In a matter of one weekend, Barbara leaves home with a suitcase and a baby in her 17-year-old belly. Mom and Daddy sit me down, tell me Barbara is marrying Michael, none of us will be going to the ceremony, none of us will have anything to do with Barbara, and none of us will tell anyone about the

pregnancy. Pretty much in one dispassionate sentence. Followed up by a "That's all. You can be excused." I scoot off to my sanctuary - my room - having no clue what to do.

My shock at my parents' behavior settles over me. Everything is just so wrong. This is not normal.

Two weeks later, I choose my first official act of defiance. A new-found behavior of lying by omission will soon become a weapon in my arsenal of deception.

Gary and I are in Atlantic City, walking up the front steps to Michael's house. This new boyfriend of mine has quickly become someone I can depend on. I like that. I am dressed in a pretty beige lace dress; perfect to be the maid of honor for my sister's wedding. I never imagined it would be happening when we were all still teenagers. Michael's parents' dark and dreary living room, with Mike's little brothers and sisters fidgeting with excitement, is set up for the Justice of the Peace to perform the low-key ceremony. Mike's parents, and a few other relatives, are sitting in a circle of chairs set up around the room.

"Thank you for helping Michael and Barbara," I smile and say. It is a long sentence for me at this time. Since I "dated" Mike's younger brother Bobby during the summer before our freshman year, I already know some of the family. Dating at that time amounted to Bobby and I sitting outside on our front porch

talking, getting eaten alive by mosquitoes. He was afraid of my dad, so he never went inside. The romance between two 14-year-olds didn't last long, but we remain friends.

Today, we are standing up as witnesses to a marriage. There is no aisle for the bride to walk down, so Barbara in her light blue maternity dress and Michael in a jacket and tie just stand up by the Justice of the Peace, with me and Bobby on either side. It seems like only minutes and the bride and groom are kissing and a party begins with a wine toast! It might appear almost normal to everyone, except I keep fretting about Mom and Dad not being there. This third wedding in our family in less than three years is notably different.

I do not know if our parents ever found out I was there. No one ever talks about it. The newlyweds eventually move to a small apartment north of Philadelphia, in a building owned by one of Michael's aunts. In the next few months, Gary and I manage to sneak away and take the train from Atlantic City to Philly and visit them a couple of times. Getting permission to stay out overnight was easy for Gary, as he lives with his sister Karen who treats him like an adult. Already a hard-working guy, he does have to arrange for time off from his busboy job. For me, I have a good friend from Ventnor who lets me tell my parents I am sleeping over at her house. We feel so grown up. So weird, and

sad, to see my older sister's body morph from a teenager into a pregnant woman. In spite of those damn smiles on their faces, their typical teenage lives are definitely behind them.

It's during this time that two major events occur. Both are life changing. One is over in a few minutes, and the other revelation becomes a vital part of my routine.

One Friday night in May, 1970 I lose my virginity in Gary's best friend's attic bedroom. Ralph's parents are going out of town for the night, and he and Gary plan our 'romantic' rendezvous for after work on Friday night. There are no fireworks for two teenagers experimenting, but it happens. I mark it on my emotional calendar, and then move on.

The second discovery happens at the drive-in movies. Our friend Vince has driven us in his car, and after Gary and I settle into the back seat together, Vince hands Gary a cigarette over the seat back. Not just any cigarette, but a marijuana joint. I am nervous but it doesn't take much peer pressure from Vince and Gary to get me to try it. After about fifteen minutes, Gary leaves to get some snacks, and my first sentence "under the influence" is, "What is taking Gary so long? He's been gone for an hour." By the time Gary returns, Vince has finally quit laughing.

It takes me a few days to comprehend the revelation. When I smoke marijuana, my anxiousness and scrambling brain

slows down. Time throttles back. Seems like this might be very valuable when I am wound up. A natural remedy of a sort, though an illegal one. Since Gary has seen some of my moments of anxiety, it doesn't take long to convince him to let me try smoking again. I like the way it makes me feel.

1970 is years away from medical science discovering the overwhelming evidence of the positive effects of cannabis. Not just its positive effect on depression, but many other diseases. To say I was fortunate to have its help as a teenager is an understatement. I spend many years being paranoid about it being illegal, but the benefits far outweigh the risks.

As Christmas time draws near, Barbara and Michael come back to Atlantic City for a visit with his family. Gary and I are at a party when Michael stops by, without the extremely pregnant Barbara. It is not long before someone calls to talk to Mike. "Barbara is in labor, and she is in the Atlantic City Hospital." Letting me know what's happening, Michael leaves for the hospital, and I leave for home, where I once again manage to lie by omission to Mom and Dad. "The party was just fine."

Suddenly the silence is broken by the sound of the doorbell. One of Barbara's friends from Brigantine is a volunteer at the hospital, and she observed Barbara being admitted. Checking on Barb before she went home, Linda discovers that

there are serious complications with the delivery, and both Barbara and the baby are in distress. Feeling compelled to come by and tell my parents, she must be wondering why they were not already at the hospital. I stand back in disbelief as Mom thanks her for letting us know, quietly shuts the door practically in her face, and goes back to watching TV with Dad. Her actions feel like a sharp, cold dagger in my overflowing heart.

Depressive episode #2 floods me with all kinds of emotions.

I wish I could describe a happy outcome. I wish I could actually remember, but once again I am surrounded in a molasses-thick fog. Simply going through the motions. My infant nephew is stillborn. We almost lose Barbara too, but she manages to pull through. Her teenage body, in addition to her diabetes, simply is not able to handle a pregnancy. The only grandparents who come to the hospital are Michael's parents. I have no actual memories of any of it, including the funeral. Gary and other friends go in my stead and tell me about it. I cannot fathom how Barbara and Michael will survive such a tragedy, but since Barbara does not come back home, I guess they at least must be together. A few months later, I hear that Michael and his best friend Vince have enlisted in the Navy, and they are all living together in Virginia Beach.

It will be 18 months before I see Barbara again.

Sadly, Michael and his friend get into some drug troubles, and feeling unsafe, Barbara decides to leave and move home to Brigantine, expecting another baby in a few months. She moves into a small apartment by herself to wait for the birth of baby number two, having received no offers of shelter from Mom and Dad. My second little nephew manages to be born alive, but soon develops breathing issues and has to remain in the hospital. It is just a couple of days later when he dies from infantile respiratory distress.

When I get home from school that day, Dad instructs me to go spend the night with Barbara, as her baby has died, and he does not want her to be alone. I sleep on her sofa; she stays in her room. I know it sounds impossible, but we do not talk. Sad. And definitely not normal.

So much pain for someone who was only 19 years old. So little support from her family.

Dear Barbara,

We are sisters by birth and grew up under the same roof for our first 17 and 15 years, respectively. Yet, from my earliest memories, we constantly oscillated between loving and "disliking one another immensely" (we were not allowed to say 'hate'). You were with me for some of the best memories, but you also had a special knack for getting under my skin.

As I write this letter you will never read, it has hit me how little I really knew about your truthful feelings. What a tragedy for us both.

What was it really like to have to give yourself an insulin shot every day from the age of 9? What were you feeling when we lay motionless and silent next to each other in my twin bed for four hours, knowing our brother John was dead? I do know you were scared to be pregnant at 17, but we never had any real conversations about it...or about countless other important life events that came along.

Never. We just sort of got along to get along.

We moved on from the teen years and grew into adults separately. For the next 20+ years, our paths as sisters would connect for brief seasons, always with our masks firmly in place. Until finally I just couldn't play

anymore. Ironically, you will be the facilitator for my being able to rip off the mask. Your baffling choices will finally kick-start my healing.

In deeply painful retrospect, I sincerely say, "Thank you." I will always love you, Barbara, but I don't know that I will ever understand you. I tried one last time, weeks before your death, but you chose to remain silent.

May you rest peacefully.

Love,

Gail

End of Part I

Chapter 10
1972-1977

"All it takes is a beautiful fake smile to hide an injured soul.
They will never notice how broken you really are."
Robin Williams

"This is the moment I've waited for…" From the back of the church, my Daddy and I stand side by side and listen to "The Hawaiian Wedding Song" being sung up above our heads in a beautiful tenor voice. Gary and I have been engaged since September 1972, but we've been waiting two years for Gary to finish technical school. By the end of this day, we will be Mr. and Mrs. Gary Nolan, adults!

As the organist begins the wedding march, Daddy and I step off in sync, down the aisle, with a finger-tip bridal veil momentarily hiding my face. By the time that elusive mask is lifted, my smile mask will be beaming.

During the past two years, we have grown up exponentially, preparing for our future together. Gary, guided by some friendly advice from our wise friend Dana, has spent his time attending vocational training to become a draftsman, and

graduated just last week. He also worked multiple jobs as a busboy, saving money for our future. When we could squeeze it in, we had date nights. *At the time, I admired his work ethic. It provided evidence of a wonderful provider. But, in the future, it would be a big part of our undoing.*

Motivated by Gary's focus on preparing for our future together, I make the misguided decision to forego college and go to work at the Atlantic City Press. Gathering what little guts I have to present this idea to Mom and Daddy, I manage to say, "We are in love. Gary is going to be finished school in two years, and then we will be married. I will never finish four years of college, so I don't want to waste your money, etc." Not only do they consent to this huge change of plans, but a couple of weeks later Dad uses his contacts to get me the job at the newspaper and makes use of my college funds to buy me a new car. *Upon reflection, this rare passive acceptance of my request alters my path for years. And I never understand why my parents said yes.*

That new adult wedding day smile will enable me to hide my true emotions for 17 years. I even use it to hide from myself, too. Sadly, like so many others in the 1970s, I will remain ignorant of the disease of depression for more than 17 years. Multiple warning signs flare up, but doctors will use the inadequate "women's issues" as a blanket diagnosis. (Frequent

migraines, anxiety attacks, digestive issues, and melancholy, just to name a few.)

In addition, it will come as no surprise that I didn't tell my doctors the truth. Individuals with smiling depression often look happy to the outside world and keep their depression a secret. To those in my world, I appear cheerful, optimistic, and focused on being the best wife and mother I can be. No one, not even Gary, should have to be burdened with my character flaws. I just need to grow up and "snap out of it."

Being newlyweds is fun. Living together! No curfew, buying whatever you want at the grocery store, meeting up with friends whenever.

We really don't have much time to enjoy that honeymoon season. Gary is soon laid off from Atlantic City Electric. He accepts a job in Marlton, about 60 miles north, and we move away from home.

All of a sudden, we are alone, together. It is scary and lonely and sad for a few months. Gary works, and I stay home. For multiple reasons, I feel desperate to find a job. Something that will provide a distraction to quiet the whirling thoughts. More income will be nice, too. We are both extra thankful when by Thanksgiving I have a job as an accounting clerk in a nearby business office.

"Mrs. Nolan, you are going to have a baby in October." It is early April 1975. I am working at a regional magazine sales office when the desk phone rings. My initial reaction is pure joy, but quickly shifts to worry. So much for the 5-year plan! This miracle of life was created by the two of us, but definitely not expected 6 months into our marriage. We have a five-year plan.

What will Gary's reaction be? Ha! It's too late now. This being long before elaborate pregnancy reveals, cell phones, and social media, I quietly call Gary at work and drop the news. After a few long moments of silence, he manages to sound excited, and by the time we both get home, we celebrate the news with the attitude that "the best laid plans" will have to change. With a genuine smile on our faces, parenthood at 21 and 23, ready or not, here we come.

Well, we are not ready, but we learn quickly. One bedroom apartment with a dining area becomes a two bedroom with the addition of a wall. The company I am working for has lay-offs and I am one of the recipients. Not many companies are eager to hire pregnant women, so unemployment compensation kicks in. I take a part time babysitting job for a friend across the way, to distract me and help pass the time. *This is the first instance of what would become a 16-year habit of survival - part time jobs.*

Unfortunately, a few serious side-effects of being pregnant show up by five months, and I am soon encouraged to just "put your feet up and enjoy the process." (OMG!) Instant drops in blood pressure cause me to pass out in the unemployment line and break my two front teeth, but it gets me to the front of the line. Fainting also contributes to me losing a babysitting job watching the neighbors' little one. It only happens once, but that was one time too many.

Being at risk for genetic diabetes, I am subjected to regularly scheduled 5-hour Glucose Tolerance tests, increasing to every 10 days my last two months before delivery. The baby is getting close to 9 lbs. The effects of fasting and multiple blood draws every hour take their toll. I have terrible veins. Crying overwhelms me frequently, wondering how this process is affecting my baby. My results are always borderline. And on top of all that, all the pregnant characters on my "stories" (All My Children and General Hospital) are having "problem pregnancies." I never think to stop watching the shows!

However, in spite of all my worrying, on October 14, 1975, I feel a little twinge. Yey! This is it. But Gary is at his class, and not due home for a few hours. "Hello, Mom. I feel pains and I am home alone."

"Don't sit down. Keep walking," said the woman who has birthed five.

"But Mom…"

Gary arrives home in plenty of time and shakes off the "Surprise!" We wait another few hours, under the doctor's advice, and then take off for the hospital around midnight. Jeffrey Gilbert is born around 6:45a.m. on October 15th, 8 pounds, 15 ounces. All those problems and worries disappear in a mystical, magical instant. Thank you, God.

This little guy will love me unconditionally, as I will him. We will laugh and cry together, and all will be well.

Oh, how I wish that I could tell you this is when I exchange my mask for rose-colored glasses. Am I happy? Yes, more than ever. I love being Jeff's mom. Gary works a lot, and for hours each day I can be just that. But we do not exist in a bubble. One of my favorite distractions is to pack up Jeff and head down to my parents' house in Brigantine for a few days. They love to see the baby, and I love being back at the beach where I grew up. It is a win-win.

Until it isn't…

"Hey, Nancy and Freddy." I call our best man and his wife, one of my bridesmaids! "I'm at my parent's house for a few days. Want to get together later on?"

"Ahhh," Nancy screams. "That would be awesome. Are you bringing Jeff? It will be fun to compare the boys."

"Excellent! I'll come over to your house in Ventnor after I spend some time with my mom and dad. See you later."

When Nanny and Pop Pop get home from work, I plop a fed and bathed Jeff in his infant seat and sit him on the patio with them. Cocktail hour is their time to relax before dinner. Taking advantage of a moment of free babysitting time, I jump in the shower to clean up before going out. And that's when I make a serious error. Not wanting to get my clothes all sweaty, I put on my cotton robe, roll my hair in electric rollers, slip into some flip-flops, and walk out to sit on the back porch and visit a little.

I can hear my mother's gasp at my appearance and see her eyes roll. *Even today.*

No one offers me a drink, a howdy-do, or even a fake smile. Jeff commands their attention, and I am "not there." So, pretty soon I excuse myself to finish getting dressed.

Through the open bedroom window that looks out onto the patio, with the designer window blinds purposely closed for privacy, I hear Mom say quietly to Dad, "Well, she sure has let herself go. It makes me sad to see her like this."

Quietly Dad replies, "It makes me feel sick. I can feel my blood sugar is off."

It's my turn to feel sick, as I slowly sink down onto the corner of the bed.

Why would they say that? I grew up in their house. I ran around in t-shirts and curlers all the time. Now, because I am married, I am expected to be a "perfect house guest?" I make my father sick?

I can do this. I will be just fine.

Pasting on my smile, I finish dressing, gather Jeff up from the patio, and leave for Freddy and Nancy's. The next morning, after they leave for work, I pack us up, scribble a brief thank you/see you next time note, and leave for our apartment.

The depressive episode, hidden securely behind my smile, creeps in like the tide. *Molasses fog, zero self-worth, anxiety.* After a couple of weeks of no communication with my parents, and lots of prayer, I decide I need to write a letter to both Mom and Daddy, and truthfully explain the incident and the repercussions. It is hard, and painful, but way overdue.

I mail it. And I wait and wait.

While waiting, we find out we are expecting again, but Mom and Daddy do not know.

I am still waiting for a response. A phone call, a letter, a visit. Something.

Two months later, I finally declare to myself, and God, that it is time for me to dial their number, for both my health and the baby's. Mom answers and just starts chatting away, as if life is great. When I manage to get a word in, my first comment is, "I think we should meet in the middle to talk. Don't you?"

Mom sweetly replies, "Sure, what do we need to talk about?"

"The letter I wrote to you and Dad in June."

Just as ice-cold, matter-of-fact as she could be, her dagger-to-my-heart reply was, "What letter?"

Well, we do meet that weekend at our usual spot, McDonald's in Hammonton. We talk superficially about life, over the sweet babble of Jeff's baby sounds, drinking iced tea. After about 30 minutes, I urgently know I am finished. I cannot fix a lifetime of dysfunction. I just need to leave. Somehow, as I gather up my son, I also gather enough strength, and enough air, to ask what I have to know. "Why did you not respond to my letter? You must know how difficult it was for me to be so truthful."

Coldly and calmly, with a slight smile on her face, Mom reaffirms, "We never received any letter from you, Dorothy Gail."

My truth-filled missive has mysteriously evaporated into thin air. I can't even process something that outrageous. "Okay, Mom. I need to go now. Say bye-bye to your grandson."

And I will not try my truth out again for a long time.

I know in my heart that at the very least Mom received it, and purposely chose to claim ignorance. I do not know if she shared the contents with Daddy, but in my heart, I hope she did not. I feel dismissed; it's reminiscent of the infamous, "Go to your room, Dorothy Gail."

The seed that had been planted generations ago has grown deep roots. My smile mask is now firmly transfixed and fertilized constantly with lies, distractions, and short-term escapes. And my Mom's shield seems virtually indestructible.

All within the first three years of marriage.

"There is no point treating a depressed person as though she is just feeling sad, saying, 'There now, hang on, you'll get over it.' Sadness is more or less like a head cold - with patience, it passes.

Depression is like cancer." Kingsolver

Chapter 11
1977-1978

"You'd never invite a thief into your house. So, why would you allow thoughts that steal your joy to make themselves at home in your mind?" A.A. Milne

Finding out we are expecting baby number two jump starts us on our first house hunt. A couple of weekends in a row are spent driving around looking at inexpensive houses in the area.

"Gary, come upstairs and check this out." Slowly making his way up the rickety wooden staircase, we both crack up, from opposite ends of the upper hall. It is both crooked and slanted, from end to end. I hold on to the bathroom door jam, imagining trying to sit on the leaning-toilet every day, and so many other silly scenarios. Cheap price for sure, but we quickly say, "No thank you."

Each weekend our search becomes a little bit more painful as we quickly face the reality of our situation. Not enough money to even afford anything close to our wants and needs. Not enough time to save more. Not willing to ask anyone for help.

It is at this time that I begin to recognize just how much of a gift Gary's mom, Mary, has become.

Sure, my mother-in-law has been in my life for more than 5 years, but it took a while for us to become close. Gary's relationship with his mom has been strained since his parents divorced when he was younger, so he remains hesitant about getting closer.

We all begin to get more comfortable when we move only a few miles away from her and Frank, Gary's stepfather. Then, Jeff's birth really closes the gap, as they both fall head over heels in love with him. A weekly routine of visits, and dinners out develops; sometimes without Frank or Gary as they are working. One day, following the house hunting frustration, she stops by our apartment unannounced and catches me crying. She sits me down and asks me how I am doing, really.

Mary/Mom-Mom gets a brief glimpse behind my mask that day; she never asks me for more than I can give. It is enough for both of us to become mom and daughter, a bond that will never be broken. Mary takes care of me in countless ways. And by doing so, she helps Gary, Jeff, and my second child, Kevin, too. She is literally my life-saver Earth Angel for the next 14 years. Our family and friends probably think she spoils me, but it is so much more. Thank God.

It's been 4 days since Mary caught me crying when 19-month-old Jeff and I pull into the Pizza Hut parking lot. Must be Thursday night. It's become a weekly routine to meet Mom-Mom here for pan pizzas and visiting. As always, it takes a few minutes to get settled, and Mary is practically bouncing off her chair.

"Sit down!" Mary beams at me. "As soon as we order, I have something exciting to tell you. "Two small pepperoni pan pizzas, please!"

Seems like the second the waitress walks away Mary starts chattering. "I talked to my bosses, and they say I can split my waitress job with you. I'll babysit Jeff on the days that you work, and you won't be uncomfortably pregnant for months, so no problem. This will give you some income, some time out of the apartment, and some people to talk to!" As I try to form a response, she continues, "And I stopped by this new housing development on the way here today and discovered a possible solution for your house needs. I have been noticing it for weeks. This company is building small 3-bedroom houses for first-time home buyers and financing them through a low-income-based government program called Farmers Home Loans. 1% interest if you qualify."

Holy cow! What the heck? Big breath for us both.

Now, I have not hinted at anything about getting a job, or details about our financial issues last week, but she knows. She just knows and she is stepping up to try to help me, Gary, Jeff and Baby-to-be big time.

This is the first of many sacrifices Mary will make for us.

Her excitement wins me over that night, and we soon team up to persuade Gary to <u>let</u> me share his mother's job.

Yes, that is the correct verb. Being allowed to do "things" had become the norm, at least in my mind.

I quickly become genuinely excited at the thought of working 3-lunch shifts a week, at a businessman's bar, across the parking lot from a seedy strip-motel, in Camden NJ. Plus, my father-in-law works across the highway selling used cars.

What could go wrong? My imagination runs wild, but absolutely nothing out of the ordinary occurs. In fact, my new job actually helps us qualify for the house. And greatly boosts my emotions. A win-win situation.

The next 10 months go by like a speeding train. After checking out the new housing project, we excitedly apply for a Farmers Home Loan as financing. Qualifications are government stringent - Gary didn't quite make enough money and so I would have to list my "job" as income, too. The two young owners of the bar offer, "We will complete the forms saying you make 'X'

amount of dollars - the exact amount you need to qualify for the loan. It's a restaurant. Incomes are flexible," Chip says.

"Who deserves it more?" Robert echoes.

That is so cool. And so kind. And life changing.

Contract signed, house under construction, closing before Christmas. Two months before the baby's due date. Yes!

Well, our lease expires on our apartment in September. Knowing the house is still under construction we arrange to stay at Gary's grandparent's cabin in Neshaminy Creek, PA. The most beautiful, peaceful month ever. I finally understand the 'Shaminy' magic. Leaves are changing, the creek is flowing, all the summer folk are gone. The breezes flow through the trees surrounding the view. Just 23-month-old Jeff, me with my 4-month baby belly, and Gary, who commutes daily to Cherry Hill, NJ. We set up a crib, a little space heater and a rug on the wood floor for Jeff to play on. We take walks every day. Yes!

Paradise for three weeks, and then the freeze hits. Way too cold for all of us. No!

Mom-Mom and Frank offer us space in their garage apartment, but it only has a half-bath on that end! The price is just right! No and yes!

Baby #2 is due the first week in March. The house is still not finished. No! Too bad.

I am filled with gratitude, and my heart expands even more, when we welcome Kevin Scott on March 8, 1978, 7 lbs.12 oz. Another healthy big boy bundle, who we fall in love with immediately. He looks like he lost a prize fight in the birth canal; a vision forever imprinted on my brain. The next day finds newborn Kevin sleeping in a bassinet in the garage apartment with Gary and me, Jeff sleeping in the main part of the house with Mom-Mom and PopPop. PopPop Frank teaches the dogs to stay out of the baby's space, and mine too!, Jeff not so much. He likes to curl up in the bassinet with Kevin. Watching them nap while I stand over them, I count my blessings.

Two little boys, very different personalities: one runs at high speed, and the other one is content to cuddle and observe. Yet, they are wired with a perceptible connection from the moment they meet. Very cool to watch and nurture.

Still is.

I am standing in the little kitchen area of the garage apartment, wiping down the little refrigerator for the last time. Looking out the small window at the big backyard where little Jeff is chasing the dogs, Petey and Benji. Living here has been a God-send, but it feels like months since we have been alone. A U-Haul sits in the driveway, packed and ready to transport us to our brand-new little red house in Erial, NJ. One last time, I pick

up 4-month-old Kevin from the bassinet and strap him into his car seat. "Let's go, little guy. We're moving into our new house today. Finally." As we walk out to the driveway, Mary walks over and puts her arms around me, and SOBS! "Mom Mom, you are supposed to be happy to be getting your house back."

"Having you all living at my house makes me happy," she cries. "And now you are leaving."

I will shake my head about Mary's answer for years. It was so sweet, and a little bit sad, too. But it doesn't take long for us to figure out the shortest 4.6-mile route between our houses. We wear that road out in both directions. Having each other to depend on fulfilled a need in both of us.

Dear Mary/Mom-Mom,

I wish that we could meet for one more pizza at Pizza Hut. I would be able to look you in the eye and tell the truth. Sometimes I would be smiling, sometimes crying, but our conversation would be real. For both of us. You could finally say exactly what you felt, and I would welcome the honesty. I could never have handled it back then.

You were ever present in my life the first 9 years of my marriage to your son. Truthfully, there were times when I thought I wanted to be alone. But somehow, I felt better after being with you. You were a marvelous mother-in-law, loving Mom-Mom to Jeff and Kevin, and selfless with your time for all of us. We perfected the "drive-by and drop off" routine, even if I just wanted to go to the "drugstore" alone. You knew, didn't you, that I would sometimes just sit in the back of the parking lot and cry?

I cannot even count the number of times you drove me to and from doctor appointments and hospital visits. In addition, what mother-in-law shares her job with her daughter-in-law? You were so special to me.

This gratitude list could go on and on, but this final example will suffice. You had been hoping that little

Jeff could spend the night with you and PopPop for a while, but we were hesitant and made excuses. Every night involved chain smoking and the liquor bottle for both of you, from cocktail hour until Frank fell asleep in his chair. You would somehow make your way into your bed. I felt strongly that Jeff would not be safe staying overnight. I wrestled with that dilemma for quite a while. Scared to have the conversation, but more scared to leave Jeff with you because he still woke up in the night. I feared the fire danger from the cigarettes. My newly found Mama-bear instinct finally kicked in, I put on my big-girl panties, and I broached the subject with you. You knew, didn't you? Before I even spit out all my words, you stopped me and said, "Well, I'll just have to quit drinking and smoking." And you did. Cold turkey with the drinking, slowing down on the cigarettes. For many, many years. Thank you for that willingness to sacrifice.

You became the second person in my life who loved me unconditionally, the first since Sarah. One in my formative years, and now you as I struggle into adulthood. I could not have loved either one of you more. You both got me and accepted me without asking for more than I could give. Eventually Gary's job moved us to Louisiana, back to NJ for a few years, and then on to Texas to stay. But our bond would never be broken.

When I shared with you my decision to divorce Gary, after 17 years of marriage, you were not surprised. With understanding in your voice, you simply said, "I knew it would happen eventually."

You always knew. And you always loved me anyway.

With love in my heart,

Gail

"Some people appear in your life when you need them most. They love you and lift you up, reminding you of the best, even when you're going through the worst. These people are not just friends, they are Earth Angels." Anna Grace Taylor

Chapter 12
1978-1980

"Suppressing emotions can add to stress… stress lingers in the body, where it can contribute to: diabetes, recurring infections, high blood pressure, heart problems, etc. Any one of these concerns can affect long-term health and longevity, especially without treatment." Healthline.com

If I only knew then what I know now.

"Achoo!"

"God bless you," I yell back to Jack, our next-door neighbor.

"Thank you," Jack calls back. "Gary watching Barney Miller?" I giggle while listening to Gary's laughter at something the character Fish says.

These little houses sure are close together. And when all the little ones are down for the night, the sounds of televisions travel through the windows.

It's just what I always wanted…a house of my own, red with white shutters, with a loving husband, and two healthy children. Brand spanking new, with wall-to-wall shag carpet, kitchen appliances, washer and dryer, the works! My Pop Pop Frankel treated us to some upgrades in the appliances, and heating and air conditioner. How we decorate, what furniture we buy, where we put things has pretty much all been decided by me, sort of.

Gary still controls the bank account.

And the mask still grips my reality.

Inside, our kitchen is clean, and the laundry folded; "spic and span clean," as the jingle goes. So, it's my turn to relax. Grabbing my current novel, I plop down on the love seat, more than ready to escape inside my imagination. Next thing I know, Kevin is letting me know he is hungry. Reality is all good.

I love the middle of the night alone with my baby.

Life in our new home quickly settles into a routine. Gary has a new job with a nice raise but continues to work many more hours. Jeff has two little buddies his age to play with, and Kevin's smile melts everyone's hearts.

I make friends with the "moms," but my mask remains securely pasted to my face. Following their lead, I hear myself saying, "My husband Gary works long hours, but I don't mind.

You know how it is when men are underfoot." What I really want is for us to raise our sons together. Spend time together fixing up the new house. That's just one of many 'little white lies' I use to fit in. In my mind, it seems necessary to be a part of the neighborhood. No one wants to know my real thoughts, though. Sometimes even I don't know what they are.

One of the first neighborly decisions we make is to go in together with our next-door neighbors Jack and Carol, and fence our yards in together. The little ones will have more room to play, and the parents will be able to share supervision. Win-win!

To present a happy, little family outside our front door is my current goal. *I know how to play the game well.*

Day after day, I focus on being the "best wife and mother I can be." Things are going just fine. The relationship with my parents remains strained, in my heart, but occasionally we meet in the middle and mom takes the boys for the weekend.

As we fall into a pattern in our daily lives, Gary quickly re-establishes himself as the provider, and he does that well. So much so that he works ridiculously long hours, accepting as much overtime as he can. *He would unofficially be named the "King of Overtime" many times over the years.* The rest is up to me: taking care of Jeff and Kevin, and the running of the household. I think I understand how important it is to Gary to be able to support his

family, but at what cost? I am beginning to be truly sad at how much time we are missing with him, both the boys and me. And how much joy he is missing watching them grow.

Oh, and I guess the honeymoon is over as date night becomes an infrequent occurrence.

But, as time has a way of doing, even uneventful days slowly pass by.

Unfortunately, a few speed bumps pop up in our path: in the next 18 months, I will need to be hospitalized for several issues.

Soon after moving into the house, I become fixated on wanting to have my tubes tied. "After all, Gary, we have managed to conceive both times without planning! Two healthy sons seem like the perfect amount to me. In addition, a family of four fits at one McDonald's table," I ramble.

Trying to talk with Gary about this idea, he is adamant: "I will not even consider a vasectomy, but I am also not sure I want you to take this permanent step yet. We are still young."

In order to make this life altering choice, I realize I will first have to convince Gary, and then the doctor, that I know exactly what I am doing. There is even a document both Gary and I must sign before the operation will actually be put on the schedule. *This is 1978. Wow, the more things change, the more*

they remain the same. I'm not sure what or who finally convinced him to say "Yes," but it's finally a go. My guess is Mary!

Or maybe it was the lack of sex.

The day of my much-anticipated procedure, all seems to go well, but one day after my discharge I can feel pain and heat in the area of the small belly-button surgical site. Rushing back to the hospital, the ER doctor informs me I have symptoms of peritonitis, an inflammation of the lining of my stomach. Back in the hospital for a few days, to be flushed with IV antibiotics. Turns out a tiny piece of dirty sponge had been left behind.

A few months later, a pilonidal cyst on the base of my spine becomes inflamed. It had first shown its ugly side when I was pregnant with Jeff and again with Kevin. The treatment process is to lance it when it becomes infected, take strong antibiotics for 10 days, and wait for the next time. Well, the "next time" begins to increase in frequency. Since it is virtually impossible to drive with an infected cyst on the base of one's spine, Mary and I became regular emergency visitors at the general surgeon's office. Each time his advice is the same: to consider permanent surgical removal of the cyst when I feel it "interferes with my daily life." This is feeling pretty disruptive to me.

Thirdly, still carrying extra "baby weight," my breasts have now become a bona fide health issue. I couldn't even breastfeed Kevin because of the added weight when my milk came in. Constant backaches and raw bleeding crevices on my shoulders are greatly affecting my everyday life, but of course, I try to play it down. Gauze bandages under my bra straps, padded straps, taking my bra off at night, etc. Research educates me that breast reduction surgery, a permanent solution, can be covered under insurance if there is proof of a medical need, not just cosmetic.

Once again, sweet Mary listens to my worries and helps see the seriousness of my situation, goes with me to consult with a plastic surgeon, and then, helps me convince Gary to relent and consent. It is major surgery, and at first, he is a definite "No. Why would you choose to have major surgery on your breasts unless you have cancer? And there's the sexual issue...I know I will miss that. Won't you?"

"What about my bleeding shoulders? I know you see those every night. The back pain? There is more than enough excess fat to qualify for a medical procedure, not cosmetic. And furthermore, I am not even thinking about the possible lack of sensitivity. Oh my God, Gary, are you serious? I am seriously

considering having the surgery, with or without your 'permission.' The end."

Eureka! That worked. Where did that come from?

It is Mary who keeps the boys during the surgery and after, drives me to and from the doctor visits. She even takes me bra shopping when I am healed.

It takes weeks to heal, but I will never regret having this life-altering surgery. The surgery was so extensive, I did lose most of the sensitivity.

About this time, finally healing from the breast surgery, we learn we will soon be losing our 1% interest Farmers Home Loan mortgage. The federal government requires updated information every two years. The good news is we now make too much money to continue to qualify, due to Gary's new job. Our options are to refinance the red house with a new mortgage, with a whopper of a monthly payment. Or sell the house, take whatever equity we have accumulated, and move to a bigger home.

House hunting time again.

"There's the sign, Gary. Robindale Manor. Wow, it looks pretty fancy, don't you think? Let's check it out just for fun."

There are three model houses and an office just one block into the neighborhood. Many of the houses look pretty new, sprinkled with some older split levels.

"Let's check out the middle-size model by ourselves before we go to the office," Gary suggests. We walk around the two-story "mansion" with our jaws dropping, knowing we can never afford this house in this neighborhood, but having fun fantasizing. As any good salesperson would do, she is waiting for us as we walk outside, laughing and shaking our heads at even thinking we could buy one of these houses. "Come over to my office and have a cold drink," she suggests.

Ka-ching!

By the time we get back into our car a few hours later, we have signed a preliminary contract, and even left a deposit check. "We better drive right to Mom-mom's and ask if she will temporarily cover our check," we both say at the same time.

By summertime, we will be the proud owners of the "Blue house in Robindale."

A stretch of a financial decision at the time; a move that will provide life-long friends and memories for us all.

In the meantime, for the remainder of our months left in the red house, when Gary isn't working, and we are able to be a family, we make some genuinely fun memories. Birthday parties, holidays with relatives of all ages, grown-up parties with our friends. One time after a blizzard, Gary and Jack, our next-door neighbor, shovel a twisty path from our back door to their back

door so the boys can play in the snow, and go back and forth between houses. It is a huge hit with the neighborhood children.

Gary's purchase of a full-size foosball table brings regular foosball parties to our house. They start out friendly in the afternoon and end up very competitive as the hours go by. Luckily, Jeff and Kevin learn to sleep through the cheering. One of our good friends from Atlantic City, Big John, buys a house a few streets over and he loves foosball. Soon after, an informal foosball league develops, sometimes coed and sometimes all-guy, louder and more serious games.

It doesn't take long for Kevin's bedroom to become the Foosball room, and for Kevin and Jeff to share a room. Crib out, foosball table and random chairs in. All the boys - Gary, Jeff and Kevin, and Big John - love the new arrangement! Works for me, too.

Two years is all the time we spend in the red house, our first real home. Seems like more. There were many wonderful memories made. Photos saved with fake smiles as the focal point.

In all honesty, I primarily remember those two years as the period that established our marriage routine as one of separate subsistence.

Gary contributes the support and sustenance, and I provide the care. He plays with his sons, and I raise them up. He

earns the money, and I pay the bills as directed by him. As for "Gail and Gary," when we could, we would still schedule a date night. Our routine works, but after six years, our relationship is far from fine.

But, hey! Here we go again. It's time to pack up and head toward a new beginning. Mary and Frank will only be five minutes away. A new house, new neighborhood, and new friends await. Jeff and Kevin will be able to attend a preschool for a few days each week. Gary will stick to his routine, just pulling into a new driveway with a nice garage at night.

In retrospect, I was hopeful.

Too bad that damn mask made the move, too.

"You did the best you could with the knowledge you had in that moment. It's easier to look back at an event and see a better choice or pathway because we already learned from our experience. Hindsight happens after the lesson, so we can't condemn ourselves for not knowing the lesson before we learned it." Emily Maroutian

Dear Gary,

At this moment, I really want you to know two certainties: I did the best I could at the time, and I wish I could have done better. Remembrance and recollection of those years as a family serves to reinforce the real love I had for you all. At the same time, those memories also serve to bring clarity to all that managed to stay hidden.

You and I were children when we began our journey together - 16 and 14! Even at that young age, you had experienced emotional trauma during your parents' divorce, magnified by the decision made <u>for</u> you to live with your father and stepmother. When I first met you, you had just left that situation and moved in with your sister Karen.

Horrible role models for you to have as we grew up together, and headed into marriage. Yet, we rarely talked about any of it.

There is no place for condemnation, no reason to lay blame. No way to change the past. We lived as a family for 17 years, enjoying our abundance of blessings, and both doing the best that we could. Our sons are both amazing fathers and providers for their families. Adults we can be proud of.

All in all, it just wasn't enough.

Please know that I gave it all I had, until I just had no more to give as a wife.

Love and blessings,

Gail

Chapter 13
1981-1983

"We all wear masks [sometimes], but the [problem] comes when we cannot remove them without removing some of our skin." Andre Berthiaume

What a time of excitement for our family.

"I believe that we are going to be happier here," my thoughts keep repeating. "The house seems so big and bright, with lots of room to spread out. The neighborhood appears family friendly, with hardly any through traffic except homeowners. It will be fun to shop for furniture, curtains, and lamps. I wonder how soon the boys will meet some friends? When will Gary and I make some friends? When is Kindergarten round-up? STOP monkees!"

The U-Haul truck has made its last trip from the red house to the blue house, we have carried in the last of our boxes, and each one of us is sprawled out on the staircase. For a minute! Then both Jeff and Kevin get a second wind when they realize they have steps to play on.

"Be careful on the stairs, boys." *Remember, I have a history with staircases.* "Up we go, Gary. We have beds to put together before we can sleep tonight."

Along with the smile, I have developed a slightly more optimistic attitude to provide me with hope. A lot of times it helps, if and when my expectations are met.

Expectations are what we hope will happen in a given situation. Reality is what actually transpires. While we hope these two will match up, they often don't. I describe these clashes as being hit by a 2x4 over the head. When anticipation smashes into the wall of reality, it's going to lead to disenchantment and discontent. Especially a "reality" that is seen through a mask,

The mask moved with me, and I didn't even have to pack it. It was safely plastered to my face the whole time.

I am grateful that my memories of what lies ahead during those next two years are mostly positive. Genuinely.

Walking around the neighborhood with Jeff, pushing Kevin in a stroller, soon brings pleasant conversations with neighbors, and lots of young ones of all different ages for the boys to play with. One courtyard has a basketball backboard, one backyard already has a built-in pool, and lots of already-installed swing sets, too.

Santa Claus is hinting about the coolest little log cabin playhouse for our tree-filled backyard. I can just see it providing so much fun for the preschoolers and kindergartners to be. Homes with pools are required to have fences, but so far many of us just leave our yards open to play.

In addition, Robindale Manor only has one main road that circles the neighborhood, with multiple courtyards branching off. It is really safe. The kiddos are learning how to ride bikes in the courtyard and strive to be brave enough to "ride all the way around." Jeff is getting the hang of it, improving every day. And Kevin is watching closely so he'll be ready when he is "big enough." It is understood by the "stay-at-home moms" that when little knees are banged up and tears happen by your house, you bring out the Band-Aids and hugs.

Lots of children can be found playing with each other outside, and inside in smaller groups, whenever they are not in school. Grownups stroll the neighborhood after dinner, sometimes socializing on random decks or porches until dark.

I frequently visit different neighbors after dinner, even if Gary is working. It's starting to feel natural.

Being alone, I mean.

After one couple invites us and another family to swim in their pool and enjoy a bar-b-que on their deck, we soon find

ourselves settling into a three-family group. Our children, seven total between 2-10 years old, play together constantly, and on weekends so do the six adults. Sometimes we all hang out at our place, and sometimes the kids go to one house for a video, with the grownups across the courtyard. It always seems to work out easily, and effortlessly. Countless games of "Horse," a basketball game, all kinds of swimming pool games, EAGLES football, Phillies baseball, food and drinks, and so much more.

It feels as if we are in the right place at the right time. Neighbors are our friends now. Friends who accept me with or without Gary being there. Friends who are beginning to feel like family.

Life <u>inside</u> our new blue house naturally settles back into our established routine. Gary continues to work too many hours, but I must be getting used to it, more accepting. I feel more content with a stronger support system that includes family, old friends, and our new friends. Mary is a frequent, but welcome, visitor, and the boys and I often stop by her house, too.

Our Thursday Pizza Hut nights expand to include watching "The Waltons" at Mary's house. Oh, how we love to laugh and cry with the Waltons together. "Good night, Jeff. Good night, Kevin. Sleep well, Gail," Mary quietly says as she sends us

home. "Good night, Mom Mom and Pop Pop," says Jeff and Kevin.

It's our favorite night of the week.

Pretty much, my health is getting better…I think, I hope, I pray. Life, and my emotions, have been pretty balanced for these two years.

Most of the children attend Birches Elementary, just far enough away to ride the bus. I drop Kevin off at a local preschool two mornings a week, using whatever car my father in law "sneaks" off the used car lot where he works. That little guy excitedly says, "School" first thing every morning, yet has a frown on his face on the two drop off days. Probably because Jeff is not there. Kevin will certainly be happy at the end of the summer, when he goes to the same school as Jeff. They have such fun together.

What will I do?

Seems like time is flying by. In September, we will have one in 2nd grade and one in Kinder.

I'm still taking trips to the drugstore to cry alone in my car, but way less frequently. Still without my husband, and my children's daddy, way too often.

Life is not too bad…

Right after the school year ends, on the very first weekend of summer vacation, Gary casually blurts out an announcement as soon as he walks into the house. "Guess what? We are all moving to Baton Rouge on a two-year job for Stone and Webster. We have to leave in two weeks."

He is looking at me to see my reaction, and of course only sees my smile mask. On autopilot, I plop Kevin down in his booster seat, and Jeff climbs up to the table, and I manage to fill up the dinner plates. "I'll give you all the details after dinner," Gary says, and sits down at the table, ready to eat.

My monkeys are flying around in my brain like the creatures in the Wizard of Oz. No! Do we have to go? Do you even know anything about Baton Rouge? What will happen to our blue house? Our stuff? Leave Mary and Frank behind? Is it even possible to move half-way across the country in two weeks?

Do my feelings even matter?

When Jeff and Kevin finish dinner, they run off to play in their room. They seem to understand a little bit about "moving," but they have no clue about this kind of moving. Gary and I stay at the table.

He begins, "We are moving. In two weeks. The company will be providing a moving service, from packing up to unpacking

in Louisiana. In addition, they will hire an agency to totally manage the rental of our house for two years. And, of course, they pay for us to travel. On top of all that, there will be bonus income with each paycheck, for living away from 'home'. It's a great financial move, for sure."

That may be the most words Gary has ever spoken.

Slowly and quietly, blinking furiously to hold back tears, I manage to say, "Yes. Yes. Yes. And yes! That all sounds wonderful, for you, but I want to stay here with the boys." Ahhh, I say it. Out loud. My truth.

Gary's cutting reply, for the first time but will not be the last, is definitive. "Well, you are just thinking crazy thoughts. We are going, all of us. I signed the paperwork today. Tomorrow we will tell my mom and Frank."

The only thing missing is the banging gavel.

When Mary finds out we hug and cry, and cry and hug, and then she says, "Well, let's stop this blubbering and get organized."

Gary and I are going to drive from New Jersey, doing some sightseeing on the way, but the boys are going to have a much more fun trip. My parents, who have now taken early retirement to Florida, offer to keep Jeff and Kevin with them for a few weeks.

It's been a whirlwind two weeks getting ready to leave, physically and emotionally. It doesn't help that my mind wanders constantly. Wonder what would happen if I <u>demand</u> to stay here, with the boys? Seems like it would be a lot less hassle. And not that much different. Maybe Gary could fly back once a month. Mary and Frank would be here to help. Ahhhhhh!

These kinds of thoughts are not helping me prepare to move. And there is no way I would or could ever be strong enough to actually do that.

Not this time, anyway. Maybe next time…

Talk about stress on top of stress. Try hugging your 3 and 5-year-old boys goodbye at the Philadelphia airport as they travel "alone" to Tampa FL. On the other hand, the joy of seeing them a month later when they walk off the plane in Baton Rouge is priceless. Two little suntanned cuties, with matching flat top haircuts, navy blue shorts, yellow button-up shirts and big smiles and bigger hugs!

"Mommy, Mommy, we can swim now. And dive! Uncle B taught us."

My heart is overflowing; I try to feel optimistic, and wear a real smile. Baton Rouge, ready or not, we have arrived.

"There are far, far better things ahead than any we leave behind." C. S. Lewis

Chapter 14
1983-1985

"Severe stressful life events are the most important risk factor for episodes of major depressive disorder. The top five most stressful life events include death of a loved one, divorce, moving, major illness, or job loss." Family Institute

Our lives have been going so smoothly in New Jersey. Two weeks later, we are in a new state, deep in the South, for the next two years. Is that normal?

Well, Baton Rouge may have been ready for us, but it comes as no surprise that I am not dealing well with all the changes. I can feel the sadness and the anxiety creeping back in. Self-doubt about whether I should have refused to disrupt the boys' lives. Deep disappointment that I feel I could not speak the truth.

We quickly find a nice townhouse to live in, in a beautiful neighborhood south of the city, with a highly recommended elementary school. Jeff will be in 2nd grade and Kevin in Kindergarten. We are close enough that they will be able to walk,

and we even practice walking the few blocks and playing at the playground.

"When does school start?" Jeff asks.

"In three more days!" I reply excitedly. Both boys are ready to make some new little friends in the neighborhood. And I am more than ready for a little down time.

The next morning, I pick up the local newspaper, and the front page's headline says, "NEW SCHOOL ZONES ESTABLISHED FOR BUSSING PURPOSES." I struggle to find our location on the printed map and am devastated when I realize we are right inside the line for Parkview Elementary School, 8 miles away towards the city. Not a one mile walk along the sidewalk to Shenandoah Elementary. Two days before school begins? This cannot be right. My two little boys are going to be bussed 20 minutes in order to comply with new desegregation guidelines?

It's 1983! Where in the hell has Gary brought us? New Jersey's schools have been integrated since the late '50s. This cannot be. I just sit there for a while, because I can't get up. This seems like an episode of the Voyagers! We have gone back in time. Now, in 1983, they finally decide to enforce bussing. So, Jeff and Kevin will have to ride a school bus across town. Have we left the United States?

I need to find the strength to change this entire situation.

Of course, the newspaper is correct. Turns out the political leaders of Baton Rouge have been involved for years in multiple lawsuits against desegregating their schools. Finally, in 1983, they actually do reach the end of the legal road. Just our luck.

Jeff and Kevin are dressed and ready to get on the big yellow bus the first day of school. So glad the two of them are together, at least. They are part of the 20% white children who are integrating the student body of Parkview Elementary. Luckily, they are too little to understand the politics behind the changes. Even more fortunate, they don't harbor a prejudiced bone in their bodies.

It will only take one week for me to begin to get a better grasp on our new reality.

"Hello, this is the nurse at Parkview Elementary. Is this Kevin N's mother?"

"Yes. Has something happened? What's wrong?"

"Well, Kevin was outside at recess, playing on the wrong side of the playground, and he got bitten by ants."

"Oh, okay." Breathe. "Thank you for telling me. I'll be sure to check the bites when he gets home."

Speaking a lot louder, and a little slower, the nurse says, "Oh no, you don't understand. These are Louisiana fire ants and

he fell into a big mound of them. He is covered in bites. You need to come get him immediately."

"Well, then I'll be right there, but it will take me 20 minutes to get there since we don't live in the neighborhood."

That call begins a month-long series of events that will open my eyes to life in Baton Rouge. I also begin counting down the weeks until our two-year stint is over.

When I get to the school to pick up Kevin, I find my little guy still snuffling in the Nurse's office, covered in white dots. Seems toothpaste is a treatment option for fire ant bites. When I question, "What is a mound of ants doing in the area where children play?" the reply leaves me stunned.

"Kevin was playing on the wrong side of the playground. He ran over and started playing with the colored children. He tripped and fell into a pile of leaves, and a nest of ants. If you would please talk to him about staying where his teachers tell him to be, we would appreciate it."

Jaw drop! I turn, take Kevin's little hand, and head out of the building.

First lesson: my children are being bussed to another school just to "show" that desegregation is happening. During the school day, in their classrooms, at lunch, recess, etc., the teachers encourage them to segregate.

If I was staying permanently, it might feel good to call attention to the hypocrisy. But who am I? My actions could bring ramifications to the boys. It feels almost impossible to even hold my head up. Which means my neck and shoulders hurt.

Oh, God, there are still 99 weeks to go.

Two days after the ant bite incident, I decide to attend a Room Mother's organizational meeting. I figure I will get to know some of the moms, and be able to help Jeff and Kevin's teachers, too. Walking into the meeting room, my keen sense of observation sees at least a dozen white moms, and only two black women. "Hmmmnn?"

I listen quietly to the how-to-be-a-room-mother information being shared, until I hear the leader proclaim, "Now, don't forget! When you call people to help with parties, all donations from our colored families must be store-bought, not homemade."

Being a Yankee born and raised, now surrounded by, and listening to, a table full of southern accents, I say out loud, in my best Yankee accent, "How can I tell the difference on the telephone? You all sound alike." Where in the hell did that come from?

Second lesson: The parents have the same opinions about integration as their elected officials. It's all a farce.

I pretty much resign from my volunteer Room Mother position before I even begin. I just can't. 98 weeks left.

The next week, Jeff gets off the bus and starts crying as psoon as he sees me. "I was a bad boy today, and my teacher wrote you a note," he finally mumbles, digging the crumpled note out of his pocket.

Dear Mrs. N,

Jeff is having some difficulty adjusting to the 2nd grade routine. He seems to be a little more immature than most of the children. I have had to remind him quite a few times that big boys don't call their mothers "Mommy." Here in Baton Rouge, he should call you Momma. Please work with him at home to help him adjust.

Sincerely,

Mrs. W.

Are you kidding me? Teacher conference needed immediately.

I say quite a few things to the teacher, but the comment that finally hits home is, "Mrs. W. I am 29 years old, born south of the Mason Dixon line, and I still call my father Daddy. My son

will call me Mommy as long as he wants to do so. And he is not to be teased about it by his teacher." Period.

I also say a few important words to Jeff when I get home, trying to reassure him that when he and Kevin call me "Mommy," it is the best sound ever in my ears. "I love you to the moon and back, Jeff. Forever and ever."

Third lesson: I guess the "mama-bear" in me comes awake and strengthens my courage when my boys are involved…97 weeks.

A couple of weeks later, Gary and I are going out to the first social gathering of the "Stone and Webster" fellow transferees and their spouses. Drinks, dinner and dancing at a popular 50s style bar and restaurant. I already know a few of the people who came down from NJ with us, and I am really looking forward to having some fun with them, and meeting new people, too.

After about 30 minutes, I ask Gary, "Where is Marcus? Surely, he's not working tonight."

Gary quietly replies in my ear, "He's not allowed to come to this bar."

"What the hell? Are you saying what I think you are saying? No way. It's 1983!" I sure have been saying that a lot lately.

Jaw drop. Dead stop on the dance floor. "Gail, there is nothing you can do about it. Please do not make a scene," Gary implores.

It's official. I absolutely "dislike" it here in Baton Rouge. I was not allowed to say "hate" when I was growing up, but it sure applies to my current feelings.

Since I have reluctantly accepted that we're not leaving for 95 more weeks, I decide that the best thing I can do is try to keep my children from being permanently damaged by living two years in this deeply troubled state of Louisiana. They are getting practically no education, in addition to the bussing issues.

My first attempt is to convince Gary to agree to enroll them in private schools. "Gary, Baton Rouge's public education is bad for many reasons. Neither one of the boys is learning anything, except to color inside the lines. Other S & W moms tell me that 'those who can afford it' send their children to private schools. Surely, with the extra money in your paycheck, we can afford to do that. Right?" Breathe.

"Gail, that would defeat the purpose of taking this two-year job - making more money." Gary assumes a tone that I know means he is not debating this. "That is a crazy idea. Jeff and Kevin are smart. They will catch up when we get back to Jersey."

I should definitely get him a gavel for Christmas. If he has one, he can slam it down and say, "Case closed. Let's move on." Think he would get the message if Santa gives him one for Christmas? He turns on the television.

I suddenly feel really tired, and quickly head up to the shower. It takes a lot of hot water, and a lot of water pressure, to drown me out.

Plan B: I march myself up to the school and volunteer my services for as many days as I am needed. Surely it will be better if I am close to the boys.

While helping in the school library, I discover two brand new computers locked in a closet, rolling carts and all.

"Oh, no one knows what to do with them," the Librarian tells me.

I teach myself enough to load two programs that teach letters, numbers, and beginning reading. Within a week, I am pulling K-2 students out of their classrooms every few days for 10 minutes computer time per student. They love it, and so do I. They are so excited to use a computer. The sound of their voices when repeating the letters of the alphabet tickles me. Some say "R" and some say "R-ah!" Some say "4" and some say "4-ah." Precious sounds no matter what. Learning is going on. And I sneak in extra smiles and hugs with my boys.

I get to experience firsthand what Jeff and Kevin are dealing with. It's not the children who segregate themselves. It's the adults. It's history. It's life in the South.

Spending lots of time at the school seems like my best option. I owe it to my boys and they seem to like seeing me there. On the other hand, experiencing the behind-the-scenes world at Parkview Elementary in Baton Rouge will not be good at all for my mental health.

Worry and fear are my constant companions. I am living in constant survival mode. It feels as if nothing can improve my mental state.

The weeks continue with more of the same. Kevin's teacher evidently has a "sleeping disorder," and nods off at her desk periodically. With a classroom of 5-year-olds! Kevin's coloring skills improve greatly, but not much else. Once his teacher recognizes me as a volunteer, I stop in frequently to keep an eye on the children.

Second grade is not going much better. Jeff remains scared of his teacher, but he learns quickly how to just go along to get along. He does not like being in trouble at all. Sound familiar?

After a few months, I know for sure they are both going to have a school year without much meaningful education. By

Christmas time, I am already calling the school year a failure, and hoping that by some miracle Gary is right about the boys being able to catch up when we get back home to New Jersey.

75 weeks to go.

The 1983-84 school year is, without a doubt, the worst year of our marriage so far. The times we are together as a family come few and far between. Gary wins "Overtime King." Is that something to be proud of? Nothing to celebrate as far as I am concerned. In my heart, what marriage we have is unraveling.

The parents on Jeff's soccer team think a friend of ours, Neil, is Jeff's dad, since Gary is hardly ever able to make the practices or even the games. When he is not working, I focus on our sons getting as much time as possible with their daddy.

By early summer 1984, it's one year down, and our 10th year anniversary. The marriage of Gary and Gail is dying a slow death. I am so lonely, and tired of feeling like a single mom. I know that I am staying for the boys, to keep their daddy in their lives, but he is hardly ever here. In Baton Rouge, he is choosing to be a good provider, period.

In my continuing depressive state, our situation is getting more difficult to handle. One day, I am going to take Jeff and Kevin, and go home. At least we have a support system there. And the next day, I swing in a different direction.

Dammit! With 45 weeks still to go, my decision is made. The boys and I need to go home. What's the worst that can happen?

However, sharing that life-changing resolution will have to wait just a little longer. We first have to make a quick trip to New York for a wedding. Gary's brother Glenn is getting married again. All four of us, and all of Gary's family, together for a long weekend. I am the matron of honor! It would not be cool to bring our family drama to the happy event.

My mask is securely attached to my face. My secret plan is simmering inside my heart. Not much longer.

The wedding is so much fun. Grandpop Acker, Gary's grandfather, is the best man for his grandson Glenn. By the time of the first dance, we have already toasted with champagne a couple of times. I actually have to "speak" to Grandpop about his wandering hands while we are dancing. Lots of uncomfortable giggles about that. That is definitely a little creepy.

Later the giggling and the dancing stops. Gary has been sitting over in the corner with his sister Karen, and they look very serious. When they stand up, they hug, and then walk across the room towards me. Not good.

Karen is already talking when she reaches me. "Gail, we need to run something by you. Gary says you will be just fine with it, but I want to make sure."

I look directly at Gary, waiting, but it is Karen who continues. "I am having some health issues, and I need someone to take care of Ranai for me. It will work out great because she and Jeff will both be in 3rd grade. Gary says she can come to Baton Rouge for the next school year. Will that be okay?"

Have you ever been hit by something so loud that your ears ring? And you cannot hear anything but buzzing? That's me at that moment.

Inside my brain I must have been saying, "Why didn't I tell Gary my decision before we left for New York? He would have been able to say no to his sister when she asked him if we would take her 8-year-old daughter into our family. And when they both came to talk with me about the idea, I would have been able to say, 'No, this is really not a good time for us.'" But I am unable to speak.

Instead, I am silently, seethingly, smiling.

Two weeks after we return from the wedding, I find myself with an 8-year-old little girl to care for. We all love Ranai! She has been in our lives since the day she was born. Birthday parties, holidays, 4th of July celebrations at the family cabin in

Pennsylvania. I understand that Gary could not have said no to his sister. After all, she rescued him from his stepmother's clutches when he needed a place to live. It's his time to help his sister.

I give it my best effort! I really try to make it work. A little girl, who I love, needs my help. It's up to me to make it work. This time there is no Earth Angel to help; no support system. We'll be here for 38 more weeks.

My decision to leave Baton Rouge has been snuffed-out.

Lying prone on the closet floor, I quietly sob, using a shirt to muffle the sound. Feeling wretched for months, I have zero faith in my ability to mother another child. Our sweet niece certainly came to us with her own emotional baggage. Thoughts of worthlessness, inadequacy, and sadness fill my mind, overflowing into my heart. I feel scared; it's a new and very uncomfortable feeling.

It is only through prayer that I am even able to come back out of the closet that day.

"But those who hope in the Lord will renew their strength." Isaiah 40:31

Sadly, I only make it about 12 more weeks; just 22 more weeks left until we go home. I just can't do it.

Our beautiful niece has some serious behavioral issues. All too soon, Jeff and Kevin begin being defiant and disrespectful, too. One day, while going out to pizza dinner, the three of them are lined up across the backseat. They are arguing about a toy for a few blocks.

"I want a turn," Ranai whines.

"No, it's mine. I got it for my birthday," says Kevin.

"Leave Kevin alone, Ranai," yells Jeff.

Pulling up to a red light, I make the infamous "eye contact through the rear view mirror," and inform them, "Stop fighting right now and quiet down."

Wham!

Coming back at me immediately, I am blasted by my niece's voice letting me know, "I can do anything I want. You are not the boss of me."

Involuntarily, I reach around that front seat, and swing my open hand at her face.

Shock covers her face as my hand just misses making contact.

Her little 8-year-old eyes are huge.

They are looking right at me with disbelief.

Only then does she begin wailing indignantly.

As soon as the light changes, I pull over and stop.

Where did that come from?

I have never raised my hand at anyone, especially a child.

I need help.

Breathe in.

Breathe out.

Shock overcomes me. Eventually I somehow drive us safely home.

As soon as Gary comes through the door, all three children start excitedly telling him what happened. They are so loud. I am pretty much just lost in stunned inner turmoil.

Sleep is all I want. Go to bed, get under the covers, and be quiet.

How could I ever strike a child? Thank God I missed. How do I get some help? Gary should call Mary. What the hell is going to happen? Why can't I sleep?

Sadly, our niece goes home that weekend. I receive my first medical diagnosis of "anxiety" and some meds to take "when needed." A few of our local friends rally round and help whenever they are able. A couple of the women share two very intriguing pieces of information: they also cannot wait to leave Baton Rouge and no one else has been working the amount of overtime that Gary is.

Good to know.

With a few weeks of drug-induced "rest," I rally enough to safely navigate the home stretch.

Two years to the day, the journey comes to an end. We are battered and bruised, but we are going home to the blue house in New Jersey, together.

Heavenly Father,

I prayed to you for strength when I was weary.

And weak. And so alone.

Thank you for answering my prayer.

In Jesus name I pray.

"Give thanks to the Lord, for He is good;
His love endures forever." Psalm 107:1

Chapter 15
1986-1987

"When confronted with questions in the midst of a depressive episode, a masker may withdraw even further. They doubt their own feelings. Frequently they feel misunderstood or not believed. Their invisible wall becomes impenetrable."

Paradigm

The trip home to New Jersey happens. Of that I am sure, but only vaguely aware. I know Gary drives, the boys seem somewhat content in the back seat, and I am under the influence. Placid, sleepy, and very foggy. That's what Clonazepam does. Keeps my anxiety under control. It's probably not the prescription I actually need, but no way does the doctor in Baton Rouge know anything close to the whole truth.

I just need to go home.

"The blue house!" Jeff and Kevin yell excitedly as we come driving around the bend. "We're home, Mommy. Look how

big the old Christmas tree is! Stop the car, Daddy, so we can get out."

Those little cheerful voices are so wonderful to hear. We <u>are</u> home again.

The moving truck will arrive any minute, and the unpackers will soon make it look like we never left. Our friends Barb and Jim from the neighborhood stop by to say, "Welcome home. You all look great. Can't wait to hear all about your time in Baton Rouge. Come over for hamburgers later, when you are ready for a break." At least Gary is greeting them outside. I'll see them later.

No one knows the truth about my emotional breakdown except Gary's family. This is going to be difficult to mask around friends, considering the effects of the meds. Later on today, I can claim exhaustion from moving, but what about tomorrow? It's been weeks since I freaked out. Maybe I can just stop taking the prescription every day? Keep it for those times when I need to sleep. No one has to know I was taking it.

How else will I get my life back?

Starting right now, no more Clonazepam, except as a sleep aid.

It is time to get this family back on track. Step. By step.

Starting with me.

Mary is the first to notice that I am feeling a little better. Little by little, we are finding our way back to the close relationship we had before. As the fog lifts, I feel safe sharing some of the Baton Rouge stories, and it helps to have someone to talk with. Until one day she randomly comments, "Surely Gary was there to help you deal with the extra work of having an extra child to care for?"

There is always a narrow line to walk when Gary is the subject of our conversations. He is, and always will be, her son. "He was his usual self, Mary. Working most of the time; playing with the kiddos when he could." It is sometimes wiser to keep my answers simple and unembellished.

She is also the only one to speak with me about the horrible episode with her granddaughter. Just once. "I am so sorry I wasn't able to help you more. Karen had her mind made up before anyone even told me anything. That's just Karen. No one thinks badly of you."

I'll soon find out for sure.

"Come on Jeff and Kevin. It's time to get in the car. 'Shaminy' here we come!" As usual, I am trying to pack up the food, pack up the clothes, and pack up the boys. Gary packs up the car. Today is a special day for Gary's family. It's the annual 4th of July celebration at Neshaminy Creek, PA, where multiple generations of Gary's family, and other families, gather every year. Good old fashioned running races, swimming races and the favorite egg in a spoon race for all ages. Prizes, candy toss, food, and "divin' in the crick" all day long. They still have the family cabin that little Jeff and I had stayed in when I was pregnant with Kevin. So, the beds and floors will be covered with sleeping bodies by midnight. A fantastic family sleepover, as long as you don't mind the line for the one flushing toilet. There is a working outhouse if you dare.

Mary was right. No one appeared to be upset with my actions or behaviors. My problem is my own perceived breach of my mask. I feel vulnerable during conversations.

Is everyone wondering if I will break again?

I am. Why shouldn't they?

Stop the paranoia.

You know how things are usually lovey-dovey for a little while, after making up from an argument with your spouse?

That's how Gary is acting today. "How are you doing, Gail? Hungry? Want to take a canoe ride? Did you see the boys jumping off the dock?" Lots more touchy-feely moments, too. Nothing that anyone else would notice, but certainly feels strange to me…in a good way!

The best question of the day: "Gail, would you like to go on a double date with one of my old friends and his wife? Willow Grove Amusement Park is close by and then we can go see the fireworks."

"Absolutely I would like to go. I bet Mary will keep the boys. They are tired out."

Could Gary and I be feeling the rebound from a wake-up call? Is it too little too late? You know the old saying, "Time will tell…"

The fire of "Gail and Gary's rekindling tour" is snuffed out pretty quickly. Gary's work soon rears its ugly head. If only we could find a happy medium.

Once again, that's a one-sided fantasy.

Gary and some of the other guys who came home from Baton Rouge are soon on the road again. This time they are commuting daily about 1½ hours away to another nuclear power

plant in South Jersey. They carpool, to share the driving, but Gary is pretty much gone at least 12 hours a day. Deja vu.

On the other hand, as my foggy brain brightens, I seem to have discovered a new sense of purpose. Self-reflection is providing clarity to put the nightmare called Baton Rouge in perspective. As my self-esteem strengthens, so does my optimism.

Having hit bottom, and never wanting to go there again, I am determined to speak honestly…at least to myself. Finally, I feel ready to identify what will make <u>me</u> happy. Where to focus my energy; what matters the most to me.

It's time to set some "me" goals, short-term and long.

"Believe you can and you're halfway there." Theodore Roosevelt

My vision continues to gain clarity. The decision I made amid a thick layer of fog is valid. Even though I have yet to say it aloud, it now becomes my goal: **I am going to end my marriage to Gary.** Not today, or tomorrow, but when I am able. I'm only 32 years old. Still, plenty of time.

I declare this to be true, inside the walls of my shower, in August of 1986. I hear it ringing loud and clear, echoing off the shower walls.

I pray, "Heavenly Father, please stand in front of me so I can see where I am going. Stand behind me to catch me when I fall. And most of all, please walk alongside me, to keep me safe on this journey. Amen."

With newly found strength, I go right after what I want.

"Gary, I have decided that I want to go to college."

"Why do you want to do that? Don't you have enough to do? Have you even thought about how you would pay for this idea?"

"Gary, I know you don't know this, but I have been thinking about finally going to college for a while. I'll start out part time and see how I do. If you are not going to give me financial help, then I am going to get a job and pay for it myself, little by little."

"Right, good luck with that, Gail. We will all be better off if you just keep on doing what you've been doing. Be happy that you don't have to work."

Rather than retreat to the big walk-in closet, or the shower, this time I check out the help-wanted ads in the local newspaper. Plus, I talk to other people in the area. Jeff and Kevin will both be in school next month, I have a used car to drive, and some past experience. Surely, I can find some kind of job.

In the regional newspaper: Wanted - Secretary for the Math and Science departments at the local high school. Secretary, check; Math and Science, bingo.

Today is my interview. What a shaking-in-my-boots morning it is. I drop the boys over at Mary's without telling her where I am going. I'll share the news soon enough, if I get offered the job.

Mr. Fred H. picks me up in the front office, and escorts me to the Math and Science office. "Welcome, Gail. Fred H., Math Department chair. Are you from around here?" he asks. "How long was the drive this morning?"

With a little bit of a quivering voice, I reply, "No, sir, I grew up in the Atlantic City area. However, now I live down the road, just 5-minutes away!" We are met at the office door by another man, definitely the Department Head for science, as evidenced by the white lab coat, with a pocket protector, too.

"Al D, Science Chair. Welcome to Washington Township High School." They both look to be around mid-30s, average builds. Mr. H gets right down to the business of beginning the interview.

I manage to dredge up enough confidence to answer the questions thrown at me by two male department heads. It may have been 10+ years since high school, but I still remember speech class. They can see from a glance at my "resume" that I have some previous, but minimal, experience. I am quick to point out my claim to fame at my first professional job with the Atlantic City Press, right after graduation. "In just two years I did every job available in the business office. Not all at once, but I kept asking to be moved around to the different desks. We were all on the same floor, one big room. Insurance, accounts payable, accounts receivable, classified, etc. I am a master of 10-key data entry! Once I mastered the job, I wanted to try something different. I like to keep things interesting." They are guy-chuckling by the time I stop for breath.

They describe themselves as nice guys who need a dependable person to keep them organized. They tend to get "caught up in their teaching." Oh, I have those skills covered for sure. My communication skills are now flowing out of me, I even manage to describe "taking care of my family" as marketable and

measurable skills. Somehow my inability to barely pass high school Algebra is skipped over. Right along with my taking "Nurses Chemistry" in a class full of girls because it's easier. Maybe I can share that tidbit if we become colleagues.

Mr. H. (Fred) and Mr. D (Al) offer me the job on the spot, and I say, "Yes," with genuine enthusiasm. Ha! Didn't even say, "I'll have to talk to my husband." School hours, school calendar, and a five-minute commute. What more could I want? I can handle all that on my own.

It feels like a huge step in the right direction.

Having successfully taken my first baby-step toward freedom feels inspiring. It is my turn to be the one to share exciting news when Mary and my sons meet me later on at Pizza Hut. The boys think it is "Cool, Mommy" and wonder if I will be home when they get off the school bus. Mary is cautiously excited. "That's great, Gail. You still need to tell Gary, right?"

Good thing Jeff and Kevin will be in bed before Gary gets home tonight. I want to be the one to tell him, not our sons. Surprisingly, he is subdued but not against the idea. "If this will help you to be happy, go ahead and try it," Gary says.

It cannot be a coincidence that my confidence is growing stronger by the day. I am now journaling almost every day, a

strategy that is both therapeutic and enlightening. I'm beginning to observe a definitive connection between prayers and progress. Hope and health. Gratitude vs despair.

Having a goal, no matter how long it will take to achieve, provides a light at the end of a dark tunnel.

My job is great and provides an outlet for my pent-up energy. My two bosses quickly become friends, and we enjoy a casual lunch together in our office area most days. I imagine some of our conversations would be considered "unprofessional" to some, but the three of us soon became very comfortable with each other. Fred is a life-long Penn State Football fan and thinks Coach Paterno walks on water. He has a Penn State room at his house where he watches the games religiously. Nobody is allowed to talk to him during the games. Al is invited over once, but never again. Interestingly enough, I am never invited into the inner sanctum. I understand.

Except for the assigned task of "monitoring" the computer lab for the last hour of the day, I am more than up to the responsibilities. Computers are still an enigma to me. I soon learn to rely on the students to help each other, a very valuable lesson. I cannot imagine being able to get comfortable with these machines.

Life in our family returns to autopilot. Gary works. Jeff and Kevin rapidly prove that they are capable of catching up to their grade level. Our friendships have re-blossomed as if waking up from hibernation. Pizza night and The Waltons with Mary each week are back in our weekly schedule.

Dare I say it out loud? "I have not been this content in years." With or without the mask.

Some days I can even go hours showing my real face to the world.

At the beginning of summer 1987, I realize we have been back for one year. 52 weeks is 52 weeks, right? Wrong! A year in Baton Rouge felt like a lifetime. This year has provided a pep in my step. I'm leaning into optimism, instead of dread.

The boys are happier, too. They are growing taller and looking healthier. They play all over the neighborhood, until the universal signal to go home: the streetlights come on. Baths, books, then bed. Kisses goodnight from me, and sometimes Gary manages to get home in time, too.

An interesting phenomenon develops whenever Gary is home. I doubt whether he realizes it, but now his presence sometimes upsets the balance. Oh, Jeff and Kevin still love playing with Daddy, but now they easily find substitutes. Older

brothers or dads of their friends, or uncles and cousins provide more than sufficient distraction. It's sad to watch but seems like a natural consequence.

Declaring to myself the inevitable slow death of my marriage has opened a release valve on my anxiety. Yes, the bottle of Clonazepam is safely up in the medicine cabinet, but there has been no need. No longer intimidated by socializing without Gary, I am even feeling my naturally flirtatious personality coming out of hibernation, whether Gary happens to be there or not. A confidence gained by interacting with adults blooms within.

I am enough. I am deserving. I am not isolated.

Which is why when we have the inevitable two blips on the radar, neither one causes total panic. My support system is close by to help in any way they are needed.

Gary is leaving us! He and a few members of his work group have agreed to go to Oswego, New York for a temporary assignment. "Oswherego?" I sarcastically reply, celebrating in my heart at how good that feels. At the same time, I ask, "When do you leave?" Gary states, "The families do not have to go." Ha! It seems that Stone and Webster made some changes to their policies. Smart move after learning that Baton Rouge was

basically a disaster for many of the families involved. I quietly sit down to at least listen to the details.

"Oswego is in upstate western New York. We will be working at the Oswego Power and Light plant. The contract says 6 months, but it might be longer. Located on the shores of Lake Ontario, it is considered one of the coldest places in the US and claims more bars per square mile than any other state."

I can't help it. "Is that why the families are not required to go this time?" Met with an eye roll, I can tell there is no laughing allowed.

"Me and three other guys are leaving in two weeks. We will rent a two-bedroom mobile home together, and drive home together for a weekend every other week. We will mostly be eating, working, and sleeping. And of course, making lots of money."

Thank you, Stone and Webster, for saving me from shouting, "Hell no!" Instead, I quietly reply, "Well, we'll miss you, but we will do the best we can. Mary and Frank are close by, and they will help. Maybe the boys and I can come visit in August, before school starts."

The second blip reappears on the base of my spine. My pilonidal cyst has shown up at the same time as my period for the

last three months. Even though the surgeon still adamantly says there is "no connection between the two cycles," he agrees it now "interferes with my everyday life." Surgery to excise the cyst is scheduled for two weeks from now, after this latest prescription of Keflex clears up the infection.

Of course, Gary leaves as scheduled.

Mary will be my Earth Angel once again.

"Plan on healing to take about four weeks," the surgeon advised. We all know I am not "normal," so in reality, it will take me until November, 16+ weeks, to be completely healed. When I first wake up in recovery, they tell me that my cyst had grown quite large over the years, and during surgery they decided the wound would need to heal from the inside out. "Really, God?" Humorously, when I wake up in my room, lying on my stomach, our best buddy Big John, the foosball guy, is sitting in the chair next to my bed. He shares his big smile with me, and proudly says, "Glad to see your eyes open. I brought you a cheese-steak sub for when you get hungry. And there's a joint in the bag. Don't throw it away." In the hospital? A cheese steak and a joint. Guess it's an improvement over the big rubber tree plant he brought after I had my tubes tied. Oh, it hurts to laugh, but he was just that kind of friend! An angel in disguise. How sweet.

So, I spend my summer break "sitting" on fluffy pillows, alternating cheeks, preferably leaning or laying down! Twice weekly visits to the doctors, to keep the wound clean and cauterized, are chauffeured by Mary.

By the end of August, it feels good enough for us to go visit Gary in Oswego, NY! He has only made it home twice since the surgery, so he has been far removed from the circumstances. But he wants to see us, and the boys need to see him. To say the drive is a "pain in my ass" is an understatement. We do have fun, though. It is beautiful there, especially at the end of the summer. Greens and blues of all shades.

Our side trip to Thousand Islands, across Lake Ontario, provides memories that I am sure will stay with us for a long time. The drive north along the scenic St. Lawrence River is jaw dropping. The coolest part is the narrated ferry ride among many of the islands, stopping periodically to walk around some of the big mansions built on these little islands. We are all glad that we had that vacation time together.

School starts back up, with our growing boys now in grades 3 and 5. I am back at the high school in the Math and Science office. Still needing to go to the surgeon's office once a

week, I "sneak" there during my lunch hour. My bosses are really good guys.

During this fall semester, being more relaxed, I venture out and about the school more often. It is these walks that provide the opportunity for me to stand outside the classroom doors and listen to teachers teach. My two favorites are Mr. C, a history teacher, and Mrs. W. who teaches English. They fascinate me and hold my attention just listening. They become the first people to light the pilot smoldering inside me.

Maybe I could get a teaching degree. That's what I have always wanted to be. Is it too late for that dream to come true?

Both Fred and Al catch me in the hallway listening to teachers, which leads to lunch conversations about my future. "It didn't take us long to realize you are smarter than the average user of the copy machines. You are definitely smarter than many of the teachers in this building. The students in the lab rave about the respect you give them. You should be teaching, not settling for secretary wages. Come on, go for it."

The feeling that begins to infiltrate my doubts is self-confidence. It feels good! These two unassuming guys, who randomly became a part of my life just one year ago, see me. Not the wife of Gary, who they have not yet even met. Not just Jeff

and Kevin's mommy, but the me who has been in hibernation for years. God bless them.

Hmmmmnn. My thoughts begin to focus on my future as if going to college is just a matter of when, not if. Elementary school or secondary level? I will have to teach math and science if I choose the elementary path. Would I rather teach children to read, or teach teenagers to discuss what they just read? Teach how to write, or how to use writing to express yourself in a meaningful way?

Exciting thoughts whirling around inside my head are much more favorable than the dark thoughts of the past.

Gary comes home for a few days during Christmas break, and our house is filled with family. December 27 is my Pop-Pop's 80th birthday and I have planned a celebration fitting the occasion. All my side of the family is gathering at our house for drinks, hors d'oeuvres, and then dinner at a fancy restaurant. We commemorate the occasion with family photos, big smiles on everyone's faces. Making meaningful memories to last a lifetime.

January brings back to school for the three of us and Gary has to spend one more month in Oswego. After that, he will return to the home office for a while.

No big deal anymore. We are all secure in our routine. Routine can be good.

Until the unexpected happens.

If you've been following this story closely, you are probably expecting the unexpected, but I was not paying attention. Repetitive, ordinary days tend to lull you into complacency.

Without noticing, we are getting close to being home for two years.

It is during a Valentine's Day "romantic" dinner that Gary shares the news with me. He really doesn't see the irony. At least he seems a little more hesitant this time. "Gail, I need to tell you something, but I hope it doesn't upset you. Stone and Webster has asked quite a few of us to move to Texas for a long-term job that may become permanent. This time we will have to sell the house, as we are most likely not coming back. Like before, the company will handle everything, including putting us up in a hotel while we look around the area. The Comanche Peak Nuclear Plant is in Glen Rose, TX, but there are multiple towns we could live in. We just need to pack our personal stuff, and head down there. I am due to report by March 15th."

Stone and Webster's solution to 'stress free' moving! Little or no consideration to how disruptive it can be to the family.

Even though I am once again taken by surprise at this latest offer, this time I am ready with an answer. "What an exciting opportunity that sounds like, Gary, for all of us. But this time I really do not want to go. I like my job, the neighborhood, and our friends. And if I don't go, the boys should stay here, too." Gary's face looks twisted at my declaration, but I pull up every ounce of courage to maintain my stance.

"As a matter of fact, I am even willing to consider going with you, if you will agree it is finally time for me to go to college. Full time."

I said it! No tears, no hesitation. Oh my God. Now what? Not sure if I have ever seen that expression on Gary's face before.

I readily acknowledge it could play out in a few different ways. Gary could say "No," to the transfer and take his chances staying in New Jersey with Stone and Webster. He could blatantly ignore my request and continue to make the plans for us all to move, again. He could outright say, "No, I have not changed my mind about handing you money to go to college, so maybe it is

time for us to unofficially split up. I'll move to Texas, and you and the boys stay here."

Or he could agree to my proposal, and we all move to TX.

"Gary, it is not my goal to divide our family in two. The boys miss you each time you leave. But I really feel that it is time for me to be able to start working on a degree. Please take a little time to think about it."

The next day, a beautiful sunny but cold Sunday in Turnersville NJ, Gary's answer is the one I have been waiting to hear for a long time. "Okay, Gail. Let's move our family to TX, all four of us. When we are settled, then you may start to look around for local colleges. You seem to have thought about this for a long time. I hope we can make it work."

It's not easy to render me speechless, but his answer does. After taking a few minutes to process what an important step this move will bring, I wrap my arms around him and tightly hug his neck.

Texas, here we come.

Once again, Gary and I are going to drive to Texas, the boys are going to stay with their Nanny and Pop Pop, and their

Aunt Pam and Larry, in Florida, and our family will reunite in Texas on March 8, 1987.

Goodbyes are much more difficult this time! Our friends host a goodbye party, complete with a big, beautiful cake. The message on the cake reads, "Goodbye Gary. We'll miss you, Gail." Freudian slip? We cover it with laughter.

Fred and Al have mixed feelings when I share the news, yet both remind me to be sure to remain focused on my future. On my last day in the office that has been the setting for our brief, but life changing friendship, we share hugs goodbye. "I will never be able to thank the two of you enough for taking a chance with me two years ago. I leave here a much stronger woman than the one who came for the interview. For that, I will be forever grateful."

There are not enough hugs to share with Mary and Frank to make leaving easier. I know we will see them again, but it will never be the same for me or Jeff and Kevin.

Dear Fred and Al,

Thank you both so much for all the encouraging words you poured into me. I know I said those same words to you 35 years ago. However, we could never have imagined then just how far your advocacy would carry me. A simple thank you does not suffice.

Something powerful happened when I walked into that office. You didn't know it, but I was beginning my adult life. Successfully navigating the process, holding my own in the conversations, were lightning-bolt moments. I was boosted even higher when you <u>both</u> offered me the position on the spot.

You believed in me from the beginning.

You life-coached me before it was even a thing!

You treated me as an equal.

We became friends through our lunches, packed with good conversations. Unless the subjects were math or science, you showed respect for my answers.

Eventually, I trusted you to know me without my mask, though in all our conversations, I never broached "that" subject.

After our move, we all sadly lost touch. Social media had not been conceived yet. Yet, you remain in my heart to this day. Especially on Penn State football days.

I wonder if your obsession survived the betrayal of Coach Paterno.

Six months after we arrived in Texas, I enrolled for the fall 1987 semester at Tarleton State University. It is a small college, but well respected due to being a branch of Texas A&M. My commute was 45 minutes each way! Funny statistic: I drove my Dodge Omni 131,00 miles to get my degree. I graduated Summa Cum Laude with a Bachelor's degree in English $4\frac{1}{2}$ years later. Thanks to a reference from a good friend, I was hired immediately to teach Secondary English, Speech, and Theatre Arts at Brock High School.

It was the beginning of an amazing career educating young adults to the best of my ability. I am forever indebted to you both for your loving push.

Blessings and love,

Gail

End of Part II

Chapter 16
1987

"For I know the plans I have for you, declares the Lord, plans to prosper you and not to harm you, plans to give you hope and a future." Jeremiah 29:11

"Where are the tumbleweeds? We drove past the 'Welcome to Texas' billboard a few miles ago. So, where are the damn tumbleweeds?" I repeat. That is about all I really know about Texas. Oh, and the TV show *Dallas*.

It's been a long 24-hour drive that takes us four days to make. Most of the time we are quiet, listening to music, enjoying the scenery. As we drive across the state line in Texarkana, it suddenly becomes real. I wonder what Gary is thinking? If he asks me, would I tell him the truth? "Well, since you asked, I am thinking about what my life will be like after I graduate from college." No way; not yet. So, I simply say, "Surely Texas has to be better than Baton Rouge. Right?" I have been thinking about it for miles.

After glancing at me, with a little smile on his face, Gary answers, "Well, for me, one nuclear plant looks the same as another, once you are inside the gate. Same work, different location. But a couple of guys have been down here for a few weeks already, and they like it. So, maybe that's a good sign. I sure didn't imagine working at nuclear power plants when Dana suggested I study drafting. But I am glad I listened to him."

I have this tingling feeling inside, kind of a mix of excitement, fear, and curiosity. I am not reacting to this move the same way I did with the previous one. Yes, it is sad to say goodbye, but I am not feeling overwhelmed by it. This time I have a dream, one that I hope to turn into a plan as soon as we get settled.

These days ahead are going to be filled with new adventures.

Of course, the first few weeks zoom by at a furious pace. In the brief time we have before the boys arrive from Florida, we choose Granbury as our new home. It's the second closest town to Gary's new workplace, and when we explore around we seem to check off most of the boxes on our list of needs. It's one of many beautiful towns we check out, but this one has the bonus of a man-made lake. I quietly investigate nearby colleges when I

stop by the little information center, housed in the original jail building for Hood County.

"Why yes, honey, we sure enough do have some colleges close by. You betcha!" says a local woman. "Tarleton State University is about forty miles down the road that-a-way, and Weatherford Community College is thirty miles the other. You planning on going to college, sweetheart?" The smile on my face is 100% real. This is definitely going to be interesting.

We rent a two-bedroom condo at the Plantation Inn on Lake Granbury for our first month, courtesy of Stone and Webster's moving plan. Jeff and Kevin will love it - pool, free donuts every morning, and Lake Granbury is right out back.

Early on Saturday, March 8, 1987, we pick the boys up at the Dallas-Fort Worth Airport, and drive through Fort Worth on the way back to Granbury. Just enough time to let Jeff and Kevin run around the cool Water Park downtown. We'll be back.

We have an appointment with our new realtor for noon at Rinky-Tinks Ice Cream Parlor on the Square in Granbury. Sure sounds like something one would do in Texas! Old fashioned twirling stools at the counter, and formica tabletops. Fried-on-the-grill hamburgers and freshly cut French fries. Plus, milkshakes with real whipped cream. "Look at that poster, Gary,

for Saturday night 'Pickin' and Grinnin' jam sessions. Maybe I could play my guitar some Saturday evening?" Hey, at least I get a grin from Gary in response.

We are going house shopping after lunch at Rinky-Tinks. I just love saying that name.

We start with a few older houses in town, and then start moving out to the surrounding neighborhoods. Houses in Texas are mostly one story, as the heat rises to the second stories. Big, steep roof lines, too. The first few we look at are doable, but nothing special. "Let's take a little drive to a beautiful area called Pecan (pah-con, not pee-can) Plantation," Carol suggests. "I believe I have just the house for you. Still Granbury school district, just a little farther out in the country."

Now, in 1987, the idea of gated communities has not caught on yet, especially in the Northeast. So, when Carol pulls up to the little white gate house, and the guard comes out to greet her, all four of us are staring in disbelief. I am thinking, "La, dee dah!" I thought Gary talked with her about our financial situation on the phone. Far be it from me to get involved in 'his' money conversations. Seriously, this place looks very expensive. Once the gate guard lets us pass, Carol drives us down this winding parkway with huge green grass lawns on either side. She slows

down as we cross over the Brazos (braz-us, not bratz-os) River - "The same Brazos River in the Lonesome Dove book?" I ask. Holy cow! Next, we turn right at a small traffic circle and in a few minutes pull up to an "Orange Castle," sitting up on a little hill. The boys are saying, "Wow, cool!" Gary is looking out the back window with a blank look on his face, and I am moaning out loud, "Oh, why did you bring us here? No way can we afford this house."

"Why doll, you surely can. Your money goes a lot further down here than it does in the North. Now, come on. You're fixin' to find out."

I quickly realize that we are all going to have to learn how to speak Texan. "Riiight quick now, ya hear?"

The size of our home has grown proportionally to the size of our family over the years, but this house is ridiculous. The outside is a combination of rusty orange stucco and bricks, with a dark peach color effect. From the walkway, up the stairs to the hand carved front door, and into the foyer, each area is first class. Glass windows and doors everywhere, custom woodwork, and a rock fireplace greet us as we stand in stunned stillness in the entry hall.

As soon as Carol encourages us to walk around at our own pace, I grab Gary's arm, and assertively whisper, "No way can we afford a house like this. Are you sure you told her our budget?" In the meantime, the guys have already found their bedrooms, plural, and a big bathroom down the front hallway.

There's that little grin again on Gary's face. Is he feeling proud that he will be able to buy this house for us? Is this what he has been working toward all these years? "I asked her to only show us places that were within our range, for both a down payment and mortgage. Don't worry about it. Just enjoy looking around."

The brief twinge I feel realizing how little I really do know about our finances gets temporarily pushed down. Each room of this house is simply spectacular. Twice as big as the blue house. The clincher for me is when Carol shows me this little secret room upstairs in the attic. It is a ready-made she-study for a mom who is going to college. Big enough for a desk and a reading chair, paneled and carpeted already. Quiet. Sold!

We all really like this house, and this neighborhood, even before Carol drives us to the "Clubhouse."

Jeff says, "Swimming pool! Tennis courts!"

Kevin, his shadow, follows up with, "Wow!"

Gary is staring at all the golf carts parked by a putting green.

Me, I am trying to imagine the Nolan family living a country club lifestyle.

We are definitely not in New Jersey anymore.

We make an offer on the orange house the next day, and it is accepted immediately. During the process, I am afforded my first real glimpse into our current finances, and an immediate sense of gratitude for Gary's work ethic floods my heart. Our tiny first house, the red one, cost $28,000. This third one, the orange mansion, $120,000. The feeling is bittersweet, though, knowing what we both sacrificed in order to provide for our family.

When I have a minute alone, a wave of self-disgust floods my heart. How could I have allowed myself to remain ignorant of our financial situation? So what if Gary got upset? Look at the result of my passivity. What a doormat. I actually feel angry realizing we had the money for me to go to college while in New Jersey. I continue my little pity-party; wondering what could have been will haunt me for a little while. But soon it will serve to fuel my determination even more. *I will forever wonder what difference real communication would have made.*

With a future address nailed down, now we can enroll the boys in their schools. Jeff will go to Granbury Intermediate to finish out the 5th grade, and Kevin will attend 3rd grade at Acton Elementary. When we move into the house, they will ride the same bus. While we are waiting to close, they each have their warm glazed donuts from the front office every morning. Then Jeff is picked up at the hotel, and I drive Kevin to school each day.

Not a bad life so far.

On the first day Gary goes back to work, and the guys go to their new schools, I drive out to our new neighborhood just to nose around some more. The gate guard has to call Carol to get permission for me to enter Pecan Plantation. Whoops - didn't expect that. Red faced with embarrassment, I wave to the guard, and enter the gated community where we will make our next home. Holy shit!

An hour later, I am still driving around in there, lost as can be. I can imagine the headline in the local Granbury paper: "Yankee woman gets lost in new neighborhood, never to be seen again." On the brink of panic, I eventually stumble across the clubhouse.

Cool! They have brochures with a map at the desk in the lobby. With great relief, I manage to make my way back to downtown Granbury and the Plantation Inn. It is only when I get a minute to read the brochure that I realize we are buying a house on a working pecan farm. The farm is in the middle, and the houses are being built around the perimeter. As Kevin says, "Wow!" I say, "Holy shit" again!

On my next available day to explore, I proactively get an area map and then head for Tarleton State University in Stephenville. It's a pretty straight shot southwest on State Highway 377, which runs from Fort Worth, cuts through Granbury, and on to Stephenville. The 40-minute drive is enjoyable with lots of new Texas scenery to check out.

The first walk across the campus, finding my way to the Registrar's office, is surreal.

It is 1987, 15 years after high school graduation; married 13 years, two amazing sons; I have had the inner desire to go to college for 10+ years.

The 'witching' hour is finally here, ready or not.

"Lord, do not be far from me. You are my strength; come quickly to help me." Psalm 22:19

"I would like to speak to someone about enrolling for classes in the fall of '87," barely squeaks out of my mouth, even though I am 33 years old.

I have taken one giant step into my future.

Our first summer at Pecan Plantation is better than anything any of us could have imagined. Swimming, rafting on the Brazos River, beginner tennis lessons, and the Teen Room at the clubhouse. Thankfully, the snack bar/Teen Room is very generous with their age-allowed policy, as long as one behaves. For the first month, I hang out by the pool to be close to the boys, just in case. It only takes a couple of weeks for them to make friends, and Mommy's presence becomes superfluous. Both Jeff, almost 12, and Kevin 9, are growing up.

When September rolls around, it brings new challenges to our household. All four of us need to be up and at 'em early in the mornings. Gary leaves first for Comanche Peak Nuclear Plant, followed by Jeff and Kevin on the bus, and I drive to classes in Stephenville three days a week. Once again, we fall easily into the familiar routine: Gary works long days, and I handle the rest. Only now, I am a full-time (16 hours) college student, not just a wife and mom.

It doesn't take long for the mask to return to my face. There cannot be even a hint that I am overwhelmed. After dreaming of this for so long, I will not fail. I will figure out how to be all that I need to be.

The anxiety and doubts and "trudging through molasses" existence slowly creeps back in. Why did I take a full load of classes my first semester? I still have two sons who need their mom. Waiting for my first writing assignment in English Composition 101 to be graded and returned is tortuous. What if I can't write? Or worse, what if I have forgotten how to study? Thankfully, my descriptive essay of experiencing a hurricane at Sea Isle City earns a B+ from the professor. It's followed by a B on my World History quiz.

At least I am able to breathe again and enjoy the opportunity to learn. I love it.

As my first semester of college approaches exam time, it's going to take much more than just breathing to successfully make it to Christmas!

My younger classmates show me how to calculate the grade I need to "make at least an 80" for my semester grade. I feel secure in four of my five classes. Having been born with a

missing chromosome for math, the Algebra professor and I have spent many hours doing my homework in his office.

The first time I visit his office, after just three class meetings, I hesitate outside the open door. Before I can say, "Good afternoon, Professor," he says, "Well, hello Ms. Nolan. I thought I might be seeing you soon! You looked pretty shell-shocked when I said 'turn to chapter 7' on the first day of class." Not anywhere close to the stern tone he uses in his teacher mode. "Come in. Sit down. How can I help you?"

"Well, since you asked," I reply with a nervous smile, "I seriously struggled with Algebra in high school, so I began your class with a built-in fear of failure. I cannot fail. Would it be acceptable if I come to you when I need extra help?"

Smiling, he teases, "Your sense of confusion is written all over your face during class. Of course, I will help when I can. In addition, there is a math lab on campus with free tutoring available. Let's start with a few problems from today's lesson."

Definitely a bonus for choosing a small university, as access to professors tends to be easier. I immediately press save in my new mental file for 'Teaching Tips': Be available for extra help if and when a student asks. In addition, I will not be hesitant

to meet with many other professors throughout my college career. It's a very valuable lesson in many ways.

In spite of this extra tutoring, as I enter the classroom on exam day, it is still mathematically impossible for me to get even an 80! So, the hope is to at least pass the class with a 70. "Why does an English teacher even need Algebra I on their transcript?" I might have whined to the registrar four months ago. On exam day, I enter the classroom with dread, anxiety, and not an ounce of optimism. However, I do have homemade chocolate chip cookies in my book bag to drop off at Professor B's office to at least say one last 'Thank you'.

Based on my gut feeling after the exam, I anticipate a failing grade. Time to give it the 'old college try' to bribe him with cookies and a promise. And say thank you.

"If you just give me a 70, I promise to never help my students with any type of math problems." He smiles, taking a bite of my chocolate chip cookie. I smile, and we wish each other well.

At the end of the next week, I am glancing through the mail and spy my first report card from Tarleton State University. Shaking hands make it both difficult to open and hard to read! Sitting down on the front steps, I exclaim, "Two As, two Bs, and

one C. Ahhhh, Professor B, you found the two points I needed. Thank you so much. I will never forget you."

Multiple generations of the Frankel family descend on the Nolan "Orange House" for Christmas. Emotionally and physically exhausted, the mask is firmly in place for their visit. To do otherwise would be unfair to the celebration. I can just imagine what would happen if I just sit down in the middle of the living room and start crying. Not going to happen. There is a popular hit song, Bobby McFerrin's song *Don't Worry, Be Happy,* being played on every radio station. Seems like as good a mantra as any.

Everyone falls in love with our new house, our new neighborhood, and Granbury. The Pecan Plantation clubhouse even has inexpensive hotel rooms, available for members, on the second floor. God bless the person who thought of that. Definitely a life saver for multiple reasons.

On Christmas Eve, most of us decide to attend the Candlelight Service at First Presbyterian Church in Granbury. We are new members of this loving congregation and enjoy our developing friendships among the young adult group. The service is resplendent with decorations, music, and spectacular lighting of candles in the darkened sanctuary, while singing Silent Night.

We all leave in silence, filled with the magic of Christmas, and return to our house for a late-night snack before bed.

My younger brother Bill, and his sweet, newly engaged fiancé Leslie, ask to talk with me privately, as soon as we each have a drink in our hands. Hmmnnn? While the three of us are sitting on my bed, Bill asks, "We would like to get married in Granbury, at First Presbyterian Church. Would you help us make that happen this April? We love everything about it - Rev. Paschal, the beautiful historical church building, the town, everything."

My mind is screaming No! You cannot handle this on top of everything else. Of course, my answer is, "Yes, absolutely, positively yes."

Mom, college student, wife, and wedding planner. What could go wrong?

Before the family finally heads home to their respective states, my daddy invites me to come up to the clubhouse to visit with him. Pre-conditioning fills me with unease. One-on-one talks with Daddy are infrequent and intimidating. He meets me in the lobby and suggests we sit in the gazebo out back, which overlooks the scenic Brazos River. "Breathe," is my mantra of the moment.

The air in my lungs gets even thinner when I hear a thickness in my stoic daddy's voice. "Your mother and I are very proud of you for finding the courage to begin college. I am also impressed with how well you did in your classes. I know you didn't quite make the Dean's list, but you have shown me that you are serious about your studies. Your Pop Pop Frankel and I would like to offer to pay for your tuition fees and books for Tarleton, as long as you continue to get As and Bs. Kind of like paying a dollar for good report cards when you all were little, only a little more expensive. We are all very proud of you," he says with tears in his eyes and a big smile on his face.

Good thing I am sitting down. First of all, this is by far the longest speech I have ever heard my father give. Second of all, this generous gift will ensure my financial needs for school are met, without depending on Gary. Hallelujah, Merry Christmas, and Happy New Year! "Thank you, Daddy. I will make you and Pop Pop proud. I love you."

The long bear-type hug we share is a rarity, and one I know I shall never forget. The Christmas gift of my life comes from my dad and his dad. It has no need to be gift wrapped and placed under the tree. It is priceless.

Dear Professor B,

Thank you so much for the compassion you showed me that semester. I came by to see you when the next semester began, but you had gone back into retirement. Hope I didn't affect your decision! I never forgot you and shared the story of our time together to countless high school students.

On that first day of class, you immediately let us know you were a retired math professor who agreed to come back to teach just for this semester. I remember thinking, "Is that a good thing, or a bad thing?" You seemed kind of resentful. Your very first instruction to twenty-nine 18-year-olds, and one 33-year-old was, "Open the textbook to Chapter 8."

My question involuntarily flew out of my astonished mouth, "What happened to Chapters 1-7? With a straight face, you replied matter-of-factly, "Well, young lady, you passed the pre-test" and continued right along. There went my goal of keeping a low profile!

Never once do I recall you rolling your eyes when I showed up at your office hours. Never once were you too busy. You always just pushed aside what you were

doing, invited me to sit opposite you, and retaught me until I "got it!"

Your kindness affected my career in education way more than Algebra ever did. That 70 you entered in the grade book as my final grade has remained in my heart. You taught me the most profound side of numbers. Sometimes the absolute numbers deserve to be given "human consideration" between a 68 and a 70. Two points in the grade book really can be life changing.

Forever grateful,

Dorothy Gail Nolan

PS. I kept my promise. I never helped any of my students with their math problems. And I always explained why.

Chapter 17
1988-1991

"It's never too late to be what you might've been." George Eliot

January 1988 begins semester two of my freshman year. Our routine is fine-tuned by now, so I just press the repeat button. Gary works, Gail handles the rest, including long distance wedding planning way before email became a household thing. It helps that my brother has said, "Whatever you do will be great." I admit to sometimes just making the decisions to "get it done."

The wedding, on a glorious sun-shining Saturday in April, turns out "just the way we wanted," gush the happy Bride and Groom. "Thank you for your beautiful singing of the *Lord's Prayer*." All the additional stress just fades away when I see the looks of love on their faces.

"Just wait until you see dazzling decorations for the reception in the ballroom of Pecan Plantation," I reply with pride. "It's going to blow your minds." Since family on both sides are in town, we fill up the tables and the dance floor with happy people. Even Jeff and Kevin give it a thumbs-up! Since we have

all the second-floor hotel rooms booked again, most people do not have far to go when the party's over.

When I finally lay my head down on my pillow, I cross this major, but love-filled, chore off my mental list. All was a success! I fall asleep feeling a tired type of good.

And then, before I know it, the Sunday morning sun is shining in the windows.

The ringing telephone wakes me, and I hear my mom's voice asking, "Dorothy Gail, are you still coming to pick us up for church? It's getting late." It's Sunday morning and Confirmation Day for Jeff and Kevin at First Presbyterian. It is also the first day of Daylight Savings time. After reminding everyone multiple times yesterday to set their clocks ahead one hour so we're not late for church, I neglect to change mine before falling asleep. Oh my gosh.

Like a whirling dervish, I manage to get the boys into their church clothes, myself into my church clothes, and Gary, who can dress himself, herds us into the car. We swing by to pick up Mom at the clubhouse and she calmly states, "Your dad is feeling a little under the weather this morning," as she gets into the car. That's it. Off we speed down the road, getting to church with minutes to spare, and we fill up our pew just in time. What a joy to see our

two handsome young men confirmed by Rev. Elisha Paschal as full members of First Presbyterian Church.

A very poignant moment for both current members, and past generations, of my family.

Two hours later, when Gary pulls up to the clubhouse to drop my mom off, she sits still for a rare minute before getting out of the car. "I need to tell you; your dad had an emergency late last night in the hotel bathroom. He banged his big toe in the dark. It would not stop bleeding, so the Pecan Plantation EMTs took him to the hospital, got him bandaged up, and brought him back here. He'll be fine. Just a little sore, and very tired. I didn't want to tell you earlier and mess up the morning plans."

At this moment, I have no filter. "Oh my God. Is that normal? To come halfway across the country for a family wedding, Dad injures his foot, and you don't say anything to anyone until hours later? Multiple family members were sleeping nearby who would have helped you, Mom. Sometimes real life gets messy." By then, Gary has squeezed all the feeling out of my hand, trying to signal me to be quiet. I sit and breathe while he goes inside the clubhouse with Mom to check on Dad.

Life goes on uninterrupted in spite of death, or bloody feet? Seems so familiar, but no easier to deal with than it was almost 20 years ago.

Thank goodness the family gathering ends the next day. I need them all to go home. I have a semester to finish, and my little family to take care of. No strength for any more extra disturbances.

Life will continue to place obstacles in all our paths the next four years. For the Nolans and the Frankels, it's life in action.

I continue to have multiple roller-coaster moments with my emotional health. In and out of brief episodes of melancholy. Luckily, I rarely tumble completely down the "rabbit hole." No way do I want to miss class. When I do lose my cool with seemingly unexplained outbursts of anger, it's Jeff or Kevin who notice.

For example, when my carefully constructed timetable is "blown to hell" by Jeff, my overreaction scares us all. It's just not cool to follow right behind the school bus for a few miles, after he forgets I am picking him up after school for a dentist appointment. It's not okay to be ranting and raving out loud to myself while the kids are watching out the back bus windows. And it is really poor parenting to pull into our driveway, jump out of the car, and scream like a wild woman at Jeff for "ruining my life" because he forgot. *Damn, I am so sorry, Jeff.*

This unanimously earns me a doctor visit, rightly so. However, the behavior is misdiagnosed as "female hormone issues" officially by the doctors, and casually by Gary. Of course, I do not tell the doctor the truth. So, the hormone therapy he prescribes just makes me even more jumpy.

I stop taking the meds really quickly.

How could anyone be expected to correctly diagnose if the patient never tells the truth?

I do begin to learn the value of "going to my room" for quiet and recovery. It seems to be acceptable for me to do that since my desk is there. I set up a little area for a study in the corner of the bedroom. There is a poster of a red Porsche roadster on the wall above my head. A girl can dream big, right?

By the way, that perfect little she-study up the stairs is not meant to be, at least for me. There is electricity up there, but no air conditioner, and no ceiling fan. Too hot and stuffy for comfort. It will be perfect for the boys' train set at Christmas.

In October 1990, 30 months after Daddy's infamous toe injury, my Mom calls. The phone rings just as I am leaving to go "Christmas shopping with the girls" in Dallas.

"Honey, I just have to let you know that Dad had his leg amputated this morning. The wound on his toe suddenly turned

gangrenous." She says it in such an "Oh, by the way…" manner. Deep, sad sigh from me.

Shock hits me twice: once at her casualness of her telling me, second at the news about Daddy. I had even considered not answering the phone as I was a little late leaving. But I did answer.

Nothing else she says registers, even though I listen. When I hang up the phone, stunned, it is too late to call anyone and tell them I can't go on the shopping adventure (no cell phones!). So, I drive to the church, and climb quietly into the front seat of my best friend Cathy's SUV. Our other friends are already in the back. "Sorry I am late," I say with a quivering chin. It is a few miles up the road before Cathy quietly asks me, "Are you okay? You don't look so good."

My absolutely spontaneous response breaches my mask, just a little bit. With quiet tears, I reply, "My father had his leg amputated this morning. I just heard it from my mom before I left the house." Cathy is shocked, and soon everyone in the car knows what has happened. I spend the rest of the day surrounded by fog-filled love.

By Monday morning I am back, armed and ready to face the world. When the time is right, I will have to talk with Mom and Dad about this lack of sharing knowledge about their health.

It's not normal to call up and say, "By the way, your dad has his leg amputated," out of nowhere. But, for now, I must stay focused on my mission.

Two months later, on Christmas Eve, I am sitting by the Christmas display on the altar, playing my guitar and singing Christmas carols before the service. When I look up to make eye contact with those filling up the pews, I watch four men of the church carry my Daddy up the front steps of the building, in his wheelchair, just in time for the Candlelight Service to begin. My mom is right behind them, all dressed in her Scottish red plaid skirt for Christmas. No notice, no previous plan, just a last-minute visit to the Nolan family.

Is that normal? I love them both, but their behavior is oftentimes as suspect as mine.

Anyone who was there that night was a first-person witness to a medical miracle. My daddy went from gangrene in his foot, to amputation of his leg, to lighting my candle at the 1990 Candlelight Christmas Eve service in Granbury in two months.

Miracles are not normal.

A year later it feels like another small miracle is on the horizon. Ahhhhh. The goal that I declared in 1986 is about to be achieved. Today is the day.

Thanks to the Grace of God, the love and support of my family and friends like family, the understanding of our sons, the prayers of our friends from First Presbyterian Church, and sheer will and determination, my graduation day. The Frankel family will gather again, this time for another double celebration: commencement exercises and Christmas.

A few of us are battle weary, but not too tired to celebrate…

I have now driven 131,000 miles between Granbury and Stephenville, in my powder blue Dodge Omni, to earn my degree. Hours and hours of homework have been completed in the vicinity of soccer fields. Jeff and Kevin are now in the 9th and 7th grades.

Sunday mornings at church continue to be a blessing. The members have all become friends, some friends like family. Jeff, Kevin and I sing in the choir together, led by Cathy. I love having them there and being a part of the circle of friends we have made. Both boys' voices have changed during the last year, and they are probably thinking they are getting too "cool" to be in choir. However, they are surrounded by adults who really enjoy their

company, so they hear many comments about the joy of music vs the joys of soccer. When Dan Woods, a music teacher in a nearby town, joined the choir this fall, Cathy sat him down right in between those two rookie tenors. I love it. Dan seems to enjoy them, too.

During the next few months, while I am student teaching at Granbury High School, and Dan is teaching music at Brock, there are at least 7 members in the choir who are educators, or student teachers. It seems the moments before and after rehearsal are filled with teacher talk. I pick up many classroom management pointers from them. More importantly, I am encouraged to join in the discussions.

"Gail, is Tarleton teaching you about the Texas state exams, like TEAMS (Texas Educational Assessment of Minimum Skills) or the latest one, TAAS (Texas Assessment of Academic Skills)?" Dan asks.

"Yes, basically we have just been taught that the exams exist, and the subjects and grade levels they cover."

"Well, you are the most up to date. Please share your expertise. Talk to us. Those tests are going to become a huge part of your teaching experience," Dan continued, with a subtle boost-my-confidence smile.

It's one thing to share ideas with other students, but these friends are seasoned educators. It begins to feel like Dan is standing right behind me for support and encouragement. A discrete mentor at first, slowly breaking through some of my self-constructed barriers. Soon he becomes a valuable friend, who will venture out of both our comfort zones to help my professional future.

During all this time, Gary has continued to do what he does best - provide for our needs to be more than met. Wonderfully, he has added soccer coach to his list of duties, so he spends more time with the guys and their friends.

Graduation is a day-long celebration recognizing the achievement of my long-time goal. Friends and family both near and far, new and old, attend the ceremony at Tarleton. Sitting front-row in the side balcony is Daddy in his wheelchair, even though he now has a prosthetic leg. He, Mom, and the rest of my wonderful cheering section, are literally right above my head from my seat on the floor of the auditorium. Sadly, my Pop Pop Frankel died in the Fall of 1988, but he lived long enough to tell me he was proud of me.

Later that afternoon, we host a party at our home for friends and family. The joy that I feel could not have been more genuine. Everyone is happy for me. Including me! Even including

Gary, I think. He seems a little in awe of what I have actually accomplished. His card of congratulations, just tossed in the card basket, stings a little bit. "Congratulations. You are now qualified to pick your nose in public." I don't imagine he even notices my embarrassment as I read it out loud. Or sees his mother-in-law's eye roll, either.

But today, I am not going to give up my genuine joy.

I turned my dream into a declaration, then a goal, and today I earned my Summa Cum Laude BA in English diploma, with Secondary level teaching certification. In addition, I have earned the Robert O'Neil Student Teacher of the Semester, following my fall semester of student teaching at Granbury High School. I have been assured by the principal that I will be hired in the fall of 1992 for a full-time English position, and he suggests I be a full-time substitute for the remainder of this school year. My future is set.

On that day, at that party, filled with my husband and sons, family, friends like family, and church friends, still no one knows what feelings remain behind my mask.

No one but me knows what else I have been planning. And I am still not ready to tell. It's getting closer, but not yet.

Well, God knows the plans he has for me, of that I am sure. Only He could have arranged what will be the grandest God moment ever to occur in my life. Without a doubt. Only He could have placed two strangers' lives on paths that first intersected in the choir loft of First Presbyterian in the fall of 1990. "Dan Woods, meet Gail Nolan, who sings alto, and her two sons who will be in the tenor section with you," Cathy says.

"Hi, Dan. Welcome to First Presbyterian Church. We are glad to have you sing with us."

By the spring of 1991, my best friend Cathy, choir director at First Presbyterian, will move to Tulsa with her family. Dan Woods, an experienced music educator, becomes the new choir director.

If I was paying closer attention, I might have felt the earth under my feet beginning to move!

On Christmas Day, just one week after my graduation, I receive an out of the ordinary phone call from Dan. This tall handsome Texan, with a great Texas accent, and an even better smile, has become a good friend to me, and also to Jeff and Kevin, in the past year. He is married, but his wife Diana attends a different church. It was nice they both came to the party last week.

But rarely have we talked on the phone. Our interactions have pretty much been limited to choir rehearsals and Sunday services. "Hi, Gail. Merry Christmas. Sorry to intrude on your Christmas, but I want to tell you that Brock school district, where I teach music, needs an English teacher immediately. Starting this January. I know you said at your graduation party that you were going to sub at Granbury, hoping they will hire you in the fall. But this job is available right now, as a full-time teacher. You'll get a much higher salary than subbing, plus benefits, and credit for one whole year of teaching. That's what I did when I began my teaching career."

Catching my breath, my initial autoreply is, "Oh, Dan, thank you so much for thinking of me. But I really enjoyed student teaching at Granbury High."

Not taking my response as a "No," Dan suggests I at least think about it. "It's a really good opportunity. A small school where you could get your feet wet. Would it be okay if I give your name and number to Mr. Branch, the principal, and have him call you tomorrow? If you are even a little bit interested, then you can set up an interview. It can't hurt having a personal recommendation, right?"

Dan's charisma is infectious and shifts my resolve. "Okay, thanks, Dan. I really appreciate it. I'd be glad to at least talk with him. I'll keep you posted."

The interview takes place two days later. I arrive at Superintendent Cheek's office, across from the school building, dressed in my finest professional interview outfit, complete with heels. Mr. Cheek and Mr. Branch greet me dressed in farm-worthy blue jeans, flannel shirts and nasty boots. Welcome to the world of Brock Schools.

Being interviewed by Mr. Branch while he is perched on the corner of Mr. Cheek's desk, I feel like I will be able to hold my own with these two cowboys! "Call me Jimmy" looks to be about my age, dark hair and seems to fit the description of a "good ole boy!" He peppers his interview questions with personal questions, but not in an inappropriate way. More about my accent, and where did I live before Texas! Not sure which one of the three of us is having more fun listening to the contrasting accents. He sure eases the tension I felt when I walked in.

Mr. Cheek, the school Superintendent has the "final say." Sitting back and giving Mr. Branch the lead, he finally asks his first question, "Do you think you can teach Theater Arts? I see Speech classes but no Theater Arts on your transcript."

I feel comfortable enough to quip, "Well, I am dramatic!"

I am offered a teaching contract on the spot, based on my winning personality, my transcript, and Dan Woods' glowing recommendation.

These two men, who just hired me for my first teaching job, are well aware they just hired a Yankee to teach English to a bunch of country Texas teenagers. However, my parting words probably cause a moment of doubt. "I look forward to my first day at 'Braaaack.'" My Texas accent still needs a lot of work.

With priceless looks on both their faces, they reply in tandem, "It's Brock, like a bass frog! Maybe you should practice saying it."

Dear Daddy,

Thank you for the gift of education you and your father proffered to me twice. Once when I was too young and naive to appreciate the impact a degree would have on my future, and yet again when I was ready and determined to succeed.

You provided emotional motivation combined with secure financial support in one amazing moment. From the bottom of my heart, I am grateful.

Your presence at my graduation meant the world to me. It was a full-circle moment.

For as far back as I can remember, I yearned to climb onto "your chair" and just sit with you. You were already suffering from arthritis, diabetes, and other conditions before I was born. Mom's cautionary words - "Don't bump into Dad's sore feet. Be careful when you kiss Dad goodnight." - still echo in my memories. I really didn't weigh very much when I was little enough to fit in your chair with you. But I was too afraid of doing the wrong thing. It would be years before I understood the perpetual pain you suffered.

I yearned for years to take walks with you and have quiet conversations. Those times were mostly reserved for your "Annie", not for your youngest

daughter. My walks with Mom were enjoyable, but conversations were usually guided by her topics of choice. Phone calls too! Sometimes I couldn't even get my questions asked, much less answered.

The gratitude I feel even now for your generosity will remain in my heart always. The memories of the day you offered it to me continue to remain clear, even during foggy moments. Life changing moments tend to have that effect.

Upon reflection, it has occurred to me that maybe you felt my need, the purpose behind the determination. You expressed such pride in my short-term success. You waited until the end of your visit, observing evidence of my renewed sense of self-confidence. I especially love the way you found a way for us to be alone -no Gary, no Mom, just us.

I guess what I craved was unfettered access to your love. Those memories are scarce, and usually cluttered with other loud voices.

I have so many unanswered questions. How did you grieve for John, your first-born child? You must have, but your stoicism masked it well. Was it your decision for John's brother and sisters not to attend his funeral, or did you follow Mom's lead? Did you notice that I had

"disappeared" from the family too, for months following John's death?

Why didn't you ever open my bedroom door on the nights I had been sent from the table for crying? Just a smile from the doorway would have sufficed.

For years, I assumed that Mom was the genetic link to masking, but that you were the "silent enforcer." Could it have been the other way? I wonder...

Conversations matter, Daddy. So much so, that lives can be completely altered by truthful interchange. Or the complete absence of dialogue.

I continue to wonder what could have been if I would have just climbed onto your lap sometimes.

All my love,

Gail

Chapter 18
January - 1992

"Life is a circle. The end of one journey is the beginning of the next." Joseph Marshall III

On January 7, carpooling with Dan, Joe, and Kitty, Brock teachers from Granbury, I begin the first day of the rest of my life.

"Just remember you are smarter than all your students. And some of your colleagues and administrators, too!" Sounds like both great advice and a little bit of insight into Joe's philosophy. His voice is gruff, and no hint of a smile. His clothing is a clue, too. Khakis, button down shirt, and pocket protector with a pen and a pencil. A seasoned teacher, probably in his mid-50s.

Dan whispers, "He keeps control of his classroom by throwing erasers at students."

I am excited, scared, and definitely having a self-confidence crisis. Wonder if Joe even remembers his first day! I remind myself that I will be teaching classes filled with teenagers, the same age as Jeff and Kevin. No problem. I got this...

Tarleton emphasizes the viewpoint, "Never let them see you smile until December." But that is going to be impossible for me; my mask is still firmly in place. Not a problem. I am a master at using tone of voice for emphasis.

I choose to stand behind the following truism, believing that one "rule" would cover it all. "RESPECT: Give it, get it. Got it?"

Ready, set, here we go.

I may have been naive in my thinking on that first day, but I never abandoned that adage throughout my career. It remained my #1 rule. There were some classes when I first had to teach and model the concept of respect. Then, model the idea that those who respected me earned my respect in turn. Over the years, most adolescents "got it," eventually. Thankfully.

At noon, my friend Dan appears at the door of my very first classroom. At 6'3" his tall stature fills out the doorway. "Would you like me to walk you to the cafeteria?" Mr. Woods says with a smile. His soft Texan drawl somehow matches his relaxed stance as he leans on the doorframe, crossing his arms. "It's lunch time." His timing is perfect, and his manners are too.

"I was just getting ready to sit in my room, eat my peanut butter and jelly sandwich, and quietly breathe!" I respond as I pack up my lunch to follow him. "The morning has zoomed by,

peppered with multiple questions from the teenagers about where I am from. Hiding my accent is impossible."

As we are navigating the way across a small courtyard, he shares, "Free lunch for staff is one of Brock's best perks. Homemade by the amazing ladies in the kitchen. Real Southern cooking! Plus, once a week they whip up giant cinnamon rolls for a mid-morning snack. You'll know it's that day when the heavenly smell reaches your room." When we arrive at the "teachers' table," a group of about ten adults are chatting and laughing and enjoying their lunch break. Dan makes introductions all around the table, before he even sits down.

Wow. Isn't that nice. It feels good to be treated so respectfully. I greatly appreciate his gentlemanly attention.

My first day as an educator could not have gone any better. Soon, inevitably, reality rears its head.

"They did not teach this at Tarleton" quickly takes up residence in my brain. The first few days are chaotic, but all in all I hold my own.

Brock school district is very small, with approximately 100 students total in grades 7-12. My daily schedule includes four different levels of English, and two levels of Theater Arts. That's a lot of lesson planning for anyone to handle. That's an almost impossible task for a brand-new teacher with no prior resources.

Thank goodness for my teacher friends at Granbury High School, who provide samples of teacher editions from the book room, and lots of reassurance.

That's not what they teach in Education classes at Tarleton. "Go big," the professors say, referring to school size. "You'll teach 3-4 classes of the same curriculum. Easy breezy. One, two lesson plans at the most. The hardest part will be remembering if you said that already in an earlier class!"

"Baptism by fire" is how beginning teaching is described in Texas. It's going to be a wild ride. One I have been looking forward to experiencing for many years.

Week two brings reality right to my classroom door. Guess that's where a lot of business gets handled.

"Mrs. Nolan, I need you to speak at this afternoon's faculty meeting, please," relays Principal Branch from my doorway. "Just a few words about the importance of academics over athletics. You will bring a new perspective to the discussion. See you at 3:30 in the library." The time is currently 1:30, so not much time to prepare. Seems like a straightforward answer, right?

Walking into my first faculty meeting is intimidating, even when the faculty numbers are small. Being the only

'newbie', of course it feels like everyone is checking me out. Lots of new faces, but most seem to genuinely welcome me.

When called upon to speak, I stand up on shaky legs, look at a neutral spot over the heads of the faculty, and speak with a nervous voice, "While both athletics and academics encourage the development of discipline, hard work and determination, I believe schools should focus on education. Teaching higher order thinking skills that will help many of the students to lead successful adult lives. We should celebrate the academic achievers as we do the athletes. Physical education, and even competitive sports, can be undertaken by the local towns and communities. Then the money spent on athletics could be channeled to academics."

Making momentary eye contact, my eyes land on the 6'5" basketball coach in the back of the room. He is also my colleague in the English department. "Coach V" he said when he introduced himself last week. His face displays his obvious displeasure. A few others are grimacing. My embarrassment propels me out the door to the hallway, followed by tears.

What the heck just happened?

Mr. Branch follows me out, before I can get my mask in place. "Hey, why are you crying? It's okay. Come on back in. It's no big deal."

"Why were there so many startled faces? Great first impression," I sputter.

"Brock's basketball program is the reigning state champions and has been many times. Boys and girl's teams. They take sports very seriously in this town."

"They sure didn't teach me that at Tarleton," is my quiet reply.

Day by day, school is becoming less intimidating, and more a world of new experiences to embrace. Oh, there are many head-shaking moments when I wonder if I have chosen the right career, but I am still mastering the skills to think on my feet. Even Coach V, the basketball coach/English teacher, and I are slowly becoming friends and colleagues. We actually laugh together about the faculty meeting.

"Quite the first impression you made, Mrs. Nolan," Coach V says, with a smile. "Jimmy Branch has a reputation of getting others to do his dirty work."

"Well, I have a reputation of being naive, but I am rapidly growing out of that. Burn me once, right? I may be a late bloomer, but I'll catch up. Still, I'd appreciate any insight you care to share, Mr. V. Hoping we are going to enjoy working together."

"Looking forward to it. Extra points for collaboration on evaluations. Come by the gym anytime. Have you ever seen a 1-A basketball game? Nothing like it."

"Will do. I have already discovered that I will be teaching to the beat of the bouncing ball. It echoes through the walls of the practice gym. Great for poetry and Shakespeare. It's going to be fun," I reply with a smile.

They did not teach me this in Tarleton.

In the small world of Brock, I am beginning to fit in, and make new friends.

The high school Theater Arts class is expected to participate in the One Act Play competition this spring. My predecessor had already purchased the playbooks, so I am "stuck" with her selection: *The Gondoliers* by Gilbert and Sullivan. What the heck? With 10 students from little Brock, Texas in the class, why would anyone choose a Gilbert and Sullivan play? When I notice that the cast list, 5 males and 5 females, exactly matches the students in my class, I suspect that is why it was ordered. Probably had no idea of the story. Plus, it has music and dancing in it. Aren't there rules about that in OAP guidelines? Looking around to see if this is a TV moment of Candid Camera, I am about to either laugh or cry when I hear, "Maybe Mr. Woods will

help us. He's our choir teacher," spoken by one of the five girls in the class. "We'll ask him."

"Great idea, girls. But I'll ask him. He is my choir director at our church in Granbury, too."

Riding home in the carpool I casually broach the subject with Dan. "I have inherited the script for *The Gondoliers* for the One Act Play competition, and it has some singing and dancing in it. Would you be willing to help me with it? Please..." (with a real smile).

"Of course I'll help, Mrs. Nolan, whenever I am available." He's smiling, too! "Kind of a strange choice of play your predecessor ordered, but I'm not surprised! Just let me know when you are ready for my help."

"We're called gondolieri, but that's a vagary, it's quite honorary the trade that we ply." Gilbert and Sullivan

Chapter 19
January 1992 - March 1992

"Never give up, for that is just the place and time that the tide will turn." Harriet Beecher Stowe

As the month of January 1992 comes to an end, the days have flown by. School days followed by planning, grading, getting home to chauffeur the guys to soccer practice, or choir practice, dinner, bed, and doing it all over the next day. It's a blur, but we have made it.

Today, the last Friday of the month, is payday. "Call me Jimmy" Branch struts around to each teacher's classroom and hand-delivers pay envelopes. "Thank you, Mrs. Nolan," he says. Spontaneously I break into a subtle happy dance. This is a red-letter day. My first paycheck as a schoolteacher. A very momentous occasion.

I am still hyped-up when I jump into the back seat for the ride back to Granbury. Dan, (Mr. Woods when we are at school) is already sitting there waiting for the rest of us. "Pretty special day for you, I bet," he says, with a little chuckle. He knows. He gets how important today is to me. I have a friend who

understands. I look at him for a moment, then turn and look out the window.

My glow of excitement lasts through soccer practice, pizza dinner with Jeff and Kevin, who think it's "really cool" I got a paycheck, and even when we get home after a long day. It's fading by the time Gary comes in from work but revs up a bit when I see the smile on his face, too. Does he know, too? Could he possibly understand how important this day is to me?

"Hi, Gail," he says. "How was your day? Let me see your paycheck." He is actually reaching his hand out.

"Sure thing, Gary. It feels great to get paid a full-time salary. I have been excited all day. It's been a long time coming." After he looks it over, he slowly folds it to place in his wallet.

What the hell? How does that work? Is that normal?

The questions are flooding my brain, but I am not able to say them out loud. Instead, I ask, "Hey, may I have my paycheck back, please? I want to deposit it in the bank."

"Oh, I'll take care of it for you," is his 'matter of fact' reply. And he walks off to find the boys in their bedrooms.

I head for our bedroom, and the sanctuary of the beautiful bathroom. While crying in the shower, my sister Barbara comes to my mind. She is one of the original women's libbers, at least in my mind. Surely she will give me some advice on how to handle

this. Bringing the phone into the bathroom and locking the door, I call her in Minnesota. After some brief small talk, I share the scene with Gary and the paycheck.

"Do I have to give him my check?" That is the question I ask, honest to God!

I have been a doormat for so long, I am genuinely torn. And so naive.

"Absolutely not," is Barbara's reply, followed by advice on what to say to Gary. After hanging up, I am momentarily tickled by the memory of always asking Barbara to be the one to talk to Dad when we needed to ask him something. Wish I could do that now.

This is definitely the time for standing up for myself. After the boys are tucked in for the night, I speak the truth to Gary. Not the whole truth, yet, but enough to make my point.

"I want you to give me my paycheck back, please. I plan to open up my own bank account and use the money for extra things that we might need during the month. It is long past time for me to establish my own account. It feels like the perfect time to do that." Breathe…

Gary's not happy; I can see it on his face, but he reluctantly agrees. Handing me back my check, his one

stipulation is, "There may be a month here or there where we wi. need it for expenses. So if that happens, I'll let you know."

As we move into February, the routine continues to carry us rotely through each day. Following a familiar schedule has always kept my anxiety simmering, rather than boiling over. However, there has been a definite shift in the atmosphere around Gary. He is definitely uncomfortable with the new and improving version of his wife, and I am having less and less patience with the "way he has always been." Not so much that anyone else would notice, but it's there.

Drawing upon my growing self-confidence, I greet the last Friday in February like the Cowardly Lion after meeting the Wizard. I even walk over to my classroom doorway to greet Mr. Branch. Continuing my path to becoming an independent woman, when the carpool pulls into the drive-through lane at Education Employees Credit Union, I ask if I qualify to open an account there. Dan says, "Sure thing. You are a teacher! I'll walk you in and introduce you to the clerk. Doesn't take long to get it done. Joe and Kitty can get some ice cream next door!"

It's Friday. Jaw drop. My first "get-er-dun" Texas moment is opening my own bank account.

Mine, no one else's. Right now. "Thank you so much, Dan, for your help."

As soon as I get home, I swoop up my two turning-into-adolescent young men and take them out for Mexican food to celebrate. Gary is working late, which will eliminate some tension for me. Enjoying the mask free moment, I proudly share with Jeff and Kevin what their mom did that afternoon. "I opened up my own checking account, with my own paycheck, that I earned by teaching teenagers. And it feels really, really cool," I say with slow tears sliding down my face.

Kevin says, "That's great, Mom. You worked so hard going to college. Do you like it?"

Jeff echoed with, "That's really great, Mom. I bet Dad's happy about having more money," laughing with his brother. They are growing up. I smile at each of them.

Not a planned surprise, but a welcome serendipitous moment none the less...When we get home, Gary is home from work. In the kitchen, putting out some leftovers for him, I can hear the boys excitedly sharing, "Guess who paid for the dinner tonight, with her own money, Dad. Guess!" Love it. Out of the mouths of babes...Thank you, God.

He never said anything to me about that paycheck. As a matter of fact, we hardly said anything at all to each other for a few weeks. By then, I knew the time had come.

Gary and I are sitting at a table at the same Mexican restaurant I took the guys to a few weeks ago. I chose it because it is a nice, quiet, public place and because it is close to home. Over chips, salsa, and margaritas, not able to wait another minute longer, I take a deep breath and quietly state, "Gary, I want a separation from you. As soon as I can find a place to rent, I am going to move out." His stunned facial expression is frozen. "I know you are shocked, but I have wanted this for a while. I was going to wait until summer, but I need to do it now. The boys can stay at the house, keep the same routine."

When I stop to breathe, and give Gary a moment to process, he swiftly says, "Why do you need to do that? Are you unhappy? We hardly see each other now, so just stay in the house, and I'll go away or something. I can agree to go to Huntsville AL for a really good offer. Please don't get a divorce. You'll take half my retirement."

In my heart and soul, I am ready to go. Stand on my own two feet. Escape for a while, lean into this life-altering event. Gary's proposal was not outrageous. But I want to do what I want to do, I know that. "Gary, I am going to move out, but let's give it a little bit and see how the separation goes for all of us. Then we'll talk again."

We focus for a little while on our dinner, and then Gary sadly says, "Okay. But you have to tell Jeff and Kevin."

It's a silent, but short ride back to the house, and the boys are still up watching TV. And looking for leftovers. They probably notice the quiet, but it can wait until morning. I head off to bed, but later, when Gary comes in for bed, I move to the sofa. It's the first night of Spring Break vacation, 1992.

Saturday morning sunrise comes in through the porch doors and wakes me up. As Gary is leaving for work, he says, "I'll go to counseling if you want. Let me know." By the time the boys are awake, I am dressed and so scared. Just like everyone else, they have been shielded from my reality. Gary and I never argue. We disagree some, but passively. Would it be easier for them if we did argue? At least they would suspect something. For a while now their Dad and I have practically not even spoken, but they hardly would have noticed that.

"Hey guys, we need to talk. Come sit on the couch with me. I have something sad to talk with you about."

Oh my, those faces that I love so much are immediately reflecting dread and confusion.

"I love you both very much, but sadly your dad and I are separating. I hope you are now old enough to understand that I need to do this. I'm sure this seems sudden to you both, but I have

been unhappy with our marriage for a long time. I have been waiting for the 'right time,' but there is no such time."

This is as gut-wrenching as I have imagined. Their sad eyes are just staring at the fireplace, not wanting to look at me.

"For now, you'll be staying here. I'll be renting a small place in town, where you are always welcome. We will still be seeing each other all the time, I promise."

One of them starts to quietly cry, hugs my neck tightly, and walks to his room. The other just sits there, holding my hand, pondering what I just told him. After a little while, he wipes his tears and says, "I love you, Mom," and walks off down the hall to find his brother.

That moment represents the first time I could not be there for them. Oh, I hugged, and answered the few questions they asked, but I was incapable of "fixing" them. There will be other heart-wrenching situations in our lives together, but this one remains at the top of their "reasons you might need counseling" list.

On the home front, I reluctantly agree to go to marriage counseling for a couple of visits. I do not have much hope, but since Gary has offered, I will try. Could be interesting to hear someone else's perspective.

Finally achieving my goal of a college degree, brick by brick the walls are coming down. Getting my first teaching job. Directing my first competitive drama performance for One Act Play. Leaving my marriage after 17 years. All in the past few months. I am definitely feeling cautious expectations behind my own mask.

After one session with the counselor, I already know I will only be going to one more session. "Tell me what you bring to this marriage," she begins. Gary: "I work hard and provide everything she and my sons need. I don't know what else to do." He is telling the truth from his perspective. It's sad how little he comprehends. My response, knowing that I am not about to tell this woman my whole life's journey: "You are a great provider, but it doesn't matter how big the house is if you are never there to enjoy it with me. I miss the 'Gail and Gary' part of our relationship. I have for many years. I need that loving connection."

Following that first session, after Gary left ahead of me, she said, "So, Gail, what are you waiting for? First you left the bed and moved to the sofa, and now it's time to go. At least, that's my quick read on the situation."

Sitting in my car in the parking lot, a painful flash of clarity hits my heart and my head. "Heavenly Father, I feel the

time has come to step out in faith. Please wrap your arms of comfort around all four of us. Guide us and keep us safe as we walk this unfamiliar new path."

"Accept yourself, love yourself, and keep moving forward. If you want to fly, you have to give up what weighs you down."

Roy T. Bennett

Chapter 20
March - April 1992

"Love yourself enough to take the actions required for your happiness. Love yourself enough to cut yourself loose from the ties of the drama-filled past. Love yourself enough to move on." Dr. Steve Maraboli

Mr. Woods and I are having fun working together on *The Gondoliers.* How can you not enjoy seeing the two star athletes of the boys' basketball team bursting out on "stage" belting out, "We are....... Gondoleri and that's a vulgary!" Or trying to teach two teenagers to sit romantically on a bench, reminiscing about their previous escapades, just using their facial expressions. Not having much to reminisce about at their age makes it tougher! That's a good thing.

Today is the day we will teach the cast how to gavotte! "A 'French kissing dance' by definition. A fancy word for waltzing," is their first basic clue about what is coming. Lots of giggles as Mr. Woods takes Mrs. Woods in his arms, holding my hand with one arm out straight, and his other around my back. As

he slides me around the stage, I whisper to him, "Watch yourself, Mr. Woods," while blushing!

Are we flirting with each other? Right in front of the students? No way. We must just be caught up in the moment. Right?

Tell that to the goose bumps on my arms.

Becoming a slightly wiser version of me, I begin to develop my sense of worth. What a difference a month makes. The next time Mr. Branch shows up at my classroom door, I sidle over to the doorway, watching my students write, and put "the moment" to good use. "Mr. Branch, the One Act Play prep is going quite well. Why don't you stop by the gym during 6th period and check out how those star basketball players are doing as gondoliers. Be good for morale, right?"

"Sure thing, Mrs. Nolan," retorts Mr. Branch, shaking his head a little as he walks away. "Gotta go deliver the mail." When I turn back around to my students, a few of them are looking up and smiling. Score one for Mrs. Nolan.

The One Act Play competition is the week we return from spring break. Days before, the state basketball tournament takes place, with Brock athletes playing in both the boys and the girls semi-finals. Being such a small school, "coaches" often have to share the students. In this case, half of the cast of the play are

basketball players, which means they will miss school for three days. So, we will have only one day of rehearsal before the performance.

No stress, right? Que será, será! "Mr. Woods, what would you do if this was your band competition? I am getting pretty freaked out."

"Well, there is nothing you can do about it. So, just breathe and keep going. At least they will all make the drama competition," Mr. slow-and-steady Dan replies. Somehow his Texan drawl matches his calm, accepting demeanor.

The play performance goes well. The students do well, no major slip-ups, and a couple of them even win individual acting awards. Mr. Woods and I sit together in the audience during Brock's 45-minute performance.

It's sheer torture for me. But Dan, seasoned through many band competitions, keeps up a study pattern of rubbing my back and whispering, "Breathe, Gail, breathe." It helps me to have a friend who notices. Kudos all around when we return to campus. All and all, my first venture into Theater Arts has been an interesting adventure. Oh, and one more very important tidbit.

When I drop Dan off at his home in Granbury, I lean across the van and give him a kiss on his cheek. "Thank you for

all your help, Mr. Woods. It's been a pleasure working with you."
Genuine and nervous smiles are exchanged. Flirting again?

Back at home, life pretty much sucks. Such a horrible word, but this time it applies. I know I am leaving, even the counselor asked me what I was waiting for. Gary knows I am definitely leaving; Jeff and Kevin are just waiting to find out exactly when and are wondering how their lives will change. Even fake smiles are hard to come by. I have found a little house to rent in town, and I am waiting for my April paycheck to make the financial needs easier. Once I get up the courage to share the news with my family, my sister sends me a check for $1000 to apply to the divorce attorney. My little brother Bill offers to come to Texas to help me move. My parents are surprised and sad but seem to understand.

Mary and Frank are sad, too, but supportive. They have both been divorced before. My conversation with Mary is difficult, but at least she is one of the only ones who is not surprised. "You are a wonderful mother to Jeff and Kevin, and I know you always will be. I have been watching from far away these last few years, but I could see exactly where you were headed. Thank you for staying as long as you did. One day the boys will appreciate your sacrifice. Be happy, Gail. I love you." *I will never forget her words. We will always stay in touch, and I*

even attended her 80th birthday party in Florida. Sadly, both she and Frank passed away.

The first Saturday of May is moving day. As planned, the boys are out of the house with Gary all day. No sense for them to have to witness Mom moving out. Friends from church and my brother Bill are helping, but I am only taking the bare minimum with me. My clothes, personal items, school items, and some books. I may eventually regret leaving so much stuff behind, but today, I just want to go.

My heart hurts tonight for my sons. I already have regrets for leaving them behind, even though they are not far away. My head knows how important this step is for me to take. Finally becoming a full-grown adult at 38 years of age. Living alone for the very first time. Earning enough to take care of my basic needs.

But they have been my purpose, my focus, my life-line for 16 years. Just like an expected death of a sick loved-one, knowing it's coming doesn't make the event any easier.

Secure in my love for them, and theirs for me, we are going to be alright. We have a few months before they have to decide where they want to be for the next few years. And the choice will 100% be made by each of them.

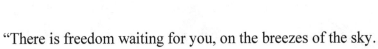

"There is freedom waiting for you, on the breezes of the sky. And you ask, 'What if I fall?' Oh, but my darling, what if you fly?" Erin Hanson

Chapter 21
May 1992

"It's only after you've stepped out of your comfort zone that you begin to change, grow, and transform. Roy T. Bennett

May begins with a special fund-raising event that I am positive they did not teach me about at Tarleton...Donkey Basketball. It's really a thing schools use for fundraising. The pressure is on for all faculty members to take on the student basketball players. No running ability necessary, as all participants must play from the backs of the donkeys. Falling off is easy, getting back on nearly impossible. Mr. Woods and I make an "I will if you will" pact, and as the moment approaches, the excitement grows. Using the make-shift corral outside, the first five 'victims' climb on, and Dan and I are led into the gymnasium. The whistle blows, and the fun begins. It lasts for about two minutes, max. The student announcer is laughing as he announces, "Both Mrs. Nolan and Mr. Woods are down, out, and finished for the night. Points scored - zero!"

On the drive back to Granbury that night, it's just the two of us for a change. Our energy is riding high for the first few miles. Chatting about the crazy event we just participated in, and then about the approaching summer break. I know I am more than ready for some downtime.

When we reach the first stop sign on our country road commute, Dan reaches for my hand, then suddenly we find ourselves embracing. We are even later getting back to our respective homes.

The inevitable kiss that follows will just be the first of many.

"It's a STOP SIGN" remains in our repertoire even now.

Monday rolls around as expected. The last couple weeks of school are going to be busy with all types of activities. State tests, field trips, assemblies, and graduations. Total focus on finishing out the year successfully. Assigned as one of those "duties" you rarely volunteer for, I am tasked with the "traditional" 8th grade graduation, and Mr. Woods oversees Kindergarten's graduation ceremony.

Traditional at Brock means "the same way we've always done it." But I have a new and exciting idea. "Let's combine the two events and let the 8th graders help with the little ones." My pitch to both Dan and Jimmy Branch is, "Come on, it will be so

fun. The parents will love it. Everyone will like it. One night instead of two. Trust me!"

It is a huge success. The students process in pairs, one 8th grader holding the hand of a Kindergartner. Some are even related to each other, siblings or cousins. The teachers gave out some special awards and surprises. As a grand finale, Mr. Woods and Mrs. Nolan take center stage and sing a duet, *Somewhere Out There,* to thunderous applause. We hold hands to take our bows. There is not a dry eye in the house, including mine.

The vibes coming from this friendship are definitely electric. We probably need to talk about it. Soon.

After receiving lots of kudos, Dan, his wife Diana (a surprise late afternoon decision), and I decide to go out to dinner to celebrate the successful event. Diana called Dan and said she wanted to come hear us sing! After the event, I tried to beg off, feeling like a 5th wheel. But they are my ride home, since anyone else going to Granbury has already left.

Oh well, it's Uncle Julio's Mexican restaurant, so the food will be great. It's been a good day.

While chatting about summer plans over chips, salsa, and margaritas, Diana shares that they are thinking of leaving the area and moving somewhere else in Texas. "As a matter of fact, Dan is already applying at some schools," hits me right in my heart,

much harder than it should. What the heck? But it will not help anyone to show my real yet confusing feelings, so I smile and wish him good-luck.

"I am surprised to hear this. I wish you luck." Damn, I can hear the nervousness in my voice. "It will not be the same at Brock or First Presbyterian Church without y'all there." Dare I ask one question? I can't help myself. "Why are you looking, Dan? I had no idea you were unhappy at Brock."

I think I fooled Diana, but I know Dan can tell I am a bit upset. Just breathe and keep going, right?

Dan, who must feel like the man in the middle, replies quietly and truthfully, "I would really like to have a real band program, at a bigger school. That's what I am looking for. To see what's out there."

When this Friday night ends, I am sadly stunned about possibly losing my friend and colleague. Afraid to even look at Dan, I smile at Diana and pray for the night to be over. It is a very quiet ride back to Granbury after dinner.

I welcome the distraction of hanging out with Jeff and Kevin Sunday afternoon. They look good and are excited about the upcoming soccer camp at TCU.

First thing Monday morning, our carpool mate Kitty stops me before I get out of the car. "A minute please, Gail. The

graduation celebration was the best ever. And that's saying something. You two did a wonderful job."

"Thank you, Kitty. The children looked so cute, and I think the parents liked it too. Even Mr. Cheek had a smile on his face."

"However," Kitty continued, "I do want to call something to your attention. People are 'talking' about you and Dan. How comfortable you seem with each other, especially after seeing you two singing at the graduation."

"Thanks, Kitty, for caring about me. I appreciate it."

"Truthfully, I have noticed it too, especially during the rides to and from school. It's none of my business, but I just thought you should know. Reputations can be ruined by gossip. Brock is a small town."

"Well, we were trying to keep our personal lives separate from school. But, since the school year is ending, I guess you should know. No one at school knows this yet, except Dan, but I separated from Gary last month and filed for divorce. It was my plan even before I moved to Texas, which kept my motivation high during college.

"But I can see how my friendship with Dan might raise some eyebrows. Only time will tell, right? Have a good summer, Ms. Kitty."

"My mind keeps on telling me that this is no good.

My heart is aching and tells me I should.

Only time will show the wiser."

-The Merry Go Round

Chapter 22
June - August 1992

"Never take for granted the gift of those who get you. No explaining. No questioning. Just BAM instant understanding and acceptance. They are keepers." ©2022 Meditations and Musings by Jody Doty

Monday morning class is a distracting one for me, with monkeys frolicking freely in my brain. But, since there are only two days left until summer break, I have no problem turning on the VCR to keep the kiddos occupied. *No, they did not teach me that at Tarleton. It is an English teacher's survival perk for teaching literature.*

Sitting in the shadow light at my desk, I am pondering some truths. This morning felt awkward, sitting with Dan in the carpool. Then, the gossip (aka concern) from Kitty proves others notice our connection. Being honest, I have the niggling feeling it's been happening at the church choir rehearsals, too.

Most troublesome of all is my mixed reaction to Diana's surprising announcement Friday night. Their plans to move away. My heart drops at the same time my brain speeds up. Usually I

share how "I have moved multiple times in my life, and almost always it has been positive experiences," when someone mentions a possible move. Friday night, I only smiled and quietly wished them well.

Bits of nervous chatter fill the car on the after-school drive back to Granbury. Last day of school tomorrow.

Not long after I get home this afternoon, there is a knock on my front door. Coming out from the little kitchen, I see that long, tall Texan leaning on the screen door frame, smiling. "May I come in for a minute, please?"

"You certainly may, Dan. Especially since you ask so nicely. We probably do need to talk."

Beginning at the same time, with the same words, we both admit, "I think I am falling for you."

Uh, oh.

We know. We just haven't spoken those words out loud. We feel the energy, the sparks. We have for a few months.

"It hit me when Diana was talking about moving," again talking over each other, and nodding our heads.

"There's a connection with you that I may never have felt before. Awkward timing, for sure," I share.

"Diana noticed something between us, too. Saturday night. We talked when we got home, and I tried to convince her

she was overreacting. So, it's probably good that the school year is ending. You and I won't be seeing as much of each other. We'll see what happens during the summer," Dan struggles to say.

We are both struggling. What an awkward moment.

Breathe... "That certainly is the right thing to do, Dan. But I will miss my friend. Please be sure to let me know your plans. Be happy, Mr. Woods."

"I will. You be happy too, Mrs. Nolan," followed by an emotional hug.

Living alone for the first time ever, the little house becomes my cocoon. The guys are away at soccer camp, so for the next two quiet, and sad weeks I grieve. Dealing with the end of my marriage to Gary after 17 years, for sure. The breakup of our family. Bittersweet at best.

Yet dealing also with the strong probability of losing my first real adult friend. Dan and I could feel the energy from the get-go. He understands me, and encourages me to be myself.

Is it "too soon," or just a rebound? I have been unhappy for a long time, but Dan is still married. Is he hiding his unhappiness too?

What if this is real? A God thing? God knows I have been yearning for companionship for many years now.

How did we get here - from choir members to best friends - so quickly? What is it about this Texan that catches my attention?

Before showing up at First Presbyterian Church Granbury, Dan had been busy living an active adult life. After graduating from UT-Arlington, he spent the first few years of his music career working for a few school districts around Texas. During that time, he got married, which eventually ended in a painful divorce. After some restless years, he married Diana in 1988 and moved to Granbury. When our paths crossed, Dan had just restarted his teaching career, teaching Elementary music, band, and choir at Brock in the 1991-92 school year.

I didn't know most of that in the beginning. Didn't need to, didn't want to. He was friends with my best friends, the choir director Cathy and her husband Don. That was more than enough for me. Plus, seated in the tenor section with Jeff on one side, and Kevin on the other, he immediately treated them as young men. Instant credibility with this mom!

When Cathy introduced him to the choir, she shared that about ten years ago, Don had been Dan's lead teacher when Dan was student teaching. Texas may be a big state, but it's still a small world. A random meet-up of the two men, at a Granbury grocery store, resulted in Dan's first visit to the church. Being a good ole'

E. Texas boy, Don invited Dan to "come and visit our church, Dan. We'd love to see you."

Looking forward to picking Cathy's brain about teaching choir, a new class for Dan, he accepted excitedly. "I sure will, Don. Thank you."

Thank you, Don. You were the conduit who brought our paths together.

Once we had begun residing inside the same world called Brock, our conversations had laid the foundation for our relationship. Seems we were both starved for meaningful discourse.

From the get-go we find we have quite a bit in common, no cliche intended. We are both lifetime Presbyterians. We are the same age. We enjoy taking rides to see the sights, rather than hiking. We believe that education should be focused on what is best for the child, not the administration. We both love music and sing Neil Diamond songs frequently.

We feel so comfortable, and truthful, and real with each other. And sometimes, we both get goosebumps on our arms at the same moment.

If he goes away, even after only ten months, I feel pretty sure we will miss each other. And it will hurt.

A little more than two weeks of our summer break has gone by, when the main man haunting my thoughts appears at my screen door again. As I look through the screen, this time I am startled to see a small smile on his face, yet a very sad look in his eyes. Wonder which one is real? "Howdy stranger. Why the long face? I've missed you a lot, Dan. Please, get on in here," I say, with tears pooling in my eyes. Seems we both tried but failed. Our connection is already palpable. We are not strong enough to ignore our growing connection.

When we catch our breath, Dan begins to explain. "Well, I have spent the past two weeks with Diana. Yet, I have been thinking constantly about you and me. Both now and in the future. The thought of ending whatever it is we have happening feels wrong. That's the truth. It's going to take a little time, but I realize my marriage to Diana is over.

"But, you and I need time alone to talk, spend some time together, just us," Dan explains. "Try to make sense of 'us.' So, I have a 'job interview' lined up in the Waco area in two days. I want you to come with me. Will you do that?"

My situation makes it easier for me to say yes. I have already moved out and filed for divorce. But never in my wildest dreams did I expect this to happen. Still, I need to take a minute.

Do what has always been expected of me? Be guarded in my choices? Encourage Dan to walk away?

Or, be impulsive and live life by <u>my</u> choices now? How else will we know what this is?

"Yes, yes, I will go on a road trip with you, Dan Woods. With pleasure!"

Before we drive off the next day, Dan hands me the CD he bought for me while shopping in Vegas. Neil Diamond's latest *If There Were No Dreams*. "If there were no dreams, how could we be lovers?" are the words of the title track. Neil gets it! We talk, we share stories about our lives, we become comfortable with silence. Leaning into the feelings of falling in love with each other. We begin to plan together.

When we drive back up to my little house, we know in our hearts that we feel right.

"A soulmate is not someone who completes you. A soulmate is someone who encourages you to complete yourself. A soulmate loves you despite any flaws because they don't define you by those flaws. A soulmate helps guide you to your true potential, your genuine self, because they recognize what an amazing person you already are." Bianca Sparacino

Chapter 23
September 1992 - March 1993

"You are the angel atop my tree,

You are my dream come true.

Santa can't bring me what I need,

'Cause all I want for Christmas is you."

Vince Vance and the Valiants

By the time the 1992-93 school year begins, my divorce from Gary is final. Dan's divorce is in the works, after a few very difficult conversations with Diana. Jeff and Kevin are both going to Granbury High School and have had a good summer, focusing on their friends, soccer and music. Dan and I are both staying at Brock for this school year at least, choosing to keep our personal relationship private. I am still living in my little rental house, and Dan lives outside of town in a single-wide trailer. Officially, Mr. Woods and Mrs. Nolan are friends and colleagues from 7:30-3:30 Monday through Friday. But it's getting harder to keep our growing relationship a secret.

After all, Brock really is a small town.

The next few weeks fly by quickly. By October, both Dan and I feel like the time feels right to leave Granbury behind for a while. The more time we spend together serves to confirm our feelings. Now it's time for new scenery for our new relationship. New restaurants to meet Jeff and Kevin. Time for a little distance.

Dan resigns the choir director's position at First Presbyterian Church. We are exiting the building but will carry the people and the memories in our hearts. We each make arrangements to move out of our rentals.

We are leaving Granbury in our rear-view mirror. Loading up the truck and moving to a two-bedroom apartment in south Fort Worth, TX. If we could have tied a grandma on top of our stuff, we would have looked just like the Beverly Hillbillies.

Driving down the road, a box falls off and breaks open. Among other items, my undies come tumbling out, blowing around like tumbleweeds. The catchphrase "Panties-on-the-Road Movers" is born. *And has lived a long life. We have moved frequently in our lives.*

There is room for the guys to sleep over, if they want. We meet up with them often to share a meal and catch up with their lives. Food in the stomach of two teenage soccer players is

always a winner. They both seem to be doing well. I hope and pray that their smiles are real. Not seeing them every day is truly the most difficult adjustment for my heart.

I'm thankful for the compassion that Dan provides. Having a secret that your best friend shares is so much more intimate than carrying one on your own.

'Dan and Gail' are now officially living together, except when we are Mrs. Nolan and Mr. Woods at school. Dan introduces me to his parents one Sunday in November, visiting their Presbyterian church in Mansfield, and enjoying lunch afterwards. Naturally, they are curious about this new woman in their son's life. But my answers to their questions seem to ease any concerns.

Presbyterian…check.

English teacher…check.

Divorced…check.

Mother of two teenage sons…hmmmnnn.

Bridge player…a definite "No!" which is followed by dual frowns.

Currently shacked-up with Dan…probably the toughest to accept.

Evidence of enjoying each other's company…check.

All in all, they are very gracious and welcoming. I guess with five sons, they have met a plethora of girlfriends.

Thanksgiving is spent with Dan's brother Jim and his family in Austin. The food is wonderful but served with an understandable amount of tension. Jim's wife Terry and Diana are good friends. No amount of smiling seems to ease the edginess. Long after everyone else has left the dining room table, I find myself still sitting there with Jim. Everyone else has scattered. We are not having a conversation, it's just that Jim is still very slowly eating, and I have been raised to stay at the table. Dan comes looking for me, and when he realizes what is happening, he laughs and says, "No one waits on Jim in the Woods family, Gail. You might be there for quite a while!" At last, we all share a giggle.

When we get in our car to leave, we both say, "Well, that went well…Not!" Followed by a quick reassuring hug and a kiss.

It's going to take time. We know it. We chose this path, and we will walk it together.

December blows in with a flurry of activity at school. My theater classes perform some Christmas plays for the elementary children, which are lots of fun for all. Mr. Woods music classes, from elementary music through high school band and choir, share their musical talents with students, parents and other guests at

their Christmas concert. Everyone is catching the Christmas spirit.

The semester finishes with a fancy Brock faculty Christmas party at a beautiful restaurant in Granbury. Mr. Woods and Mrs. Nolan make a date of it, a revelation to say the least. Smiles and hugs greet us at the door when we make our entrance. Later, our ears ring with tipsy giggles floating over from colleagues at the bar. Guess they noticed our quite romantic dance to *"All I Want for Christmas is You,"* the Vince Vance and the Valliants' version. One of the secretaries shares her approval with a quite boisterous "Go for it, Gail," from her bar stool. "Have a merry Christmas." When we dance by Jimmy Branch and Mr. Cheek, I swear they both roll their eyes, with a smile.

Gail and Dan have come out of the shadows and into the light. 'Tis the season to be jolly. We are headed on a road trip to Florida to visit my family for the holiday. Sunshine and beach are on our horizon, right after they greet Dan. I am really excited for my parents to get to know this wonderful friend in my life. I'm looking forward to sharing our teaching experiences, too.

Mom and Daddy now live in a retirement community in Tampa; the "lifestyles of the rich and retired" we jokingly refer to it. High rise condos, with all the bells and whistles they could want. Total life care is available across the street when needed, in

the assisted living and hospital wings. It's beautiful, and actually fun to be among the senior citizens. They love to have visitors.

Evidently, my mom is already a mover and shaker among the residents, and Daddy reminds me, "Don't forget, Dorothy Gail. Your mother has a reputation out there, so behave," as Dan and I are heading down to the swimming pool.

We are still giggling when the elevator doors open on our floor. While getting on and clearing the door, one of the residents on the elevator quickly asks, "Are you Anne F.'s daughter? We know she is expecting family for a visit."

Smiling, I ask, "It depends. Do you like her or not?" Oh, I know Mom's going to hear about that! Rice Krispies for me. Laughing, I admit the truth. "Yes, I am Anne and Gordon's daughter Gail, and this is my friend Dan. Merry Christmas." We escape the elevator on the pool level.

All in all, our first long road trip is a success. Our Christmas morning begins with lots of tears, as this is my first Christmas without my sons. I'm very grateful for the privacy of the guest room that enables me to temporarily remove my mask.

I'm thankful to have my little nephew Nicholas to provide some joy. Children should be the focus of the celebration. Dan loves being able to play golf on Christmas with my brother Bill, and Leslie and I ride around with them. Great therapy.

Daddy is aging quite a bit, but Mom is still like the Energizer Bunny. The lifelong secretary that she is, she volunteers her services in the marketing office. She is their number one walking advertisement for sales. University Village seems like the perfect place for them to live out their lives.

What a blessing it was when Mom and Daddy decided to move into a life care facility. Removing the burden from any of their children having to make that decision was a gift. It was too soon for Mom, but this life-changing decision provided the safety net she needed for Daddy. In addition, both Daddy and Mom were able to live out their lives with dignity.

We start the new year off up to our necks in school activities. Days just zoom by, but it feels great to be productive. After living my life behind a mask for so many years, except for rare moments of self-reflection, I revel in these new feelings of freedom. While still maintaining our professionalism, it seems that both the students and the faculty are enjoying our subtle courtship. "You sure do visit Mr. Woods's room a lot, Mrs. Nolan," one student comments with a grin. "Saw you both at the basketball game last night, too." Goofy teenagers. It's approaching spring, when love is in the air.

Still not yet understanding the whys and hows of my mood swings, I do embrace the relief Dan provides through his

heartfelt encouragement. It's so amazing to be listened to and heard. To have my opinions matter and appreciated. Day by day, our connection is strengthening. I feel better physically as my state of mind grows more positive.

Communication matters, especially truthful sharing with a trusted partner. I have felt alone for so long.

As the March Spring Break week approaches, we are again anticipating some quiet time off together. Teachers live for breaks!

Dan's divorce is final, bringing a close to that chapter of his life. Even when you anticipate the outcome, it still takes your breath away for a minute.

Another One Act Play performance has come and gone. *The Inner Circle,* an emotion-grabbing drama of a teen who is diagnosed with AIDS due to a blood transfusion, is timely and leading edge. I needed to first defend my choice to both Mr. Cheek, the Superintendent and Jimmy Branch. After all, Brock is a small, Southern Baptist town. "The AIDS storyline is written appropriately for high school students. Submitting *The Inner Circle* entry to UIL will be trailblazing for Brock. And we've got just the right teenagers in my class to play the parts. You will be proud of our production."

Then I sit and breathe and wait nervously. Finally…it's a go. "YES! Thank you so much. We won't let you down."

"Ask Mr. Woods if he will help you again," calls Mr. Branch as I head for the door, with a smile in his voice.

"No problem," I whisper.

UIL competition day arrives two days before Spring Break. It's been quite a learning experience and an emotional one for all. Excellent script. Time to let students shine. "They are ready," says Mr. Woods. Definitely a highlight in my teaching career.

Our students do fantastic (except for the one chewing gum!).

The solo judge not so much. Completely unprofessional. She admits to the administrator of the competition, in a closed-door meeting immediately after our performance, "I just recently lost a close friend to AIDS, and my emotions totally distracted me during the Brock students' play. I am sorry for my lack of professionalism. I literally did not watch clearly for more than five minutes."

I knew it. I felt it when we were watching. I even nudged Mr. Woods, who was sitting next to me. Her strange behavior distracted me, watching her from a few rows back. In the small lamplight at her judges table, placed halfway back in the

auditorium, I observed her head down, wiping tears away, early on. I lost my focus, too.

In the 'University Interscholastic League manual speak,' the rules state, "It's a live performance competition. Your play will not get a do-over. The judge will get an official reprimand and be removed from the active list of judges. We are so sorry this happened," states the contest administrator.

Mama-Bear-Teacher awakens for the first time. Mess with me, adult to adult, we'll talk calmly about it. But I need to be the advocate for my students. MY teenagers will learn a tough lesson today. Hard work, teamwork, and representing your school are supposed to make you feel good. And later on, we will talk about that concept. But today, there will be no ensemble award, no individual awards, either. No extrinsic mementos to show their peers. Just a random moment of horrible timing.

I am angry, disappointed, and struggling to maintain my composure. Counting to 10 (but only making it to 5), words to that effect spew from my mouth. To the judge, "Well, I certainly understand your grief; however, it speaks well for the play. Raw emotions make this situation even harder to accept. However, you are the only judge. Which results in really bad timing for our live performance, and for my students."

To the administrator of the contest, I continue as diplomatically as I can. "I hope UIL uses this example as support for three judges at every One Act Play competition. Even a back-up emergency judge in the audience. After we reflect a bit, I will be asking my group to write to the UIL Fine Arts director about their experience today, including my perspective, too."

My last words to the judge are, "I invite you to visit my students in their dressing room and share your reactions with them personally. It could at least be used as a perfect teaching moment."

She doesn't do that, but does at least take a moment to mention the cast and *The Inner Circle* during her awards presentation. We clap and cheer for the other schools.

We needed a saving-grace moment.

It's a very subdued group on the drive back to Brock. Tough real-life lesson for us all. My full-on sad body can't totally be masked, but the tears do remain damned up until we reach our apartment.

Perfect time for a week's vacation. With my best friend. Dominican Republic, here we come.

Our time together that week was everything we needed it to be - especially seven days of total mask-free anonymity for the

two of us. This remains one of our favorite vacation locations among many. And this next story, a legend...

Five days into the beachfront vacation, we are enjoying a walk along the beach in the bright full Caribbean moon. It has been picture perfect. Room on the beach, massages in a Tiki-hut by a native woman, beautiful weather. At midnight, sitting in the sand, mesmerized by the moon glow, I jump up, grab a shell and write, "Will you marry me, Dan?" in the sand. My 100% totally genuine smile reflects in the bright moonlight.

Laughing and happy-dancing and looking directly into each other's eyes, Dan shouts, "Yes!" Loud enough to echo out across the dark blue Caribbean.

We leave on Spring Break as best friends, and we return as fiancés. Such a damn fine vacation.

"Everything you see changes with the light. And suddenly, I understand that the only thing we see in this world is light. Sometimes, though, it's not the light from the outside that matters but the light inside that shades everything, that determines which colors you see." Elizabeth de Veer

Chapter 24
April - August 1993

"In case no one has told you today: You're beautiful. You're loved. You're needed. You're alive for a reason. You're stronger than you think. You're going to get through this. Don't give up." HealthyPlace.com

Deciding it is finally time to share the happy news with our administrators, we catch them before school on the first day back. Dan shares the news, "Gail and I are engaged," with his big handsome smile on his face.

Catching Mr. Cheek and Mr. Branch somewhat by surprise, they are gentlemanly enough to say, "Congratulations. That's happy news."

Not missing a beat, Jimmy Branch asks, "Did you two behave yourselves on the One Act Play trip?" He and Mr. Cheek are practically falling down laughing. It only takes until lunchtime for the news to spread across the school. It feels so good to receive so much love and good wishes.

Another very important piece of news almost gets lost in the love fest. Seems that over Spring Break the story had gotten around about Brock's One Act Play performance. The local theater facility in the next town reaches out, offering us a chance to perform *The Inner Circle* in their auditorium. What an amazing opportunity to get the AIDS message out there, but also a fitting reward for all my students' hard work. Needless to say, Jimmy Branch and Clead Cheek are thrilled.

This cast began as a mashed-up group of teens, diverse in their choices. One young man rarely made eye contact, much less spoke. Today I observe friendships across perceived boundaries. My special quiet guy is sharing small talk back and forth with the six-foot five basketball player. None of us will ever forget this experience, especially this positive ending.

We fill the seats with high school students who are bussed-in from all around the area. It is noisy and packed until the lights go down.

The second live performance of the Brock High School theater arts students is a slam-dunk. As exciting as any basketball state championship, that's for sure.

At least in my and Dan's humble opinions. We love working together, and we seem to be good at it too. It's really nice.

April begins with a few events that still cause me to wonder about their cause and effect. I have been assured many times that each was a separate event unto its own, but I continue to wonder.

"Dad is being transferred to Huntsville AL immediately," Jeff and Kevin drop in our laps at the beginning of the month.

"Is this an April Fool's joke, or for real?" I wouldn't be surprised either way, coming from Gary!

"It's the truth, Mom," says Jeff. "We have talked it over, and we want to stay in Granbury High School, at least until the school year ends. We really haven't decided yet if we want to move to Alabama with Dad or stay with you and Dan in Texas."

Dan and I suggest they move into Windrush Apartments with us and drive the 30 minutes down to GHS each day. No way can I let them stay at the orange house unsupervised. Not a good idea at all. There's only two months left until our wedding. By then, they will each have to decide what they will do next.

"You don't have to choose the same plan. Jeff only has one more year of high school anyway, and then he will be off to college somewhere. Keep that in mind when you are thinking about what you want to do. Your dad and I agree it is totally your choice."

I have to shake my head at the irony. Even divorced from Gary, my life is still being affected by Stone and Webster. Really, God? What is your plan this time? Road bump number one.

Realizing their long-term visit will soon have us tripping over each other in our apartment, the rental management company rents us their smallest apartment, right across the parking lot from our building, for a month-to-month deal. We throw some mattresses on the floor, stock some basic essentials for two growing teenagers, and lay down some ground rules. Thank goodness they have always been pretty grounded guys. We are trusting them to do the right thing, even when no one is looking.

Monday morning, we all go off to our respective schools. I know I for one am praying while we drive. "Keep them safe, please God."

Meanwhile, back at Brock, Mr. Woods is one of the senior class sponsors for this year's graduating class of 20 students. It is a tradition for the class to take a trip right after graduation, sponsors included free of charge. The students earn their way by working in a school store/snack bar during lunch. This year's trip is a Disney Cruise at the end of May, and Dan is on the manifest. Sitting down with the other sponsor, Dan says he wants to add me to the cruise, paying the same amount as the other guests. "No

problem," came back from the administration, "But you cannot share a stateroom unless you are married." Road bump number two.

Well, after some discussion, and a little good-natured whining about me getting left behind, we decide to go ahead and get married. We really hadn't even talked seriously yet about when, not being in any big rush, but we decided it would be ironically apropos for the two of us to attend graduation on a Friday night, get married on Saturday afternoon, and take a honeymoon cruise with a class of graduates on Sunday morning. Who else would sign up for that kind of fun?

The word goes out to those we love, both near and far. Save the date...we will be married on May 30, 1993, in St. Stephens Presbyterian Church in Fort Worth, TX. Many are surprised, many are happy, and a few aren't sure what to think.

Big road bump number three coming around the corner.

Two weeks later, enjoying a quiet Sunday morning by ourselves, there is a knock on our door. Jeff, looking like he has had a hard night, is standing in the doorway, rambling words and sounds that make no sense. He is obviously in the midst of some type of episode, but I have no clue. Dan suggests that he might be tripping on some type of drugs. Jeff needs help, that we know.

What we don't know is where Kevin is, or how Jeff got here, or what happened last night.

This will be the first of a handful of episodes Jeff experiences in his future. This one required hospitalization for a few weeks. As devastating as it is for those who love him, it is so much worse for Jeff. It is his story to tell, if he chooses. Kevin, Dan and I continued for a long time to do everything in our power to keep him safe.

While we slowly piece together the details of their Saturday night in Granbury, we know immediately that our trust has been broken. The plans for Jeff and Kevin are going to have to change rigt now. Unfortunately, we cannot get Jeff to sleep, and his thinking is so confused and growing worse. It is going to be heartbreakingly necessary to keep him safe at a rehab hospital. Gary disagrees long distance but does sign off on his health insurance. The process is horrible for all four of us, but Kevin, Dan and I are in agreement. Emergency admission will keep him safe for three days minimum while he gets medical care.

When I return to Brock two days later, three of us are in the car. Dan has been keeping Mr. Branch apprised of the situation, and Jimmy Branch has proffered a plan. Both Jeff and Kevin will be withdrawn from Granbury High School and enrolled in Brock, effective immediately. When Jeff is ready, he

will finish out the school year at Brock. Kevin will begin today. This is a win-win for all, as it satisfies Texas attendance laws, too. Thank you, Mr. Branch, for your compassionate response.

Both Kevin and I are pretty much in a fog, but we have to smile at each other when he walks into my English I class as a student. "Class, this is my son Kevin. He's going to be finishing out the year here at Brock. I hope you'll make him feel welcome." And they do! So does the faculty. This time it really helps that Brock is a little school.

Late afternoons are spent visiting with Jeff. He is being given medications now, attending some group therapy, and improving each day. Seeing him like this is gut wrenching. Such a sad and subdued version of my usually hyper son. Confusion for most of the time, but brief moments of clarity flash. "Mom, take me home, Mom. Why can't you take me home, Mom?" Jeff pleads. My mask is firmly in place until the tears flow on the drive home. For the first time, I find myself on the receiving end of Dan's frustration and helplessness. With a defeated tone of voice, Dan questions, "Why don't you ever cry in front of your sons, Gail? They need to see your true emotions. We all do. It's ok to do that."

I completely understand his confusion. I have asked myself the same question for years. But I do hear his voice

through my fog. "They are older now, aren't they? Old enough for us to be real with each other."

"Yes, Gail. They will have to deal with it. You cannot keep hiding behind a mask, and hope to be healthy."

I tell myself that I have to do better. I am not that person anymore. Press 'repeat,' again and again.

I would be lying if I claimed to have clear memories of my classes those last few weeks. I do know I had a lot of help and support from colleagues and friends. And from my students. Many of them had not understood my philosophy "RESPECT: Give it, get it. Got it?" when I first met them last year, but now they showered me with respect. I had earned it and so had they. And so did many other teenagers who came through my classroom doors over the years.

Jeff is released from the hospital on the day of the annual end-of-the-year Brock Talent Show. Dan is directing the event, of course, and 90% focused on its success. When the school day ends, Kevin stays to help Dan, and I ride back to Fort Worth to pick up Jeff. One of our mutual students, Robert, has secretly encouraged me to come back for the show, as Dan has something special planned. So, Jeff's first experience at Brock High School is going to be at the Talent Show. We get there just as the lights are dimming and slip in the side door of the gym. Excitedly,

Robert shows us to two saved seats right in the front row. I am caught between excitement and dread. Jeff is still somewhat confused, and unsure about what's going on. Hopefully, he will be okay for an hour.

I am brought back to reality when I hear, "Ladies and gentlemen. For the finale of the show, it is my pleasure to introduce Mr. Dan Woods singing, *My Sweet Lady* by John Denver. This one's for you, Mrs. Nolan." Robert had a hard time just getting through the announcement. I listened through my tears, flowing freely. Jeff is innocently smiling, and Kevin is full-on red faced. An amazing night for all. Especially since all four of us are going home together.

During the last week of school, the faculty and the people of Brock throw us a wedding shower after school. Dan's parents come, too. We are really touched by everyone's genuine happiness for us. While the common sense choice would have been to postpone the wedding until Jeff is feeling 100% himself, we have thrown sagacity out the window. Full steam ahead this weekend. Graduation Friday night, wedding Saturday afternoon, leave on the flight to the honeymoon cruise early Sunday morning. There's no stopping us now.

Our family members and close friends begin arriving at the Green Oaks Hotel Friday afternoon. When I stop by to get

some hugs and kisses from my side, I find everyone gathered on one side of the swimming pool. Across the pool is a guy sitting in a chair with the exact same beginning-to-recede hairline as Dan. He is watching his four children swim. "You have got to be Dan's brother Woody," I say. "There's no denying the resemblance."

Jumping up to give me a hug, Woody says, "Good to meet you, Gail. Welcome to the Woods family. Hey, kids, this is Gail, the bride to be!"

Cool. That seems like genuine good cheer. "Come meet my family, Woody," walking him around to introduce him. We will all be having a good ole' Texas Bar-B-Que in the backyard of Dan's family home tonight, after the rehearsal at our now home church, Saint Stephens Presbyterian. We will be getting married in the big cathedral. It's a small group of guests, but the music of the brass quartet, on a raised platform in the back of the sanctuary, should echo from the rafters. Thank you, my music man, Dan! Everyone should get to walk down a long aisle to the resounding 'Trumpet Voluntary' by Jeremiah Clarke!

The gathering around the pool, blending two new families, is going well. I'm so filled with gratitude that Mom and Daddy are here, along with my sister Barbara, brother Bill, Leslie and Nicholas, Beth, and others. I am really enjoying catching up

with my oldest and dearest friends from Brigantine, and Jeff's godparents, Terry and Dana.

Until they ask to talk with me in private.

From the privacy of their hotel room, they completely catch me unaware of their true feelings. "Gail, you know we love you very much," Terry is looking tense as Dana speaks. "But we don't believe you are making good decisions. You are moving too quickly, and Jeff and Kevin seem to be getting caught in the crossfire."

Terry looks sideways at Dana, as he continues, "Gary seems to have dropped the ball, too, leaving for Alabama. We would like to offer to take Jeff back to Massachusetts with us for his senior year. Kevin too, if wants to go. You know they will be like part of our family. We love you all."

Whoa. Talk about a 2x4 across the head. I am momentarily stunned but try to regain my masked composure. I am face-to-face with the result of my masking for all these years. They have been unsuspecting victims of my masking since 1968. It's my own fault they doubt my sanity. Probably many others are wondering, too. How can I blame them for loving me and my sons?

"Wow, guys, I understand why you might have concerns, but let me assure you that I have my eyes, and my heart,

completely focused on my decisions. At least now I do. And getting clearer every day." Dana wants to interrupt me, but I keep going. "I actually decided to divorce Gary before we transferred to Texas. Just no one knew. While it seems fast to most, to already be marrying, we know that we are good together. Time will show that we are doing the right thing. Jeff and Kevin have both decided to move to Alabama with Gary, so they will be together. I hope your doubts will be put to rest tonight, when you get to know Dan better. Don't worry, be happy. Please? I love you both."

Rushing back to the sanctuary of my hotel room, I manage to reach Dan on the phone at his parents' house. They are all in the midst of setting up the rehearsal dinner. Dan's immediate response is, "I'll be right over," but I assure him I have it handled. No one is going to keep us from getting married.

"I love you, Dan. See you soon!"

"I love you, Gail. Stay strong. Don't let them bum you out."

"You either!"

Just the rehearsal in the big cathedral is awe-inspiring. We joined this church last November and have had many moments imagining our wedding. Elisha Paschal, our pastor from Granbury, will officiate. Dan's brother Jim is best man, and my

sister Barbara is my matron of honor. Most appropriately, both my sons will walk me down the very long aisle. They will be the ones to officially "give this woman to this man" in marriage.

The backyard party is a great success. At one moment I look around and wonder if we should have just been married here - no fuss, no muss. But, no. We will have our day of public declaration of our vows tomorrow afternoon.

"To love and to cherish. For better or for worse. In sickness and in health…" Omitting the one about obeying. Not going to go that route ever again. Of that, I am sure.

May 30, 1993, at 2:00, Dorothy Gail Frankel Nolan and Dan Clifton Woods are united in marriage. Accompanying Gail down the aisle are her two sons, Jeff and Kevin, one on either side, while the brass choir plays. The bride is wearing a peach lace dress, and the groom is waiting at the altar in a black tux. It is a beautiful, joy-filled service. "Heavenly Father, may we live happily ever after."

When it's time to leave the reception, we run out the doors to find Dan's truck decorated for the newlyweds. Hugs and kisses for many, especially those two handsome sons of mine. They are packed and driving to Alabama tomorrow. May God keep them safe.

Dear Terry and Dana, and countless others who lived life with me,

'Shoulda, woulda, couldas' involve areas of our past that cannot be changed or undone. Memories that will flood us with regret, if we allow them.

Saying "I'm sorry," does not suffice, even if one's whole heart is filled with remorse. Too little, too late.

Searching my memories provides lessons to reflect upon and understand. To help unmask my behaviors and choices in order to clearly see your journey.

During the process of writing my 'coming of age at 38' story, I have unexpectedly been confronted by the peripheral damage of my behavior. Especially to those who have been, and continue to be, a part of my inner circle. The mask provided a means of "keeping my personal turmoil hidden," even without having any knowledge of depression at the time.

Through the evolution of medical science, and the healing journey I continue to take, I am finally able to grasp valuable lessons from my experiences. It is my hope that you too will find, within these pages, some clarity of the times our paths intersected, and the choices I made.

May we all embrace the moments of time gone by and take the lessons learned on our journey forward. My love was always real, and always will be.

Blessings,

Gail

End of Part III

Chapter 25
August 1993 - June 1994

"For I know the plans I have for you, declares the Lord, plans to prosper you and not to harm you, plans to give you hope and a future." Jeremiah 29:11

Let the honeymoon begin. We are spending the night at the DFW airport Hilton as it's convenient for our early morning flight to Miami. The joy of cruising with 20 now graduated teens hits us smack in our faces as we board the plane. The standing ovation is in honor of our being the last two on the plane. Let the comments fly. Hurrying to get settled so the plane can taxi, it quickly becomes obvious that we have "mistakenly" been assigned seats in two different sections of the plane. Our lead sponsor, and a Brock teacher for many, many years, simply says, "Those are your assigned seats. Please sit down."

"Oh, it's going to be like that, is it? A passive aggressive response to our relationship?" I mumble to Dan. This is the same teacher who said we had to be married to go on the cruise. Our

first airplane trip as husband and wife is spent many rows apart. Not worth the hassle. Surely the boat will be big enough for all of us.

The trip really is fun. There's plenty of space to get away, yet we also enjoy gathering for dinner every evening. Good company, and we mix up our table mates to keep conversations interesting. The best night by far is Karaoke night in the disco. Yes, that tenor voice is my husband singing "All My Exes Live in Texas" accompanied by lots of laughter. That's why these trips are scheduled for after the students are not our students anymore. Oh, the memories we all make that week. What happens on Disney Cruises stays on Disney Cruises.

We come home suntanned and relaxed and happy, after what has to be one of the most unique ways to honeymoon. Time spent dreaming and sharing our ideas about "what next?" Dan and I are going to spend the next couple of weeks looking at available teaching positions, especially Band Director positions. If Dan gets an offer, then we'll probably relocate. If not, we'll stay at Brock. Dan has recently been giving me an inside education on "life as the wife of a band director," and I've learned that most districts will "find a job" for the spouses of coaches and band directors they hire. I feel this little twinge in my neck about that policy, but hey, why try to change the Texas good ole' boy system

already? "Don't bite the hand that feeds ya," sounds like the correct cliche.

Off we go on a South Texas road trip, stopping at a few school districts for Dan to interview. South Padre Island is down in this area, so that sounds interesting. A beach town on the Gulf of Mexico that resembles Brigantine would be really nice. I drive around the little towns, or sit in the shade in the parking lots when he is interviewing. The third one is the charm. Jourdanton TX, south of San Antonio, northwest of Corpus Christi, offers Dan a band director contract for the 1993-94 school year. And he would like to accept the offer. It's a 3-A school, with an established band program, and checks all the boxes on Dan's list. "Well, absolutely, Mr. Band Director. Say yes! Remember, if there were no dreams?" I reply excitedly. Escorting me into the superintendent's office to introduce me, I am not surprised to learn that there is an English teacher position open in the high school, and it is mine if I want it.

"Well, thank you sir. Two for one deal sounds perfect for everyone. Would you like to interview me first, though?" Trying not to sound anywhere near as insulted as I feel.

"Oh, that's not necessary, Gail. Dan showed me your resume and Tarleton transcript and you should fit in really well

here at Jourdanton. We would like to welcome you both if you will agree."

At the time, this felt like a bigger hiccup than it was. I was feeling a little disrespected as a professional, but mostly because of our differences in backgrounds. My lack of local knowledge. This is Texas, the land of Friday Night Lights, where football and band programs attract everyone in town on game night. It's how they do what they do, and continue to do even now. I taught English I and II and Speech Communication that year and worked hard to earn the respect of my colleagues and my students. In the long run, it all worked out. We will be blessed to work at the same schools a few more times in our careers. But never again was I hired just because I was the wife of the band director. In addition, over the span of our careers, Dan will be hired twice as the band director after I am already under contract.

We are newlyweds on the move for the rest of the summer. We pay a visit to Brock to resign our positions and pack up our classrooms. It is bittersweet saying goodbye, but exciting to see where we are going. There are trips from Fort Worth to Jourdanton to find an apartment, and a real honeymoon trip, just for the two of us, to Lake Tahoe.

A summer of getting to know so much more about each other. Two thirty-somethings, empty-nesters, beginning a new life together. It's been years since I felt so authentic and free, maybe my entire life.

Soon it is time to hit the road. We stop by for a quick goodbye to Dan's parents. We were able to spend some time at their place this summer and it has been nice. We'll see them soon, as we're right on the way from Fort Worth to S. Padre Island. Long drive, but they have a condo there.

The journey to our next chapter is only about 5 hours south on I-35. "Just down the road a piece."

To this Yankee born and raised, who has lived five years in North Texas in the almost all-white town of Granbury, this journey seems much longer than 5 hours.

To be honest, when we finally arrive in San Antonio, it feels as if we have left the United States of America and moved to Mexico. As I look around, it is very noticeable that the population is way more Tejano than Caucasian.

This will be an exciting learning experience for me and for my students. Just wait until these teenagers down in Jourdanton TX hear my accent.

Our first few months of marriage have been so busy it's almost a relief to get back to the routine of a school year. Jeff and

Kevin make a last-minute visit to San Antonio, which makes this momma's heart happy. Jeff will be in his senior year and Kevin in sophomore year at a new school in a new state. As always, I am glad they have each other for support.

Jourdanton is an interesting town, very rural, yet close enough to San Antonio to make the 35-mile commute. We choose to live in San Antonio for the after-school benefits - food, culture, entertainment. However, many families are going in the opposite direction, desperate to get their children out of inner-city schools. This makes for some tough kids in my classes, along with native Jourdanton teens.

We are definitely not in Brock, Texas any more.

To say this new path is going to take some getting used to is quite an understatement. The wife of the Band director, who has taken on quite a large band program, does not come with a manual. And I believe I am going to have a whole lot of learning to do.

Lacking adult assistants, the band director needs an adult sponsor for the flag squad. "How hard can that be?" I ask Dan when we are talking over dinner. "I can chaperone the group as long as their captain knows what she is doing creatively."

Dan's face shows some slight skepticism at my offer, as he responds, "Well, it's not that you are incapable, but a large

group of teenage girls can be daunting, and time consuming. To say nothing of their moms!"

"How about we both sit down with the flag captain and see how it feels? I'll decide one way or the other after that. It will also help me learn the ropes, you know."

"And you work for free!" Dan says, as he grabs my hands. "Thank you, Gail."

"Oh, it will cost you, Mr. Woods!" I say with a grin.

What do I know about real Texas band programs? Nothing! But by the first couple of practices, I have learned enough to know I will never say "Yes" to supervising another group of Texas teenage girls, and their mothers, again. I can be a very quick learner. They are a breed of humans unto themselves. Almost as bad as cheerleaders, but not quite. The best part about it is it only lasts for the football season. Secretly, I wish for some losing games so the team will not go to the playoffs. Shhh! The football coach is a good guy!

The next life lesson learned involves band practice on the practice football field after school. Flag practice is over, so I am resting in the bleachers waiting on Mr. Woods and the band to finish up. A few students show up and sit a few rows above me to watch. No problem for about a minute, but then they start mouthing off and messing around. Putting on my teacher-face, I

turn around and say, "Can you guys quiet down please? This is band rehearsal time." 'Ignoring' their muttering, the second time comes with the addition of, "You are going to have to leave if…" card. They are not savvy enough to stop, so I reluctantly stand up and escort them from the practice field. They leave, but they are not happy. They are angry. And loud.

I just want to sit in the bleachers, enjoy the afternoon sun, and observe my music man direct his band.

Disrespectful jerks. They sure do not get my philosophy of Respect: Give it. Get it. Got it?

The following day one of our mutual students comes to see me right before lunch. Javier is a member of the band; one Dan has already spoken highly of. He is definitely agitated, so I smile and try to slow him down, "Breathe, Javier. Slow breaths. It's OK." He moves to close the classroom door, but that is not a good idea. Ever.

"Leave it open please," I request, trying to keep my desk in between us. Always better to be safe than sorry.

Moving away from the doorway, Javier shares his message, "Mrs. Woods, I saw what happened in the bleachers yesterday, at band practice. I was going to tell Mr. Woods, but you did good getting them to leave. But I just had class with one

of the guys you tossed, and I overheard him threaten to slash your tires.

My turn to breathe.

Which gives Javier time to ask, "You want me to take care of this guy for you, Mrs. Woods? His name is Cody P."

What?

Did he just say what I think he said? Take care of *him*, not it?

"Oh, no, no, no Javier. Mr. Woods and I will take it from here. But Mr. Woods will probably want to talk with you about it. Thank you so much for letting me know. You did good. You go on to lunch so you don't miss it." I waited a few moments to let him get ahead, catching up with Dan at our lunch table.

Here's the rest of the story, the part where I learned a few lessons. I turn in a discipline referral on Cody, for his misbehavior at the practice field. I add the threat he allegedly made in his class, with Javier's permission. The principal calls Cody into her office, gives him a talk, and assigns him a detention. Oh, and the gates to the practice field will now be locked. Case closed.

Not so fast.

Friday night's football game is an away game, far away. Dan has to drive the band bus, so we park our truck inside the fenced-in, padlocked, school-property parking lot. Do I even need

to say it? When we return late Friday night and unload all the students and various band "stuff," and finally stagger to our truck, two tires have been slashed, and are flat as pancakes.

We are stranded, all alone in the parking lot, 45 minutes from our apartment at 1:00 am.

We both pretty much lose our cool for a while, and eventually walk to the local motel. Too tired to say more than "I love you," we crawl into bed. In the daylight we get a colleague's help, and make it home later that day. Once we finally sit down together, trying to relax, we are both sad and disappointed.

"Damn, I am feeling guilty for triggering the events of last week," I said, hoping to open a conversation about the elephant in the room. "I do not want to dampen your enthusiasm for your new position. If it is better for me to steer clear of your band program, just say the word. I know I have a lot to learn.

"No way do I want that, Gail. How else are you going to understand the ins and outs of the world of band if you stay away? It's not your fault, anyway. These are some pretty tough kids," Dan assures me. "We'll be okay, together. Hopefully, things will calm down soon."

Mostly, we are unsure of how this act of vandalism will be handled, both by the administration and by the students.

Monday morning brings an emergency meeting with the Principal, Cody, his father (born and raised in Jourdanton), Dan, and me. After introductions, and sharing the facts as we know them, Cody's father emphatically declares, "Well, my Cody said he didn't do it, and he doesn't lie. He knows if he does lie I will whoop his ass."

Still sitting and processing what that man just said, I actually hear this woman principal say, "Well OK, Cody, we'll take your word for it then. You may go back to class. Thank you all for your time." Dismissed.

Gavel drop, chin drop, eyes rolling up into my forehead.

Nothing else is addressed. No reimbursement. No "We're sorry and how can we help?" Nothing.

Lessons understood: administrators do not always back their faculty, especially when someone else hires them. I definitely need to be more aware of where I am and who is with me. Being the wife of the band director is much more visible than teaching English. And this place has a different breed of Texan.

They're people unlike any I have ever had in my life before. Oh, Dan, where have you brought me?

Our bright, shiny happy faces have dulled a little by the time marching season is over. Dan experiences some inner band rumblings, yet pulls together quite a spectacular show featuring

Phantom of the Opera. I support him as best I can. We have subtly developed a buddy-system when not in our respective classrooms. The ole 'I've got your back' kind of thing. It eases both our minds.

However, we do have to teach our own classes.

Texas state standards dictate much of the curricula, and the textbooks reflect the grade level choices. English I students read *Romeo and Juliet* and English II reads *Julius Caesar* across the state. Same for writing and grammar textbooks. Where there is some choice available to the teacher is through the "independent novels, etc." selection. New teachers are often subject to choices based on "whatever's left in the book room, plus has enough copies to cover the class." That is why in the last month of the fall semester 1993, in my sophomore English classes, we are reading *A Separate Peace,* by John Knowles. A coming of age novel set in a boys' boarding school during World War II. Nominated as one of America's best-loved novels by PBS's The Great American Read.

Given a choice, it probably would not be my first pick for a mixed-race, lower economic population.

Wrong! A positive lesson learned is that it's just as important how you present the literature as the author's words themselves. These tenth graders really get into the story of teens

living in a world they cannot even imagine. Their written responses may have multiple spelling and grammatical errors, but their comments are spot on.

"What kind of friend would try to make his friend fall out of the tree?"

"What kind of name is The Super Suicide Society for a gang?"

"Are Finny and Gene gay?" And so much more.

Given the right time and the right place, teens have something to say worth listening to. Even teachers can gain knowledge from their students' introspection.

I vow to hold onto that thought throughout my career.

A few weeks into the book unit, riding high on the continuing success of this novel, I am smacked off my perch by the classroom door opening and the appearance of a uniformed and armed police officer entering my classroom. Still momentarily stunned, I hear him say, "Mr. Juan Castillo, get your stuff and come with me right now." Thankfully, Juan cooperates and seconds later the door closes. 25 pairs of eyes are looking at me. Expecting some administrator to show up any minute, I tell them the truth, "I really do not know why that just happened, but I am relieved it went smoothly. Hopefully I will hear from the office soon."

"Mrs. Woods, Juan is sorta' a scary guy. He moved here this year from San Antonio," shares my trusted student, Javier.

"Well, let's just wait until we know what really happened before we start rumors. OK class? OK everyone, pack up. The bell's about to ring."

Two classes later, I have to take myself down to the principal's office to learn the details. Sticking my head in her doorway, she glances up and says, "Oh, Mrs. Woods, I was going to come see you later. We did not have any advance warning about the police coming here this morning. So sorry."

"Just a quick knock on the door would have helped," is my spontaneous reply. "I could have come out in the hall first." But I really just want to know what happened. "Do you know what's going on?" I ask, thinking I have to work with this woman for six more months, at least.

"Juan is suspected of assassinating a rival gang member Saturday night. Shot him point blank and left him in a ditch on the side of the road just outside Jourdanton."

Now I am down, dropping into a chair, trying to breathe. My mind is racing. While I've been teaching *A Separate Peace*, a 15-year old student has been sitting at his desk after allegedly killing another teen on the weekend.

What the hell?

What if I had said something he didn't like? What if I had thrown him out of the practice field? As I slowly make my way out of her office, I ask the secretary to get word to Mr. Woods to please come to my classroom as soon as he can.

I need my husband's support.

My decision is made in my heart by January. I do not want to stay in Jourdanton next year. I have learned enough lessons to last a long time. I show up for school each day, but can feel the fog and anxiety invading my space. An "I'm there but not there" feeling. Doing enough to get by, but my enthusiasm has been squashed.

The principal eventually has the last word, and a little bit of revenge, when she does not offer me a contract for the next school year.

Surely, when I explain the situation at future interviews, I will be given the benefit of the doubt. Right?

Dan will survive a few more months of various hills and valleys with the band program, but in due course, he accepts defeat too. We are not a good fit with Jourdanton.

Where shall we go next? Not anywhere else in south Texas.

Here's a little hint...remember the football coach I mentioned earlier in this chapter? Coach D. is such a great guy he

gave Dan a lead and a reference a month ago for a band director job in Blooming Grove, TX, a small town back up in north Texas.

"You should always take the best from the past, leave the worst back there and go forward into the future." Bob Dylan

Chapter 26
June 1994

"Things falling apart is a kind of testing and also a kind of healing. We think that the point is…to overcome the problem, but the truth is that things don't really get solved. They come together and they fall apart. Then they come together again and fall apart again. It's just like that. The healing comes from letting there be room for all of this to happen: room for grief, for relief, for misery, for joy." Pemba Chodron

I'm finally noticing.

There has always been a connection between the rhythm of my life and my "episodes," for lack of a better name. When I experience unexpected incidents, an event outside the routine, it messes with my health. The worries creep in, my self-worth drops, and my digestive process suffers.

When life is steady, with moments of down time, I feel better.

Hmmmmm?

I also notice that being able to talk truthfully with someone who gets me helps significantly. Communication lessens the severity and the length of the fog. I am getting more and more comfortable without my mask. And Dan is getting adept at noticing when I back slide and reach for it.

Oh, and by the way, our love for each other grows stronger every day.

'On the road again' is beginning to develop into a theme for our lives. We also find ourselves repeating *The Road Less Traveled*, by Robert Frost, as we travel across Texas. "*...Two roads diverged in a wood and I - I took the one less traveled by, and that has made all the difference.*" I like the roads the two of us have traveled so far, even with all the bumps and potholes. We are smarter, and stronger for the experiences.

Traveling north on I-35 is not a road less traveled anymore. Knowing we were leaving Jourdanton, we have driven back and forth a few times recently, looking for teaching jobs for the 1994-95 school year, and prospective places to live. So, the 'Panties on the Road' movers head north. With the truck packed securely, we are already celebrating Dan's new position in Blooming Grove TX.

In addition, once Dan accepts his new job offer, with my blessing, we actually pin Blooming Grove on a Texas map, and draw a circle around communities within commutable distances. We have previously agreed that the first to get an offer will be where we place the compass point. This circumference serves to guide our search for a home within commutable distance, and my search for schools who need English teachers.

We have found a new home to buy. We are so filled with excitement, knowing our home-to-be is well within the 'circle,' out in the country a little bit. We are waiting to close on our first house and five-acres of land in Maypearl TX. Plenty of room to breathe, and lots of room for visitors.

After a few hours of driving, Dan laments, "Too bad Blooming Grove doesn't need an English teacher. We would begin this summer with two secure contracts."

"True, but I already have a few interviews lined up. Schools need a lot more English teachers than Band Directors," I reply. "So, I feel confident. If I am completely honest, I am kind of gun-shy about a repeat of Jourdanton. I feel a need to prove my qualifications on my own merit."

Ha! My summa cum laude transcript from Tarleton and my references from both Jimmy Branch and Mr. Cheek at Brock

mean nothing to the principal interviewing me at West High School. Stopping to meet with him on the drive north, the interview is going well, and we are strolling around the campus when he very unethically asks me, "How familiar are you with German Lutherans who settled the town of West years ago?" Really? Another fine example of Texas being its own little country!

Well, that's an awkward question, but I answer truthfully. If I refuse, I feel like the interview will definitely be over. "Truthfully, I have already enjoyed teaching various groups of Texans, but I do not believe many were of German heritage. As for being Lutherans, I really do not know. It is not something I feel is relevant in my classroom."

Sounds good to me, but I guess not to him. The interview wraps up quickly after that, and we are back on the road after stopping for some wonderful German pastries called Kolaches. Seems like a good trade off. No job offers, but great dessert.

It's time to head for our temporary landing spot, the Woods homestead. It will be great to see Jay and Dena, but we are also anxious to set up our own home.

We only have a few days in the area before we head out to Alabama to celebrate Jeff's high school graduation. We are both very proud of his determination.

The second day back in Mansfield, I have an interview with Ferris High School, for a high school English and Speech position. Well within the commuting circle from our future home in Maypearl, across country roads - my favorite. It would be a fun commute in my little red Toyota.

Dressed in my best interview outfit, with my portfolio in my hand, I am welcomed at the front office by a very friendly school secretary. I have known for a long time that the lead secretary is the most important person in the building. Jourdanton's was kind of scary! Miss Chisholm is just the opposite. "Well, you must be Mrs. Woods. Welcome to Ferris High School. Just have a seat and Mr. G will be right with you, honey."

"Thank you, ma'am. I appreciate it," trying my best to not let my Yankee accent give me up, yet.

I just sat down in the chair when I see a man coming out of the office down the hall. He is smiling, and doing some sort of bowing, imitating the "I am not worthy" motion. I start to get up, giggling, when this professional casual dressed, upper 30s man

emphatically states, "Mrs. Woods, welcome to Ferris. Jimmy Branch says you walk on water, and that we should jump at the chance to hire you. Come in. Come in."

Quite an icebreaker. The lighthearted tone continues, in spite of my preconceived notion that interviews should be taken seriously. In between our banter, Mr. G checks my transcripts, flips through a few other references, and casually asks me about my classroom philosophy. "I treat my students with as much respect as they earn. It is my expectation that each one will try to achieve their very best, with the knowledge and teaching methods that I put in front of them. I set a high standard, with lots of support for every student to reach those heights…"

"That's excellent, Mrs. Woods. Your words match what your references say. Let me visit with my superintendent, and we'll let you know in a few days."

It feels good; it feels right. It's a nice campus. The classrooms are a good size. And Mr. G and I certainly clicked. Sending up a prayer as I drive toward the Woods' place.

I am just walking in through the kitchen door when the phone starts ringing. My mother-in-law Dena answers it and says, "Well, yes, she is just walking in the door now," and hands me the receiver.

"Yes, this is Gail Woods...Hello, Mr. Gibson," I sputtered. "I did not expect to hear from you so quickly!"

"Oh, Mrs. Woods, I knew I wanted to hire you before you even came to the interview. You come very highly recommended. We would like to offer you a teaching contract for the 1994-95 school year."

"Well, thank you, sir. I gratefully accept. And I look forward to working together." Sitting down on the kitchen stool Dan offers me, I am bursting with pride and joy.

"Great! Good to have you on board. Come back over tomorrow morning, and we'll get the paperwork signed. See you then."

"Thank you," and he's gone.

Ahhhhh! A very excited, happy dance is going on in the Woods' kitchen, with Dan, Dena, and me. We will close on our home in Maypearl in a few weeks. In August, Dan will go to work in Blooming Grove, and I will head to Ferris.

Breathe in, breathe out. The pieces of the current puzzle are falling into place.

Let's go see Jeff and Kevin. Huntsville AL here we come.

We have seen Jeff and Kevin three times during this school year and talk on the phone regularly. They came to Texas during Christmas break, we went to Huntsville during Spring Break, and now it's graduation time for Jeff. They live in a house with two adults, Gary and his new very young girlfriend. Every time I ask how things are going, everyone says, "Oh, fine. Just great. No problems," and I accept the answers.

Now, at the end of the school year, as we gather at their house before graduation, I am told the truth: Kevin missed 60+ days of school, only passed English II and Drivers Ed classes, and somehow, they all managed to avoid the truant officer all year.

Two steps forward for Dan and me, one big step forward for Jeff, and a giant leap backwards for Kevin. Dammit! What did I just say about the pieces falling into place?

"You know, this is a terrible time to tell me this news, now that it's too late to save Kevin's year." I am angry and sad, but at least see some slight shame on Kevin's face. Neither Gary nor his girlfriend have anything to say and are hanging back in the kitchen.

"We're here to celebrate Jeff's accomplishments. He successfully completed his senior year in a new school, after all he went through last spring, and we are really proud of him."

Determined to not let Kevin's news dampen Jeff's graduation, I give Jeff a big hug.

"Kev, why don't you, and Jeff if he wants, come have breakfast with us at our hotel? You can share your plans for your future then." Rarely do I not have unlimited hugs for either one of my sons, but today my arms are just too weary. "Now, let's go so we're not late!"

When we hugged goodbye a year ago, after our wedding, it was Jeff I was worried about. There was still some residual fuzziness in his thoughts. But he did it. He has always had to work harder for good grades than Kevin. I imagine he drew on some of that determination.

I have tears in my eyes as he marches across the stage to accept his diploma: tears of joy for Jeff's success, and tears of disappointment in Kevin. In addition, I am angry that Gary dropped the ball the first time he was really needed. Why was Kevin allowed to miss all that school? Who was parenting him all year? 15 and 16 -year-olds still need supervision. Wonder what Dan thinks about this?

Stop the whirling thoughts. It's Jeff's night.

Smile.

By the time we are back in our hotel, sitting in bed, we both confirm we are on the same page. "Kevin made his choice to live with Gary. He also made the choice to abandon school. It seems to me he has another choice to make now," Dan shared.

"I agree completely, Dan, but I need to know how you will feel if Kevin moves in with us. Our assumption all along was that the guys would live with Gary. Will you be okay full-time parenting a teenager for two years?"

"Absolutely. I knew you had sons before I fell in love with you. I feel like we need to offer that choice to Kevin. We even have a bedroom for him at our new house. Come back to Texas, live with us, and finish high school, or stay here and work at McDonalds all your life."

"I love you, Dan Woods." I stop for a moment and thank God for bringing us together. "Seems pretty cut and dried to us, but Kevin may feel differently. What's done is done, but hopefully his school credits are salvageable. We'll talk with him in the morning. Sleep well."

"Have sweet dreams, Gail. Remember, we are in this together now. You do not have to carry your sons alone. I love you too."

The breakfast meeting goes pretty much like I expect. Neither Jeff nor Kevin are great conversationalists yet, definitely taking after their dad. Questions such as, "What were you thinking, Kevin?" are answered with monosyllabic sentences, "I don't know." "What are you going to do now?" gets the same reply from Kevin, but at least Jeff has some plans.

"I have applied to the University of North Texas in Denton, to study geography. Dad said there is money available from Pop Pop Frankel's estate for education expenses. But first we are planning to drive to New Jersey and stay at Aunt Karen's house for the summer."

"Jeff, that all sounds like a good plan, if Aunt Karen knows you two are coming. One thing is for sure; you will have a blast staying at that party house."

Once it becomes obvious that Kevin has no idea how to get his life back on track, we suggest our plan. "Kevin, we would like you to come live with us in our new place in Maypearl. You can go to the high school at Ferris, where I will be teaching. It seems like a good school, not too small and not too big! Of course, you will live under our roof, our rules, and you will finish school."

I believe I see the first glimmer of hope in Kevin's eyes. My heart hurts for him as I realize how deep a hole he dug for himself. Too many changes in his life for a sixteen-year-old to manage. It feels right to offer him a lifeline.

"I know I messed up, Mom. It got so I didn't know how to fix it," Kevin says quietly. "If you and Dan are willing to help me, I would be nuts to turn it down. Dad is leaving for Saudi Arabia soon and so I for sure can't stay here. Thank you both. Seems like a better choice than the ones I have been making. I would still like to go to Aunt Karen's with Jeff, and then I'll be in Maypearl by the end of July. Promise."

The crisis is over by the time we get back in the car to head home. Hugs with both guys feel good. In the few days we have been in Huntsville, the puzzle pieces of life are being juggled again, but we have been here before in our brief time together.

"The truth is that things don't really get solved. They come together and they fall apart."

Repeat.

Our immediate plan is to move into our new home, now including setting up a bedroom for Kevin. His decision is made to come back to Texas and live with us. I am pacified by that

decision, but assign Kevin the job of telling Gary, since this situation was created by the two of them. "Tell your dad if he has any questions, he should call me."

I won't have a new phone number for a while!

I have no idea, even years later, how that conversation went. I do know Kevin moving back in with me and Dan created a rift in his relationship with his dad that has been slow to heal over time. Seems Gary wanted Kevin to live in New Jersey at his Aunt Karen's. She was willing to do it at no cost to Gary. So, our offer changed that scenario. The situation was exacerbated by the legal changes necessary as a result of Kevin's change of residence. I had not originally requested child support, as the guys were going to live with Gary. Now I would be Kevin's custodial parent. Seemed matter-of-fact to me, but Gary absolutely refused. Even with legal intervention, the subpoena was finally served just as Gary was getting on a plane for the job in Saudi Arabia. Didn't have to be that way, but Gary was always tight-fisted with his money.

Hopefully, we will all have time to enjoy the summer and begin the next school year relaxed and ready.

Why does it feel like Deja vu all over again?

"Money can buy a house, but not a home. Money can buy a bed, but not sleep. Money can buy a clock, but not time. Money can buy a book, but not knowledge. Money can buy food, but not an appetite. Money can buy you friends, but not love."

Daily Inspirational Quotes

Chapter 27
August 1994 - June 1995

"God grant me the serenity to accept the things I cannot change; courage to change the things I can; and wisdom to know the difference. Living one day at a time; enjoying one moment at a time; accepting hardships as the pathway to peace..."

Reinhold Neibuhr

It's a hot sunny day in North Texas. The back roads between Maypearl and Ferris provide views of farmland, tiny towns, horses and cows. Relaxing sights on the way home from the school day, I bet. I am heading to Ferris to talk with my new principal about enrolling Kevin. It's usually a given, to enroll the faculty's children, but this situation seems like it needs a face-to-face visit. "Good morning, Mr. G. Hope you don't mind me stopping by unannounced. I wanted to get some planning materials, and visit with you for a minute, please."

"Not a problem, Mrs. Woods. What's up?" Mr. G asks.

"Well, since I signed my contract last month, there have been a few changes in my family. My 16-year-old son Kevin has

moved back in with Dan and me. So, I wanted to talk with you about registering him at Ferris. I should prepare you: he comes with issues!"

"Ahhh, how bad can he be? Jimmy B didn't mention anything about Kevin when we talked." *Gotta love the good ole' boy network in Texas!*

Here I go. Sharing my personal baggage with my new principal. Before I even have a chance to prove myself in the classroom. "I got a divorce at the beginning of Kevin's 9th grade year, and at the end of the school year he moved to Alabama to live with his father. Unfortunately, he managed to miss 60+ days of his sophomore year. He passed Driver's Ed and English, 1 ½ credits. That's it. From the honor roll to the bottom."

I am pretty sure I hear Mr. G mutter "Oh shit," before he is ready to speak out loud. I am also sure it won't be the last time I hear it. At this moment I am angry at Gary, his girlfriend, and Kevin. How could they just ignore what was happening? I managed to keep both boys on the honor roll for 10+ years.

"How about this idea, Mrs. Woods. I want to stop you here, and let's get Kevin in here to speak for himself. One-on-one with me. If he convinces me he is willing to do what it takes to catch up, and then move forward, then we'll sit down and figure

out his course load. Of course, this all hinges on whether you want him to be here at Ferris."

"Seems to me he has earned some close supervision for the next two, or three years, so yes, I do want to have him under my nose. He will be back in TX in two weeks, and I'll bring him in immediately. Will you put it on your calendar, please?"

"Sure thing. Hey, the faculty here will help him, if he meets them halfway. It sounds like it's time for Kevin to do some growing up. He's not the first one to go through this."

I chuckle about those last words on my drive back to our house in Maypearl. It is time for Kevin to grow up, but it's also the perfect time for me to give him the room to do that. Sending him to this meeting with Mr. G alone seems like a good start. Whatever the two of them decide, I will be supportive, but from a distance.

Fourteen days later, Kevin and I are driving over to Ferris so he can meet with Mr. G. I hope this works! In my brain, I know I raised my sons to be good people, and to take pride in what they do. My heart hopes that all has not been lost in just one year. My prayer is that Kevin wants the same.

All I know about Kevin's first visit in the principal's office is that Mr. G agrees to enroll Kevin at Ferris. After an hour of working in my new classroom, emptying boxes, arranging

desks, etc., Mr. G walks in alone. "I have one question for you, Mrs. Woods. Are you willing to let me be Kevin's go-to guy on campus for a while? Will you trust me with him? He has some 'stuff' he's carrying, and you should probably not be his safety net. Give me a semester and we'll see how it goes."

Whoa. I hit it off with Mr. G right away, but this is way more than that. "Is Kevin willing to have you play that role?"

Abruptly, he says, "Yes or no, Mrs. Woods?"

Breathe. "Yes," I say, taking a leap of faith.

"Well, OK, I'll go tell Kevin how it's going to be, then. We'll get the counselor to work on his schedule of classes. I got him, Gail."

As my 4th school year begins, my prayer is that we will all be able to stay put for a while. There have been a lot of moving pieces for the past few years, and that alone wears me out. For sure, I am much happier and healthier with Dan in my life, but we are both ready to put down some roots. We have a home with acreage in Maypearl, a commitment from Kevin to turn around in the right direction, and Jeff just an hour away at college.

Let's make it a good year. Please.

Once again, we are all adjusting to new schedules. Kevin comes home from his New Jersey visit with a used car from his Pop Pop Frank, so at least he does not have to commute to school

with his mom. He also wants to get a part-time job. Dan heads off to Blooming Grove, the one with the longest of days due to marching band. I am teaching a few sections each of English I and II and Speech, which is the least number of different preps I have had. Full classes, but so far so good. As always, it feels good to be back in a routine. I have grown more confident in my role as teacher, and totally enjoy my time in the classroom. Administrative stuff, negative parents - not so much.

Kevin has the most difficult transition of us all but seems to be aware of the importance of getting back on track. All is not smooth, but Mr. G, who has now become Danny G, is holding him accountable at school. Seems he also spoke in detail to all of Kevin's teachers before school began, and my new colleagues are on board with keeping him informed on Kevin's progress. *Desperation must have affected my need, and Kevin's right, for privacy! I was very trusting of Danny G, too. Thankfully, it was not misplaced. We had an outstanding professional relationship for years.*

Dress code issues pop up, as Ferris requires shirts to be tucked in! Defending one of his new classmates against a "mean Ferris girl" in the cafeteria earns him time in in-school suspension for describing her as a "bitch." However, he is doing well with

his grades. I am so appreciative of the support of so many new friends at Ferris High School.

At the house, there is plenty of room for all of us - a living room and bedroom on one side for Kevin, kitchen in the middle, and family room, guest bathroom, guest bedroom and master bath and bedroom on the other side. All the privacy we need whenever we want some.

As the weeks zoom by, and we all adjust to the many changes, I can feel the tension easing in each of us.

Could we be heading into a peaceful lull? That would be heaven.

By now, I should recognize God's hands all over this "peaceful lull". It is a way above-average semester for all of us; not perfect but pretty darn good. Kev is passing all his classes. He even meets his future wife in Chemistry class, and by December, Dawn asks him to go Christmas shopping with her.

"Ma, Dawn asked me to go Christmas shopping. What should I do?" Kevin asks, stopping by my classroom during the passing period.

"Ask her what time you should pick her up, Kev. Nothing like dating a cheerleader to perk up your mood."

Really enjoying my classes, for the first time my confidence overpowers my doubts. Dan continues to work hard

with his band program at Blooming Grove, and the Friday night football games end our work week. I really dislike going into the band hall before the game. All those musical instruments tuning and warming up is the definition of cacophony to my ears. On the other hand, I love sitting with the band and witnessing their spirit. Even Jeff has settled into college life, living in the dorm, working in the cafeteria, and doing well in his classes. We would like to see him more often, but Kevin frequently heads up to Denton on weekends to hang out with him. He keeps us posted on life in college town.

Compared to the past few years, the 94-95 school year definitely feels like a hiatus from chaos.

Until it doesn't.

Well…we almost make it to the end of the school year.

It's a lazy Saturday morning at the Woods' house, and Dan and I are still lying around in the bedroom waking up! When the phone rings, I answer it and hear my sister Barbara's voice say, "Hi, Gail. It's Barbara."

"Well, good morning, Barb. How are you? Is everything OK?" I ask, as it is not a 'normal' time for her to call. We chit chat for a few minutes, and then she shares the reason for her call.

"I am sorry to tell you that Uncle Bill died. He called me from the hospital and asked me to come to Florida right away. So of course, I flew there as soon as possible."

Naturally, I am stunned, and wondering what happened. "Oh, no. That is so sad. 'Unkie B' was the coolest uncle ever. Such cool memories we made with him riding bikes and playing miniature golf on the Boardwalk. What happened, Barb? When?"

"He had been sick for a while but didn't want anyone else to know except me. He was admitted to the hospital with congestive heart failure, and a few other problems. That's when he called and asked me to come. I spent the last 3 days at his bedside." I switch hands on the phone so I can hold Dan's hand. My heart does not like where this conversation feels like it is headed.

"Thank you so much Barbara. At least he wasn't alone. That helps to know. I hope you are doing okay. When is the funeral?" I ask her quietly. "I'll make arrangements to fly out."

"There isn't going to be a funeral, Gail. He has already been cremated, and his ashes scattered over the lagoon. Those were his last requests. He died a week ago. I am already back in Minnesota," are the words Barbara says that light the fuse of the time bomb inside my body. I bet Dan can feel my hand begin to warm up.

"What? He has already been cremated? Did you let Mom know, or Aunt Janet? Our brother, Bill? Anyone? This doesn't make any sense."

For the second time in this short conversation, Barbara answers, "It was the way Uncle Bill wanted it. His last requests. I just did what he asked me to do."

I need to hang up right now. This does not sound right, nor does it feel right in my gut. "Barb, I am sure I will have more questions later, but I need to hang up now. I'll talk to you later."

Jaw drop! Phone drop! Head down. What the hell just happened?

Quickly filling Dan in on the other end of the phone conversation, my frustrated tagline is, "My family sucks at death. My brother John, my sister's two little babies, my Grandad Deatcher, Pop Pop, my Granny Deatcher and now Uncle Bill. I have only been to one of their funerals, and that's because Mom and Daddy weren't going. That cannot be normal?"

As Dan comforts me, I try to slow my breathing and wrap my head around the conversation. "Basically, according to Barbara, we are to believe that she is the only one Uncle Bill trusted with the information that he was sick, about to die, and wanted to be cremated. Plus he did not want her to tell anyone else in the family until it was over. And she followed his wishes."

"What would make him choose Barbara, and shut out you and your brothers?" wonders Dan. "When I met him last year, he seemed like he loved all of you, and was grateful to have you in his life. This does feel weird. Give it a little time and see if Barbara reaches back out."

Within hours, I hear from my mom and my younger brother Bill. They all received the same incomplete information from Barb. So did my Aunt Janet, Mom's youngest sibling. Bill wants more of an explanation as soon as possible. I sense something is off, but cannot imagine Barbara doing anything underhanded, and Mom (and Daddy) request patience from all of us; trying their damndest to give their oldest daughter the benefit of the doubt.

And so we wait. School ends, and Dan and I are heading off for a planned camping trip from up to North Dakota and back. Kevin is working at a local car wash, so he'll be around most of the summer. Jeff is staying up in Denton. We will check in by telephone when we are able. And in case of an emergency, they will be able to reach out to Dan's parents.

Speaking of parents, it's time to check in with mine from the freezing northern part of the US. "Hi Mom. We are in Keystone, South Dakota enjoying every minute of our trip. Parked amid a forest of tall pine trees that smell wonderful. It's a

little cold up here in the pop-up camper, but we stocked up on warm clothes at Walmart. How are you and Dad? Anything new from Barbara yet?"

"We are just fine, Dorothy Gail. Enjoying time with young Nicholas, while Bill and Leslie work. Bill reached out to Barbara to offer to help her with Uncle Bill's estate, but she turned him down. Said she was handling it."

"Bill's offer to help makes perfect sense to me, since he is in Florida where the will was drawn up, and she is in Minnesota. Weird! I'll get in touch with her when we get back to Texas in a few weeks. Stay healthy. Love to all of you in Florida."

Seems as if traveling hundreds of miles across this beautiful part of the country is not enough to remove this quandary involving Barbara. The questions came with us, and the answers are nowhere to be found.

"Time to head for home, Dan. Slowly!"

"A lack of transparency results in distrust and a deep sense of insecurity." Dalai Lama XIV

Chapter 28

June 1995 - Jan 1996

"When doctors rule out all of the possible causes of fatigue, body pain or intestinal problems, it may be time to take a closer look at the mind. Even if there's not something physically wrong, your body can show signs of depression in a physical way because your mind and body are connected." Amy Williams Ph.D.

Somewhere during our 2000+ mile road trip through ten states, in spite of all the beautiful distractions, my body chemistry begins to rumble. Hard as I try, my brain is having a tough time shutting out the "Barbara situation." I should feel great, enjoying time alone with Dan, through amazing scenery, yet I feel restless and moody. I begin to pay closer attention to rest stop locations, just in case of bathroom emergencies. It's not yet a serious problem, but it is uncomfortable.

Every once in a while, Dan or I will bring up this mind-boggling situation, but we are just as clueless now as we were weeks ago. "One thing I do know, Dan, is that silence breeds mistrust. That's just a truism. We are worrying because of what we don't know. Barbara will not let anyone in. I wonder what Ed (Barbara's second husband) thinks? Maybe I should ask to talk to him."

"Try to relax, Gail. Worry won't change anything, right? We'll figure it out when we get back home. I love you and want you to feel good," assures Dan.

Hmmnnn. I haven't said anything yet to Dan about feeling a little 'off' but I guess he is learning to recognize the signs. "I want to feel healthy, too, Dan. But I am beginning to wonder what's going on with my digestive tract. I'll see how I feel when we get back home. Promise."

"The best laid plans of mice and men…" It's August by the time we get home, and the new school year is just around the corner. Hopefully, it should be a somewhat smoother year, as Kevin and I are both returning to Ferris. And we're both in a much better situation than a year ago. Dan is off to a different school, but it is closer, so that should cut down his time commuting.

I did try to talk with Barbara and Ed on the telephone, but Barbara just pressed 'repeat' on her answers. Asking to talk with

Ed, I questioned, "Do you know what the heck is going on with Uncle Bill's estate? Barbara is being practically silent."

"Well, Gail, try to look at it from Barbara's perspective. Look outside the box, if you will," said Ed, the engineer. It is one of his favorite lines. But nothing more. That's clear as mud.

What is clear is that Barbara's silence is ringing loud alarm bells, but Mom and Daddy are still preaching patience. It is also becoming clear that my digestive issues are growing worse, but the cause is still unknown. My local family doctor hasn't been able to figure it out, so my first appointment with a gastroenterologist is finally scheduled for next month. The positive side effect is weight loss, but I can think of much better ways to shrink.

With years of experience, I slap that smile mask on my face Monday-Friday during school days, no problem. I am determined to keep my private life out of my classroom. Kevin is doing much better, and believe it or not, is on a path to graduation in May 1996. When not at school, he works hard loading and unloading trucks for Rodeway in Fort Worth, and it is nice to see him take some pride in himself. He and Dawn are still in a relationship, so what free time he has is usually spent with her.

About the first of October, my brother Bill finally runs out of patience. Taking it upon himself to check into public probate

records, he unearths what seems to be an answer to Barbara's behavior.

Calling me with his startling discovery, he sounds stunned on the phone. "Uncle Bill's last will and testament is dated the day before his death. The signature of record is Barbara T., who is also the executor, and the sole beneficiary. The document directs her to disperse any and all of Uncle Bill's funds to charities of Barbara's choice."

Silence follows, while we both struggle to breathe. Knowing the answer to "what has Barbara done?" only exacerbates my growing list of concerns. My thoughts are whirling...Oh my God, why would she do this? Why? Of all of us, she is already well-off thanks to Ed. Daddy will be so disappointed and angry with her. What about Uncle Bill's sisters, my mom Anne and Aunt Janet, and his other nieces and nephews? There has to be more we do not know. Could Uncle Bill have pressured her?

"Gail," Dan says loudly, breaking into my panicky thoughts. "Breathe, sit down, and please hand me the phone. I need to talk with your brother."

"What do you think we should do, Bill? Have you told your parents yet?"

Bill lets us know that he is headed over to see them when he hangs up. Evidently, time is of the essence now. No more time for patience. The estate will clear Florida probate in a matter of days, unless someone files a challenge. In one week, the matter will automatically be settled. "Well, call us back when you have a plan. We'll help in any way we can, Bill. It's going to be tough to explain this to Anne and Gordon. Thanks," Dan says as he hangs up.

The fuse that has been burning inside me since Barbara's infamous phone call four months ago is now being fueled by consistent fires. A classic case of how knowing more is not necessarily a good thing. My physical symptoms ratchet up to a new high…fatigue, headaches, chronic diarrhea, and lack of appetite. Yet, the doctors I am seeing for the digestive issues keep running the same gastro tests and yet finding no answers. Unfortunately, they do not ask the right questions and I continue to be unwilling, and unable, to remove my mask.

During these last few months, "Barbaragate" (the horrible label we created for all things surrounding Uncle Bill's death) intensifies. Now that the contents of the will have come to light, moving quickly becomes imperative. An injunction is filed within days, and soon the details begin to surface. Aunt Janet shares that their mom's (Granny Deatcher) estate was never dispersed by

Uncle Bill. Janet had seen his previous will, and his estate was to be divided among his 6 nieces and nephews, Janet and mom's children. So, she thought all would be fine in the end. The two sisters are advised that they have to file a lawsuit against their daughter and their niece, Barbara. That way the probate will not go through. Depositions will be taken in January 1996.

Day by day, one foot in front of the other is my current mantra. I cut off all phone conversations with Barbara, but a short series of letters are exchanged. I try my darndest to break through Barbara's wall, and she holds strong to her "doing what Uncle Bill requested" story.

Once again, I am able to teach each day, masking my feelings, and most of my health issues. No way do I want my colleagues and students to see me as anyone other than a successful, optimistic teacher. Just like I did in the past, I do feel haunted by that old fear about needing to be stronger and better than ever, in order to not make the situation worse for my parents.

We talk on the phone, but the calls become "short, sweet, and to the point," controlled by Mom. "How are you, Dorothy Gail?"

"Fine, just fine. How are you and Daddy?"

"Doing fine. Looking forward to seeing you and Dan for Christmas. Love to you both."

"Love you too, Mom. What is…?"

Silence. She's hung up. *Absolute truth. For years, I would make a list of what I needed to talk about, but 99% of the time the conversations were controlled by Mom's agenda. Short, sweet and to the point.*

Dan is my shelter from the storm. He doesn't have the answers, but he encourages me to continue looking. "Something is not right, Gail. There just has to be a reason for your gastro issues." His concern helps keep me motivated to not give up searching.

"Well, my next appointment is after Christmas, at the Baylor University Medical Center's digestive diseases department. Surely, they will at last be able to diagnose the problem. I am wearing down. I feel it."

"I know, babe. Take it as easy as you need to around the house. Kevin and I have got you covered. I love you." As we hug, Dan throws out one more question, "Are you going to be okay to visit your parents for Christmas? They will notice your weight loss for sure."

"Sadly, I know how to play the part. I have been doing it for years, right? So, yes, let's go visit, but maybe not stay as long this year. How does that sound?"

"Sounds like a plan."

It is the plan, but my expectations are set way too high. As soon as I see Mom and Daddy, it's obvious that we have all been silently suffering. Such a sick way to behave. Dad looks like he has aged a lot, like he's been beaten down by life. Mom is still running around like the Energizer Bunny, but only because if she stops, she'll have to deal with reality. I can see it in her eyes. Bill focuses on doing what the lawyers need and shielding Mom and Dad as best he can. He is wound up tight as a guitar string. What a dysfunctional family group.

I must look at pictures to really remember this Christmas visit. We kept up the Santa Claus routine for Nicholas and his little baby sister, Lauren. There are photos of us at Bill's house, watching them opening packages. Dan made sure he got to play golf on Christmas Day. And I have a vague memory of one conversation among all the adults about the upcoming legal event - Mom and Aunt Janet giving their depositions. The conversation ended abruptly when Bill lost his cool and raised his voice in frustration at Mom, and then walked out. Whoa, that does not

happen in our family. Definitely a difference of opinion there. We were scheduled to leave the next day. Thank you, God.

The new year brings more of the same, at an even quicker pace. Anxiously anticipating the visit to Baylor Medical Center, with a leader of their gastro unit, Dan and I show up nervous, but quite hopeful. We are at the top hospital in the metroplex. They have been sent the results of the multitude of tests already run in the past few months. Lots of evidence, but so far, no answers. Now is the time. Leaving Dan in the waiting room, I am shown into the doctor's office first, to have a conversation before an exam. He walks in with a quite thick file, and greets me cordially, and opens with the now standard, "Well, tell me what's been going on, and how I can help you" line. I am a little startled, assuming he would already know some of that from studying my file.

But I take the time to answer his question with my rote reply, "I have been suffering with chronic diarrhea for months now, and multiple doctors have not been able to pin down the cause. I also have a few other concerns."

"Okay, Mrs. Woods, I glanced through your file, and I am going to schedule you for our complete battery of tests. Only by doing that will I be able to get the complete picture," Dr. "Gastro" explains very matter-of-factly.

At that moment, my long-lit fuse hits its first target. I jump up immediately, and shout at the stunned doctor, "I will not be treated so condescendingly. I have been sick for months. I will not go backwards and start over again. I took the time to have all my previous results forwarded to you for a reason. This is not why I came to Baylor. I came for answers now, today!" And then I charge out of his office, grabbing Dan on the way through the waiting area. Somewhere along the way to the parking garage, I lose it, with a confused Dan right there holding me.

"Damn, damn, damn. What is happening to me?" I cry.

Home we go to Maypearl, with still no solution in sight. A few days later, when I am calmer, I write a letter to the doctor at Baylor. I am very truthful about my medical issues, and brutally honest about the effect his cavalier attitude had on my heart and my hope. I just have an intense need for him to know. Surprisingly, he writes an excellent reply, thanking me for my honesty. "I promise to improve upon my patient-doctor compassion and my bed-side manner." Though I'm not sure if he will or not, I feel like he at least understands a little.

As for me, this "letter writing" habit has stayed with me, as you have seen. Seems I had found an effective way to express my truth, yet not having to do it face-to-face. I can control my emotions that way.

I did not need therapy to understand why that coping mechanism worked.

"The greatness of a man is not how much wealth he acquires, but in his integrity and his ability to affect those around him positively." Bob Marley

Chapter 29
January 1996 - May 1996

"In the last few years, the very idea of telling the truth, the whole truth...is dredged up only as a final resort when the alternate option of deception...has been exhausted." Michael Musto

The following week, across the country in Florida, the hits just keep on coming. Choosing to actually stay as far away from this unbelievable scene, brother Bill shares the details with me later that day.

"Mom, Aunt Janet and I showed up at Barbara's attorney's office to give their depositions. Our lawyer expected it to be pretty cut and dried - just the factual answers to the questions asked - with probably a few clerks in the room to help facilitate. All four of us were stunned to see Barbara sitting there, next to her attorney, ready to hear what Mom and Aunt Janet had to say. Awkward, to say the least."

According to Bill, Barbara went on record with her actions for Uncle Bill's last three days. "I arrived in Florida on Friday, and immediately went to the hospital to see my uncle. He

was still conscious and seemed mentally alert. After we exchanged small talk, he asked me to find a lawyer as soon as possible, as he wanted a new will to be generated. I located a law office close by the hospital on Saturday and hired a random attorney who followed Uncle Bill's instructions as communicated by me. His estate was now to be left to me, disbursed to charities of my choice, exactly as he wanted. I signed and witnessed the document and rushed it back to the hospital for Uncle Bill's signature. Fading quickly, he could not hold a pen, so the nurse signed as a witness. By Sunday, Uncle Bill was gone. On Monday, his body was cremated. I returned to Minnesota without contacting anyone in our family."

I can only imagine the horror my Aunt Janet and Mom are experiencing at that moment, hearing those words come out of Barbara's mouth.

"No other explanation, no words of comfort, no emotion in her voice," says Bill. "We were all stunned. After a short break, it was Mom's turn to answer questions on record. Gail, I am sorry, but Mom could not do it."

Bill continued to describe the goings on to me on the phone. "Mom told the room that 'I cannot go forward with a lawsuit against my own daughter, even though I believe that Barbara manipulated the situation. I just do not understand why.

But no amount of money is worth going through this pain. I am sorry for letting you down Janet, Bill, and all our children. I know how much you all could have used this financial windfall.'"

Bill's voice is sounding both tired and angry. "And then Mom walked out. And in a matter of an hour, the suit was terminated. Aunt Janet reluctantly agreed to go along with Mom, and that was it. Our sister Barbara won without much of a fight. Hope it was worth it to her."

"No, no, no!" is my immediate reaction. In addition to losing the money, we may never get a truthful explanation. The questions whirling in my head might never be answered. My sister has managed to hurt a large chunk of her family, who may never forgive her. The rest of us are young enough to eventually move on, but Mom and Dad may never recover from this devastating blow.

There may not be a mask strong enough to hide behind this time. My entire body is in reaction mode.

Ironically, two weeks later Barbara writes $1000. checks to her brothers, me, and my cousins Deb and Rich. The letter accompanying the gesture simply states that she has decided to disburse a [small] portion of the estate to each of us, in addition to the charities of her choice.

Bill's reaction to the mail-out is loud and clear. "Do not cash that check! It will go on record that you condone her deplorable actions." To the best of my knowledge, all of us ripped up the worthless pieces of paper.

The chasm in our family is now wide and deep. Barbara's choices, without explanation, are confusingly accepted by one branch of our tree. My brother's children, and their mom Beth, have remained close with Barbara over the years, and as a result have turned away from those of us who challenged Barbara's integrity. Letters are exchanged, but it is a classic example of agreeing to disagree.

In a far-reaching corner of my heart, I am glad that Barbara is not alone. At the same time, their absence from my life leaves a painful hole. "Do they know something I don't know about Barbara's actions?"

The fissure is too big for me to even think about building a bridge right now. My heart craves healing, but I am slowly and surely sinking deeper down the rabbit hole of sadness.

Life has a way of moving on, day by day. There is no improvement or clarity concerning my medical issues, so I have taken the self-medicating route. Imodium has become one of my drugs of choice. The box says, "short term" only, but it does what

the doctors have been unable to do - keep me from dashing for the closest bathroom.

Kevin continues on the path to graduation in a few months, thanks to his determination, and Danny G's continuing help. Missing a couple of necessary credits, the principal arranges CLEP (College Level Exam Program) tests for him to take. Once Kevin's girlfriend Dawn hears that, she gets permission to take a couple of tests, too. If she passes, she will be able to graduate this year, too.

In the category of great news, they both pass their necessary tests, and will graduate from Ferris High School in May, 1995. Kevin begins planning a move up to Denton, to attend The University of North Texas, and live with Jeff in the condo Gary bought to save money on both residing in the dormitory. No idea what Dawn's plans are yet, but she is really smart, so Dan and I assume she will be going to college somewhere.

One month to go until summer break. As a result of all the personal drama, I am praying daily for strength to finish out the year. Dan and I have a trip to St. Kitts planned to celebrate our 3rd anniversary the week after graduation. "Dan, just get us on the plane, and the island will heal our bodies." Sounds simple. After all, God does not burden you with more than you can handle. Right?

Oh my! God definitely believes in my strength.

The second week in May, one of my students drives off a foggy road on the way to school and dies alone in a ditch. Remember my mantra, "They didn't teach me this at Tarleton?" Thank goodness they didn't teach me about the possible death of a student, because it would have stopped my education in its tracks. My family doesn't do death, remember? Even at my best, I suck at death. My head is barely staying above water at this point, but drowning is not an option.

It's full-on mask time. My colleagues and I must lead these students through the grief of the untimely death of their friend. We rally-round their broken hearts, and their questions of "Why?" It is surreal in every sense of the word. To heap bizarre on top of unreal, someone approves of holding her funeral in the gymnasium. J was born and raised in Ferris, and her life revolved around school.

So, of course, why not have her funeral in the gym?

Is that normal?

So, every time her peers come to PE they will "see" her casket, draped in her Ferris jersey? In the climactic moment in the basketball playoffs, the coffin will cloud the athletes' view. I do not understand.

Through my foggy state, as the service is ending, I hear loud and clear from the Southern Baptist preacher standing by J's open casket, that if "You have not been saved, you may NOT walk by the body to pay your respect." What the hell. Did he just say Presbyterians are not worthy?

Thankfully, one of my Earth Angels, math teacher Mr. Reed, has been checking on me for weeks. Kevin has shared that Mr. Reed asks about me almost every day when he is in math class. Very quiet, very professional kind of guy with empathy.

Today he met me at the door of the gymnasium. "I saw you come in this morning, and you are looking a little off your game. Let's go sit in the bleachers with some of the other teachers." We climb up a few rows and are behind the funeral crowd seated in chairs.

Born and raised in primarily Southern Baptist communities, Mr. Reed understands immediately why I am about to stand up. "Mrs. Woods, this is not a battle you will win today. This entire gymnasium is filled with Southern Baptists. Wrong time, wrong place. Just stay with me and we will leave by the side door. Put yourself first today. Trust me. It will be okay."

"Thank you, Mr. Reed." *Thank you to all those Earth Angels who were there when I needed them.*

He is right to encourage me to leave it for another day. I really do not have the strength left for anything else at this moment. Yet, I still have faith I will get myself back on my feet again, and I will fight those battles later.

Just putting one foot in front of the other for two more weeks is the plan of action. Breathe in and breathe out.

Before there was a 'Barbaragate', the whole family had a wedding on our calendars. My amazing nephew let us all know to save the date: May 1996. We had flown to New Jersey to celebrate his mom Beth's second wedding, his sister's wedding, and so naturally had long-term plans to attend this happy family gathering.

And then the world tilted, and a month ago we decided to send our regrets. The thought of being in the presence of the entire branch of the family where we are persona non grata is way too much to handle. At this moment, we are grateful for that decision.

Can you imagine walking into this lion's den? Hours of total masking could just be my ultimate tipping point.

The weekend following the funeral debacle, my mom telephones and blows those plans out of the water. She announces that she is going to attend her grandson's wedding. "It is only right, Dorothy Gail, that I am there. Barbara's choices should not

control mine. Dad and Bill are staying home in Florida, and want me to do the same, but I feel strongly about this. Don't worry. I will be fine."

The moment I relay my mom's declaration to Dan, his response is instantaneous. "Your mom should not go to that wedding alone. So, I will make plans to meet her in New Jersey and be her companion. Fly up Friday night and come back Sunday. Short and sweet, as Anne likes to say."

Thank you, God, for bringing this compassionate man into our lives. What an amazing solution, right?

Of course, I could not accept his offer. That would be too sensible. "It's my mom, my family, and you should not have to be the one to brave my disgruntled relatives. I'll go, be there for Mom, and come right back to finish out the school year."

As we have countless times during our relationship, we compromise. Both of us are going, and together we will be stronger. That's how we roll.

"Heavenly Father, you are our protector. You are my God. In you I trust." Psalm 91

The wedding is beautiful, as is expected. The bride and groom appear to be very much in love. In the church, we enjoy a moment of peace before the storm. Driving out to Beth's home

on the lake, we take a minute to remind ourselves to keep it simple, and to protect Mom from any uncomfortable moments.

Ha! We walk into the backyard reception as an apprehensive group. My brother Scott, his third wife Judy, Mom, Dan, and me. *There's an infamous photo to perpetually remind us of the looks on our faces.* I first see my beautiful niece across the lawn, dashing in her red dress and black shawl. I spy Barbara running around helping, looking like she is having a wonderful time. Everyone is mingling, celebrating, but we awkwardly remain a little bit removed from the group.

Sure, some extended family members and guests are greeting us, but to me it feels like we are observing from outside a bubble. The sound is muffled. Faces are laughing and talking, but it feels like a live nightmare. Not sure if I can cling to Dan's arm any tighter.

I honestly cannot share many details of that day. If there was a splintered Frankel family photo taken, I don't remember. I do know the weather changed, and there was a hurried mission to anchor the tent. I remember sitting at a small table with our select group. And I remember feeling pain in my heart walking by my sister and neither of us acknowledging each other. That's it.

That is more than enough.

Sunday morning breakfast is covered in gloom. Not much conversation, even though we had stayed in Brigantine at Beth's beach house. Right across the street from our favorite Brigantine restaurant, Pirate's Den, is the amazing Atlantic Ocean. If only I had taken time to sit on the beach and be still. It will have to wait until next time.

I feel wretched. Everything hurts, especially my heart. Literally - the area inside my chest aches. That's a new addition to the list of ailments, but what the hell, it reminds me of the pain I had right before I started high school. I just spent the last thirty-six hours playing the most evil game ever: "Look at us. We are the most loving family. Every one of us is just fine. Smile."

How can that be normal?

We are not zombies.

We are alive, with real human emotions and reactions.

Deep, slow breaths.

Using motion-sickness medicine before the plane takes off puts me right to sleep, but when we arrive back in Texas the dull ache remains.

It feels good to see Kevin, who is excited about his upcoming high school graduation this Friday. He looks like a different person since he came back home two years ago. More

confident, happier, much thinner after dieting all year. Ready to begin the next phase of his life.

Monday morning, all three of us leave the house, each with our own thoughts of surviving just one more crazy week of school.

"No matter how much it hurts now, someday you will look back
and realize your struggles changed your life for the better."
Unknown

Chapter 30
June 1996

"Owning our own story and loving ourselves through that process is the bravest thing that we will ever do." Brene Brown

Midnight: Could I have pulled a muscle somewhere during our trip to New Jersey? Maybe carrying luggage?

Two a.m.: I found myself holding my breath a lot during the weekend. Could I have done something to my lungs?

Five a.m.: Time to rise and shine, no matter if my chest is hurting. This is a big week coming up.

If you have ever worked with children, in schools, on the last week of the calendar, you know. Total chaos! Exams are finishing up, books are being turned in, you need to grade your exams, enter the grades, complete semester and year-end averages, pack up your stuff whether you are leaving or not (maintenance reasons) AND keep your classes under control any way you can. Audiovisual devices are scheduled to the minute, and if you take your eyes off one in your possession, it could roll away and disappear.

I now am wise enough to schedule an acceptable novel to read in my lesson plans, with a really good video version, that last month of the year. For example, *To Kill a Mockingbird* movie lasts 3+ class periods, times two classes of English II. Perfect. This year I am set, as far as my classes are concerned. The problem is going to be remaining "in charge" of my classes when I feel so horrible. One hour at a time, sit down when I can, fake it as best as I am able. My next-door neighbor knows I am feeling sick, and so does Danny G, so they stop by and check on me. Kevin is in and out, finished with classes but busy with graduation business. "I'm good. I got this. Heading out as soon as the students clear out," are my brief responses. "I'm fine."

Finally, the bell rings to signal the end of classes for today. Made it through day one. Just four more to go.

Sitting in my car in the parking lot, I close my eyes to be still for a minute. Dan and I are meeting at our usual Monday afternoon stress relief spot: a small golf course that is halfway home for both of us. Today, I doubt that I will be able to play, but it is too late to head him off. I feel a little worse since one of my seniors stopped by with the "gift" of Taco Bell for lunch. It seems to have literally added to my "heartburn." Normally, we both enjoy playing golf, being out in nature and embracing the quiet.

Sometimes I just ride, keeping score for Dan, sometimes I take some shots. But I always enjoy the opportunity to relax.

When we meet up in the Red Oak golf course parking lot, we share a big hug and Dan takes one look at me and says, "Well, it is obvious that you do not feel any better than you did this morning. Tough day in the classroom?"

"Not really. Even my students have tuned into my mood. One brought me lunch, a couple students in each class helped pack up my 'stuff', and a few teachers checked in on me throughout the day. I just need Friday to come as fast as it can. But let's get a golf cart and go out on the course. I will enjoy the ride, and you can take your stress out on the golf ball!"

After a few holes, we pull up to the tee box of a short par-3 hole. "I want to hit one, Dan. Maybe it will feel good to stretch my muscles a little."

In the middle of my back swing, my body sounds the alarm…shooting pain down my arm.

The pain in my heart drops me to my knees.

"Dan, I think I might be having a heart attack," is what Dan hears as he rushes to my side.

Wasting no time helping me up off the ground, securing me in the golf cart, and driving the most direct path back to the

parking lot, Dan takes charge of the situation. There is no mask on my face now. We are both truly scared.

Pushing my hand against my chest and trying to keep my moans quiet, I am very grateful when we pull into the emergency area of Waxahachie Medical Center. Dan's voice brings immediate attention, and I am wheeled into the exam area quickly. It seems to take a long time, but finally the nurse hits my hard-to-find vein, and the meds begin to do their thing. Whatever exams I have, with Dr. Whoever, happen after I drift off.

I wake up hours later.

Dr. Whoever introduces himself to me very early the next morning. I open my eyes to see him sitting on my bed! "Hello, Gail. I am Dr. Walker, your emergency room specialist. We met last night in the ER."

"Hello, doctor. I'm sorry but I don't remember much of last night. Is my husband here?" I mumble.

"Dan went home a few hours ago to get some sleep. I am sorry to wake you so early, but I wanted to have time to talk with you before rounds. We ran multiple tests on you last night, and first determined you were not having a heart attack. Eventually, we have come to the consensus that your pain may be stress induced.

I want you to tell me a little bit about your life. Begin with now, and then go back slowly into your past."

In spite of reeling from the glimpse of the going-to-die feelings, and still feeling the effects of the ER meds, God gives me the strength to finally click the truth button. Taking a few minutes to breathe, I decide it is time, actually way past time, to begin to tell the truth. He is actually the first doctor who has asked this question.

Before I can tell him about my present, though, I must tell him one vital truth from the past. "I was raised by parents who taught me to always have a smile on my face. To be perfect outside the front door. I am 42 years old, and I am still controlled by that edict."

Sometime after the sun rises, Dr. Walker stops me and issues his suspected diagnosis. "I believe you may have suffered from clinical depression for a very long time. If you will trust me, I want to prescribe an antidepressant for you, and recommend that you also see a counselor for talk therapy. I highly recommend my friend and colleague Dr. Jim Esely, here in Waxahachie. I will follow up with you for the next few months, and we'll see if you begin to feel better."

Through my fog (and my tears!), I agree to give his suggestions a try. Obviously, I do not know much about

"depression" at this moment, but I feel some hope to be trying something, finally. To have a diagnosis at last.

As we are finishing up, Dan walks into my room. "Dr. Walker, have you met my husband, Dan? He is the best thing I have going in my life. He will be right beside me as I walk this new path."

"Dan and I met earlier this morning. I wanted him to know my observations. Gail, I want to keep you here for a few days, to monitor the new meds, but we will make sure you are able to attend your son's graduation on Friday night. Catch Dan up on our conversation, please. I will see you both later on."

Closing the door to my room behind him, Dan wastes no time climbing up next to me in the hospital bed. Hugs are a vital part of our loving routine.

My eyes shed tears off and on all day. My emotions flit back and forth between joy at finally having a plan towards feeling better, and sadness at accepting that I will have to take medicine to feel "normal." As the day progresses, including a timely visit from two of my students from Ferris, clarity begins to poke through my fog.

This is the first sign of hope in a long journey searching for answers. The path forward may be difficult, but I've mastered inconceivable obstacles before. That night in my hospital room,

all alone for the moment, I declare to God that I am going to do this.

"Heavenly Father, I am going to do everything in my power to heal, physically and emotionally. I ask you to wrap your arms of protection around me on this journey. Thank you, God, for placing Dr. Walker on my path last night. May he have the answers for what we have been searching for."

True to his word, I am released from the hospital Thursday afternoon. I am feeling a little better just having a plan, but the antidepressants will take a few weeks to get completely into my system.

In the morning, it's just in time to put in an appearance on the last day of school. There is only a half-day, with a senior breakfast and graduation practice on Kevin's schedule. He drives us both into school, just to be safe.

I am surprised and so grateful to find my classroom all packed up and ready to go. Needing to finish up my grades, I stop by the senior breakfast to wish them all congratulations, and then head back to my room to finish up. Students and colleagues pop by to say, "So glad to see you back, Mrs. Woods." "Hope you get lots of rest this summer." "We missed you." Lots of love and support feels good. When Kevin is finished, we head out the front

door together. After graduation tonight, he will not be back, but I plan to return for the next school year.

Healthy, I hope with all my being.

Dan's parents are coming to the graduation with us tonight. They have really enjoyed getting to know Kevin better in the last two years. And like us, they are proud of how he has turned his life around. Jeff has come down from Denton, and he too is excited for his brother. Should be a great celebration for Kevin, Dawn, and all the graduates. The ceremony is held outdoors on the football field, and the weather is windy and warm.

Warm or not, when Kevin Scott Nolan walks across that stage, accepts his diploma and shakes Danny G's hand, I have goosebumps all over. My smile is genuine, and my tears are flowing. Dan is also beaming with pride in this young man who has become like a son to him. When Kevin walks over to our seats following the ceremony, the senior Woods get the first hugs. "Congratulations, Kevin. Now get out there and make a difference," Jay says.

"Thank you, Jay and Dena, for coming tonight. It means a lot to me," Kevin says, while hugging Dena.

Dan and I grab on for a group hug, and both of us share our congrats. We have already spent lots of time discussing 'what next'?

Gary continues to work in Saudi Arabia, so he misses Kevin's moment of achievement. There are still more than enough congratulatory hugs to go around, including one from Danny G. "Kevin, you surprised all of us here at Ferris. Take your determination with you to UNT, okay? Make us all proud."

"Yes, sir, I will," Kevin says with pride in his voice. "Thank you for all your help."

Dedicating his summer to helping me get better, Dan takes his mission seriously. He packs our bags, with my supervision, gets us on the plane two days later, headed for a week in St. Kitts in the Caribbean. A few hours later, we arrive at a stunning resort on the water. After a slow stroll around the grounds, we head to our room to "clean up for dinner," a euphemism for taking a nap. I wake up to the sound of pouring rain outside our window, which dampens my spirits a little. "Hey, what's a little rain when you're in the Caribbean?" Dan teases. We get dressed and ready to dash out the door to the dining room. We open the door and beautiful sunshine greets us. What the heck? Walking around the corner, past the back of our room, we

see water flowing down from the air conditioners on the second floor.

"Well, Dan, it seems we are both a little bit goofy after this long school year. We definitely need to rest and relax. I was a little worried about the timing of this trip, but it's just what the doctor ordered. I love you!"

"The only thing I worry about is you feeling better. It is so frustrating not being able to find answers. I hope that Dr. Walker and the counselor will both be able to help," Dan says, grabbing my hand and squeezing it.

We have a wonderful, low-key adventure together. Dan is hell bent on keeping me as stress free as possible and is doing a fine job of that. A few self-tours around the island, hours on the beach, lounging by the pool bar, and naps, lots of naps. Each day I feel my shoulders and neck relax a little bit more, in relief, I imagine. The pain in my chest is down to a mild ache.

We already know it is going to take quite some time to climb out of this deep hole, but we feel some hope. Our conversations focus on going forward, again. "We have been through a lot of ups and downs in just three years of marriage. But we survived. A little bruised and battered, but still on our feet," I share with Dan one night on the beach.

The moon is bright, reminiscent of the night I asked him to marry me. We are surrounded with the smell of flowers and the sea breeze on our faces.

"Yes, we have Gail, more than our share. And now we are going to concentrate on getting you healthy. I'll be here to support you, but you have to do the heavy lifting - tell the truth, the whole truth, and nothing but the truth. That's the only way the doctors will be able to help you." Dan smiles at me and I can feel the intensity in his words, "Okay?"

"Yes, Mr. Woods! I have already promised God to do just that. And I give you the same promise. Now, let's walk down to the water and get our feet wet. It's still really warm tonight in the Caribbean on the island of St. Kitts! Can you believe that's where we are? So cool. I really don't want to go home tomorrow."

Three days later brings me to my first appointment with James Esely, MDIV, LP Counselor. When he comes into the waiting area to invite me in, I instantly feel welcome. The cozy office area has the expected couch, muted lighting, his armchair across the carpet, and a beautiful desk behind the sitting area. "Come on in and sit down. It's nice to meet you, Gail." I cross to sit on the rust-colored sofa, feeling a little shaky, but hopeful. Mr. Esely sits down in his armchair, with a yellow legal pad and pen on his lap. "Dr. Walker has shared a little background with me,

but why don't we begin by just getting to know each other a little bit. Hopefully, it will become evident through our chat which direction we need to go from here."

I am thinking about how simple he makes that sound - just talk back and forth to each other about my life! Out loud, I say, "Okay," with a big gulp.

"Why don't you tell me about the event that led to your being hospitalized last month?" Mr. Esely asks.

"Wow! No small talk first! Jump right in feet first. Well, before I can tell you that story, I have to tell you this first. I was raised by parents who required me to hide my feelings. From a very young age, I was taught to wear a mask almost 100% of the time. And I am still wearing it 42 years later."

"Well, that sounds like quite a heavy burden you have been carrying then. Let's see if we can remove some of that weight off your heart. What was happening the weekend last month when you ended up in such pain?"

"My nephew got married in New Jersey, and my husband Dan and I accompanied my mom to the wedding. It felt as if most of my family were inside a bubble, and I could not reach them because…"

And, the words came tumbling out, briefly describing "Barbaragate," why we chose to attend the wedding with Mom,

touching on the atmosphere at the reception, and then going off on a few other tangents. Mr. Esely takes a lot of notes, which messes with my head in the beginning, but I soon stop noticing.

I speak all TRUE WORDS! Until suddenly the hour is up. "Well, time certainly flies by," I joke. "Sorry if I ramble too much."

"This is an excellent start," Mr. Esely says, laying his pad and pen aside. "Let's see each other twice a week for a while. School is out so the timing should be good for you. I'll read over my notes and have a direction for us next time. Does that sound agreeable to y"u?"

"Yes, that will work for me. After many years of struggling, I finally feel ready to tell my story. Truthfully. I'll see you in a few days."

"Ok, Gail. You may call me anytime in an emergency."

As I leave through the front door, feeling better than when I walked in, I count it a success. I really like his demeanor and feel no judgment from his facial expressions. I understand that finding the right person for a counselor can be difficult, but I feel comfortable already.

On my third visit, Counselor Jim welcomes me as usual. I sit down on the couch, he sits in his chair and immediately says, "Gail, I want you to close your eyes."

Woah! Slow down there please. "Are you going to hypnotize me? Shouldn't we talk about it first? What is it going to feel like?"

"No, I am not going to hypnotize you. I am going to take you on a mind walk. In your relaxed state, you will feel like you are dreaming, but you will remember it when you 'wake up.' You and I are going to a funeral for your brother John."

Bullseye.

Damn, it didn't take Jim long to figure out the crux of my problem. Excitedly scared, I draw heavily on my newfound trust for this man.

Laying my head back, I shut my eyes…

And then I am there, in a beautiful green valley in Pennsylvania, surrounded by budding trees and spring flowers. There is an open casket off by itself, shaded by a big flowering Dogwood tree. That's Mom's favorite tree. I walk toward it with anticipation, not fear. In my mind, I know John died thirty-six years ago, but I never got to say goodbye to him. Looking down on his familiar face, I touch his pale cheek, then lay my hand on top of his hands and begin to talk out loud.

"I have been wanting to say goodbye to you for a long time. You were the best brother ever. There hasn't been a day that I haven't missed you, John." Stopping for a moment to catch my

breath, it is so quiet except for the birdsong coming from up in the tree. I notice how vivid all the colors on the flowers are: green, white, pink. Looking back at John, I continue to speak my thoughts. "For the longest time, I dreamed you were still alive, watching over me from up in a tree but I just couldn't see you. I would talk to you mostly when I was alone in my bedroom. I believed you always listened. You were the only one listening."

The breeze picks up just then, blowing a few of the dogwood blossoms down into John's casket. The temperature is dropping. I hope this is not a sign this mystical moment is about to end.

"John, you went away way too soon. Our family was never the same again. It seemed like we each went into our rooms most of the time. When we did something as a family, it felt so sad and weird that you were not there.

"I need to tell you goodbye now, John. It's the reason I am here today. I feel you are watching over me, so you already know all about the life I have lived. Years filled with joy and sorrows. But I am working on finding more peace. My husband Dan is a rock, and we love each other very much. You would love your two nephews. They are my best work! Thank you for always taking care of me when we were growing up.

"Goodbye, John. I love you. May you Rest in Peace."

Then I reach up and slowly close the lid of the casket. I notice a bench placed close by, so I walk over and sit down. Tears are streaming down my face, but it feels right. Looking around, the sun is beginning to set. In the twilight, there is enough light to see that John's coffin is not there anymore. And that's okay.

"Slowly open your eyes, Gail and lift up your head when you are ready."

It takes a minute to get my bearings. Opening my eyes, I am looking right at Counselor Jim's tearful eyes, sitting across from me. "That was wonderful. Magical. I was in a beautiful valley filled with colors and spring flowers. Most importantly, John was there, lying peacefully in a casket. I shared my feelings about his death, told him how much I missed him, and he listened. Now, I feel tired, yet peaceful. Thank you so much for whatever that was."

"This is a technique I use to open up the place inside you that holds all those unleashed emotions. Releasing them from you into the ethos. You have needed to say goodbye to John for all your adult life. Today, with my guidance, you were able to do just that. With just a few quiet prompts from me, your words began to flow from your heart. Those feelings have been bottled up for many years. From now on, when you think about John, you

should remember this vision. Savor this memory, instead of the sadness and anger."

Counselor Jim continues, "As we continue meeting, we can do more of this if you want. Unleashing the real emotions and words you masked and reveling in the release. If you want to heal from your years of masking, this is the best path."

"If the other sessions feel like this one, I want to do more," I enthuse.

"Well, I'll see you on Tuesday, and we will get back to work. By the way, my personal description of this technique, not yet published in any professional journal, is called **'Savor the strawberries and flush the shit!'** Think about it while driving home, and share it with Dan. Have a good weekend."

Once again, I find myself sitting in my car, marveling at what I just experienced. As tears trickle down my face, I notice the complete sense of calm that surrounds me.

Thoughts of John invade the quiet moment, and I embrace them with love.

May we both finally be at peace.

Heading for home and my waiting husband, I cannot wait to share this with him: "The pain I have carried since John's death has finally been flushed down the drain. Dan, you are not going to believe this story."

Dear 'Earth Angel' Counselor Jim,

I always believed that our paths intersected through the guidance of God. We even talked about it as our relationship grew from counselor to friend to family. We were such a perfect fit for each other.

Such a gift you are to both Dan and me, still a strong presence in our hearts after 26 years. Your comforting companionship carried us through not only my lifetime of masking issues, but also Dan's burdens, and then Jeff when he was diagnosed as Bi-Polar.

Your timeless wisdom comforted our family.

Your attendance at Dan's father's death provided invaluable strength to Dan, and to me.

Your meticulous plan for helping me to heal was at times miraculous. Together we savored many strawberry moments and flushed the shit 'til my body felt cleansed.

Thank you, Counselor Jim. May you continue to look down upon me always, as I remember you with gratitude in my prayers. I have mentioned numerous Earth Angels throughout my story, but you are the Alpha Angel who shepherded my healing.

May you also be resting in peace.

Love and blessings,

Gail

The End…until we meet again.

Epilogue

My most vital task has been managing the fragile balance between feeling grounded as opposed to tilted. Thankfully, medical science breakthroughs continue to bring new medications, and new information about the disease of depression. It has taken twenty-plus years since my initial diagnosis to process, reflect, and love myself enough to feel empowered to tell you my story.

Thank you so much for coming along on the dynamic ride of the first 40 years of my life. As you turn the last page, I have finally begun a life-long, healing process. Counselor Jim and I continue to meet twice a week for months, unpacking closed-off memories, unlocking my true emotions, and learning the tools needed to heal. As time passes, Jim becomes Dan's counselor, our couple's counselor, and so much more as a professional relationship morph into family. He guides us from a crisis point to reconciliation with countless life-events.

Our next sojourn, from 1998 to 2016, will continue to primarily focus on maintaining our health and happiness during some tumultuous years. Dan's "situational depression" resurfaces after many years, mostly job-related. Thankfully, another faith-based counselor, Dr. Donald, will blessedly join our circle in

2006 for the next wild ride. I cannot emphasize enough the value of having an objective, trustworthy voice to communicate with, truthfully. I continue to have Dr. Donald on speed-messaging.

Navigating our teaching careers will keep us mostly in Texas, except for one 'year from hell' we spend in Las Vegas. You are not going to believe that chapter! On the opposite side of the scale from the Vegas experiences, once back in Texas we both also face the shadow-side of organized religion. Working at churches and schools where leaders exhibit poor behavior 'in the name of the Lord.' That can shake the very foundation of any faith-based solid marriage.

During the mid-1990's, both sets of parents joyfully celebrate their 50th wedding anniversaries, surrounded by family. Sadly, beginning with my Daddy just two years after Barbaragate, one by one they passed away. That moment when you realize the matriarch and patriarch of your family are gone is gut-wrenching.

Beginning "adulthood," Jeff and Kevin's lives will continue to be as twisty as a roller coaster. That's what growing up should be: in and out of relationships, jobs, and living spaces.

Here's a sneak peek into Kevin's future…ten months after he graduated from high school, our phone rang. "Mom, I really need you to meet me for dinner as soon as possible. Just you, alone. How about tomorrow night?"

"Sure, Kev," I reply. "What's up?"

"I'll fill you in when I see you."

When I hang up, my comment to Dan says it all. "Kevin wants to meet just me for dinner tomorrow. Either he is dying, or they are pregnant." Well, he is not dying! He and Dawn have created our first grandchild! An unexpected gift and a blessing. Sadly, in 2005, Kevin and Dawn will divorce, and all our lives will change again.

Our final journey will take us to Costa Rica in 2016. Spending the last 7 years 'retired' has been more than we ever dared to dream. Living in this country of kindness has afforded us the time, the healing, and the paradise-like surroundings to ponder and then to write my story.

Most importantly, to the very best of my cognitive ability, my smile-mask has been ripped off 100% throughout these pages, and 99% in my life. Sometimes, I still get wacked over the head with a 2x4, but together Dan and I learn how to minimize the episodes.

As I close this first in-depth description of my descent into depression, it is my hope that my readers recognize the interdependence between nature and nurture. Sadly, currently there are now five generations of Deatcher/Frankels diagnosed with various types of emotional/mental illnesses. When I began

this memoir, there were only four. Who knows how many more are as yet undetected?

The simple mantra "Communication Matters," by all definitions, has taken on an almost desperate call to awareness. Besides the Covid pandemic, depression and suicide victims have risen in epidemic numbers on their own. I have made it my mission to model truthful communication. Sometimes, my family and friends turn away from my directness. But I will not go back. As a matter of fact, I cannot mask even for a few hours, without feeling the negative effects.

Radical Mindfulness and acceptance of who you are was introduced into my life by a new friend, Daniel Gutierrez, who wrote the incredible book by the same name. His techniques have led me away from the pain of my past, toward peace, silence and profound understanding. In retrospect, those earlier moments, when I mustered the strength to declare my true intentions, I realize I was practicing Daniel's technique.

Lastly, but just as powerful, is the realization that the understanding and the sharing of our stories will most definitely help to lower the stigma attached to mental/emotional illness. Ask someone how they are, and then stay a minute to listen.

Writing these words has been a journey filled with compassion. My heart came to understand that my parents were

raised during a different era. One was affected by having to travel across the ocean to reconnect with her father at age five, and the other never knowing his father who was tragically lost during WWI. Both grew up way too young. What purpose would it serve to blame them? I was born into the "perfect storm," a sensitive, empathetic little girl who led with her heart and parents who practiced almost perfect stoicism.

Most humbling is discovering how many people have crossed my path, whether it was for a minute or a lifetime, who helped me and my sons along the way. Living 35+ years in the fog of depression prevented me from seeing so many details clearly. As the cliche goes, "I wish I knew then what I know now." Thank you all from the deepest part of my heart.

Foremost, I wrote my truth, from my perspective, and I stand extremely proud of my story. Through deep soul-searching, I continue to discover connections between many depressive episodes since my 'awakening.' Someone chooses not to do the right thing, to me or someone I love, and it stabs my heart and hurts like hell. Doctors, school administrators, priests and others who claim to be Christians, landlords, family members, and good friends, to name a few. When my heart gets rocked, I wobble. When accused of writing a "bash our loving parents'" story, before anyone had yet to read a word of the manuscript, I didn't

just wobble but I fell down the rabbit hole for a while. It's the nature of the disease. Controlled but not cured. It's one of the downsides of having such a huge, empathic heart. But thankfully, Dan and I now understand the steps to minimize the effects.

May this intimate look at my journey give you the strength to better understand yourself, and others who may be struggling with emotional illness. Blessings.

Author Bio

Please meet Gail Woods, a journalist and writer who uses her life experiences to aspire others to go after their dreams. After retiring from teaching in TX, Gail and her husband Dan packed up seven suitcases and relocated to Costa Rica 7 years ago. Her FB page SoJourn-E, you will learn how looking for the right road leads to the Monkey Trail and more fun adventures. She shares her quest for peace and joy in the hopes that others will be inspired to turn those dreams into realities.

Gail F. Woods is a freelance professional writer and editor whose work spans North America. A retired English and Communication teacher, Gail and Dan, retired music educator, followed their dream and "retired" to the mountains of this beautiful Central American country. Always one to use her life as an opportunity to help others, to set goals and strive to achieve those aspirations, Gail writes about her quest for finding much needed peace in *Smile of Depression*.

Gail F. Woods was chief editor and staff writer for Wildfire Workshops and the Evolutionary Business Council for four years, after retiring! Gail continues to be published as a freelance writer as the right story inspires her.

Gail's first book, *Smile of Depression,* is the emotional memoir of her lifelong journey with undiagnosed clinical depression and her eventual path to good health. Book #2 will be a "fictional" story, "Behind the Closed Door," sharing the eye-opening adventures of a Texas teacher. You won't want to miss this tug-on-your-heart-strings novel.

References

- History of Depression
- Causes of Depression: Nature or Nurture?
- What is Depression
- Getting Help for Depression
- Physical effects on the body from depression
- Why I was relieved to be diagnosed
- Marijuana for Depression Treatment
- Explore Smiling Depression
- What Exactly is Smiling Depression?
- Bipolar disorder
- Radical Mindfulness by Daniel Gutierrez
- Communication matters
- Quotes about Depression
- Brainy Quotes.com

CPSIA information can be obtained
at www.ICGtesting.com
Printed in the USA
BVHW050211100523
663913BV00011B/254